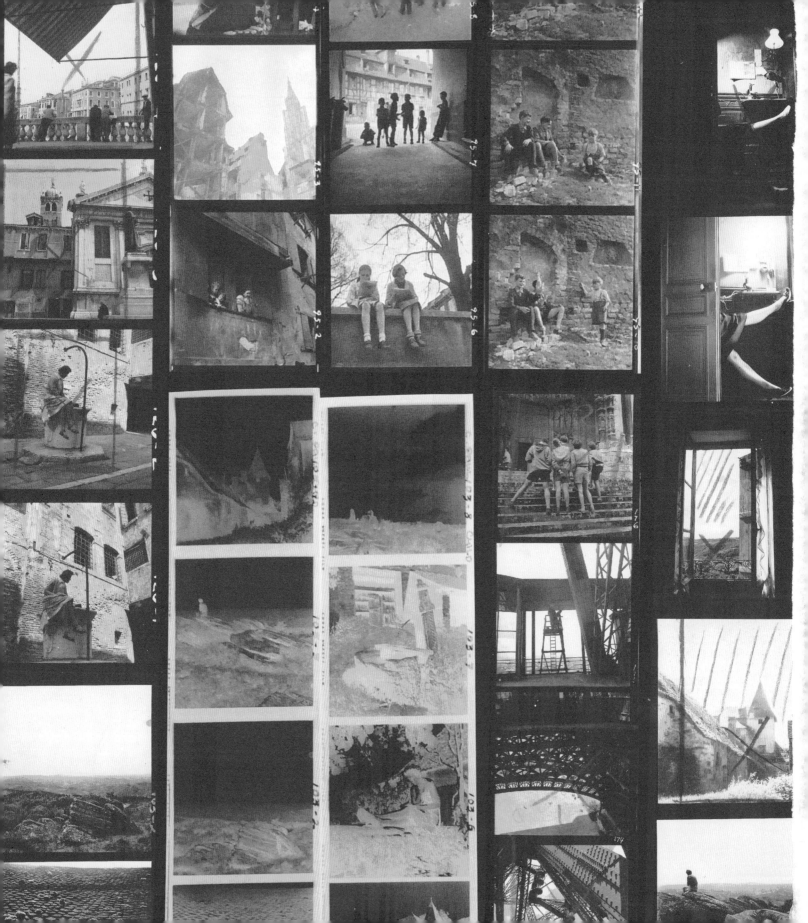

FRANCE
IS A FEAST

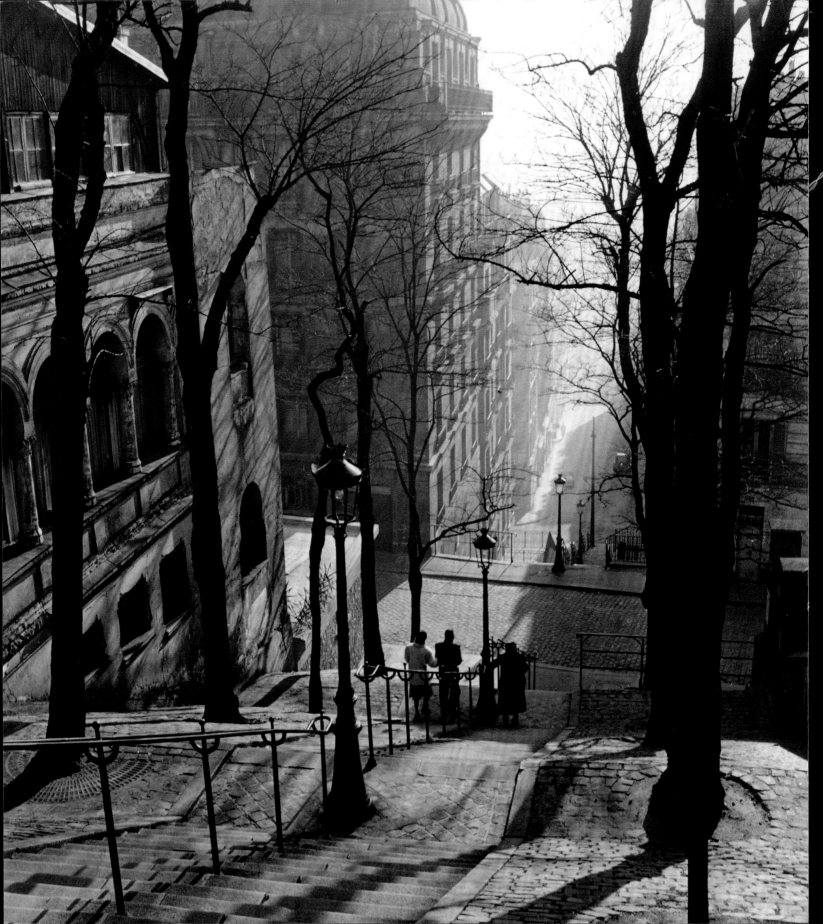

FRANCE IS A FEAST

THE PHOTOGRAPHIC JOURNEY
OF PAUL AND JULIA CHILD

ALEX PRUD'HOMME & KATIE PRATT

Thames & Hudson

To Paul and Julia Child

Designed by Anjali Pala, Miko McGinty Inc.

First published in the United States of America in 2017 by
Thames & Hudson Inc.
500 Fifth Avenue
New York, New York 10110

www.thamesandhudsonusa.com

Library of Congress Control Number: 2016932144

First published in the United Kingdom in 2017 by
Thames & Hudson Ltd
181A High Holborn
London WC1V 7QX

www.thamesandhudson.com

British Library Cataloguing-in-Publication Data
A catalogue record for this book is available from the British Library

ISBN 978-0-500-51907-3

Printed and bound in China

FRONTISPIECE: "Paris Steps," La Rue Chappe, Montmartre, Paris, 1950

CONTENTS

Foreword

―――

KATIE PRATT

> Your world is full of beautiful visual, physical, visceral
> experiences, Katie. It all comes down to understanding
> how to recognize the beauty in everything around you.
> —Paul Child

Over the many years I knew Paul Child, he shared inspiration and showed
by example how to live creatively and thoughtfully. I regularly saw him in
Cambridge as well as Santa Barbara and France, and he always pointed me in
the direction of observing and appreciating the beauty of art, wine, food, and
the world around me. He had a keen sense of design and appreciation of things
well crafted in every aspect of his life.

　　I was two years old when the Childs moved to Cambridge and were intro-
duced to my family by my uncle, Davis Pratt, a former student of Paul's who
became a professional photographer and teacher of the medium. For the many
years I was friends with Paul and Julia, I knew it was special to be around such a
high level of aesthetics combined with down-to-earth hearty friendship. I tried to
bookmark every experience in my mind—the patient and supportive art lessons,
the meals, the travels, the cozy family times with them (though I was not related)—
because even as a young girl I knew my world would be dimmer without them in it.

　　In Paul's later years I visited him in Santa Barbara. Julia, still busy with her
television and book projects, was often away, so I spent time with Paul, sharing
his "routine": breakfast with tea, toast, and fruit; daily walk along the beach;
newspaper bought at the Biltmore Hotel; going to the hardware store on errands.

Julia looks from the balcony, Strasbourg, France, 1956

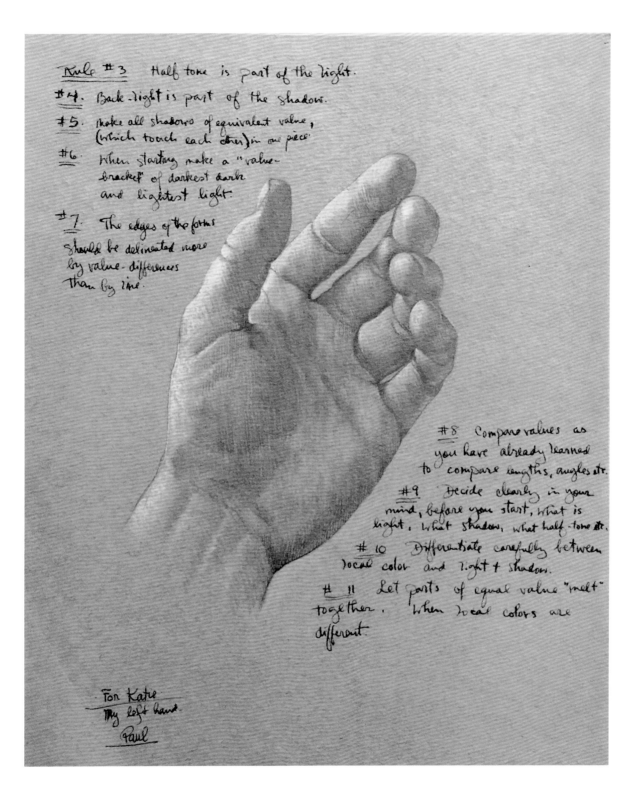

Rule #3 Half tone is part of the light.

#4. Back-light is part of the shadow.

#5. make all shadows of equivalent value,
(which touch each other) in one piece.

#6. When starting make a "value-
bracket" of darkest dark
and lightest light.

#7. The edges of the forms
should be delineated more
by value-differences
than by line.

#8 Compare values as
you have already learned
to compare lengths, angles etc.

#9 Decide clearly in your
mind, before you start, what is
light, what shadow, what half-tone etc.

#10 Differentiate carefully between
local color and light + shadow.

#11 Let parts of equal value "melt"
together. When local colors are
different.

For Katie
My left hand.
Paul

Paul Child, For Katie, My Left Hand, c. 1974

Paul Child,
art lesson,
c. 1974

After Paul died, I continued to visit Julia in Santa Barbara. When I shared my idea with her about paying tribute to Paul's artistic life in the form of a book of his photography, she immediately said yes. She too felt that Paul's exceptional talents as an artist of many disciplines had been downplayed, as that was how he wanted it. It was extremely important to me that the public see and know about Paul's work as a photographer.

He was a true artist, always pushing himself in his own creative process, continuing to explore the media he was using (primarily photography and painting) and always driven to improve on his own work.

In a world that rewards climbing the corporate ladder, Paul encouraged me to follow my heart and pursue my creative studies in Europe, learning foreign languages and making glass art. He was and today still is my mentor in my role as a photography and art consultant and curator. My perspective, and how I observe and understand the world around me, seeing design, light, color, balance, and beauty in things, is forever enhanced by my knowing Paul.

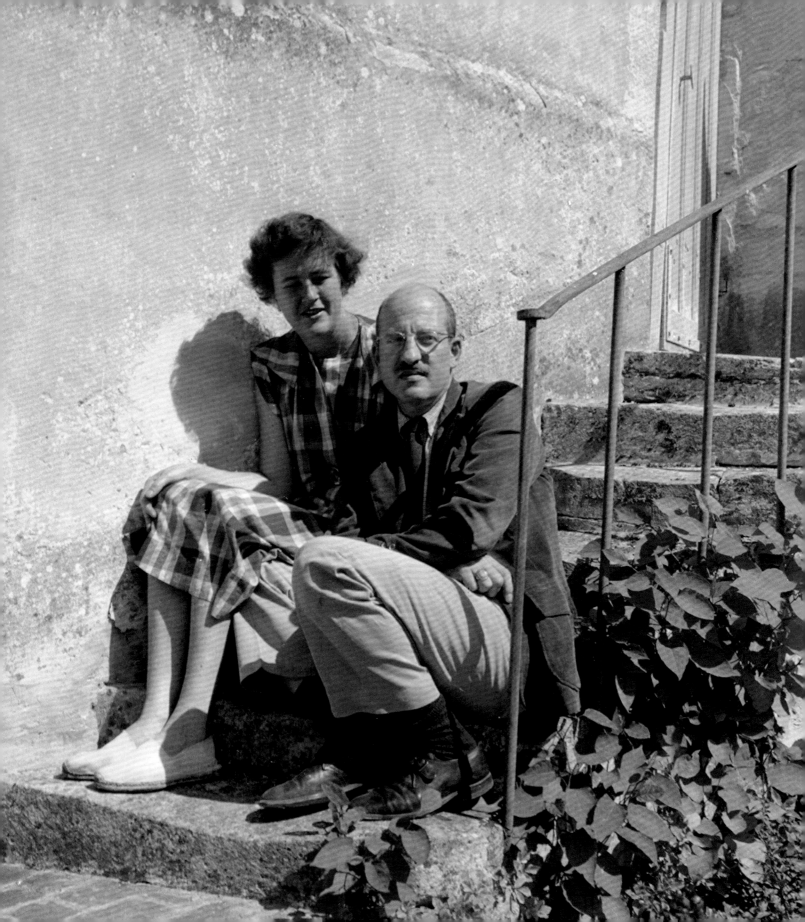

PROLOGUE

A Brimming Cup

ALEX PRUD'HOMME

In 2004 I helped Julia Child write her memoir, *My Life in France*, which was illustrated by the photographs of Paul Child, Julia's husband and my grandfather Charles Child's twin brother. When that book was published in 2006, there was a tremendous public response—both to Julia's stories and to Paul's evocative images. On countless occasions, people said to me: "I love those pictures. Have you ever thought of doing a book of Paul's photographs?" The answer was yes.

My Life in France was largely the story of how Paul and Julia lived in France both after the Second World War and then again in Provence in subsequent years. The book in your hands is a visual extension of Julia's memoir, an extension that lets Paul's imagery take the lead. *France is a Feast* shows the story of the Childs' lives in Paris, Marseille, and elsewhere throughout France between 1948 and 1954, largely through Paul's photography and from Paul's perspective. During the roughly five years that Paul and Julia lived in France, Paul developed his skills as a photographer and his philosophy as an artist and, as I hope this book demonstrates, became a twentieth-century photographer of note. All of which sets his marriage to Julia and their years in France in context.

Paul Child later became best known to the public as Mr. Julia Child: the man who helped illustrate her cookbooks with drawings and photographs, and the calm guiding hand behind television's ebullient "French Chef." But Paul was my great uncle, and I knew him as a far more complex and polymorphous man than that

Julia and Paul, Château du Couëdic, France, 1949

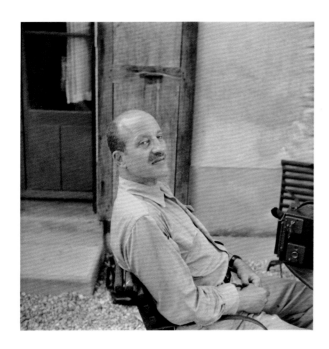

Paul with camera,
Paris, 1949

description suggests. Foremost, he was a talented artist: a photographer, painter, lithographer, woodworker, metalsmith, stained-glass expert, writer, and poet. He was also a world traveler, a linguist, a black belt in judo, a deeply read teacher, a sophisticated diplomat, and a reticent man who trained himself to be an effective visual and verbal communicator. And, of course, he was a food and wine lover who first tutored his wife in the joys of *la cuisine française*.

Though Paul Child was not a professional artist, he easily could have been. He and Julia were childless, and Paul devoted nearly every minute of his free time to photography, painting, and writing. But while his twin, Charlie Child, was a full-time painter, Paul made art while maintaining a career: as a schoolteacher before the Second World War, and as a Foreign Service officer after the war. Paul was just as talented as his twin with a paintbrush, and their styles were similar but not identical: Charlie's paintings tended toward the dramatic and mystical, while Paul's evinced a more graphic realism inflected with cubism and moments of surrealism. When it came to photography, Paul stood alone; Charlie was only a snapshot taker. And it was in photography that Paul found his most natural artistic voice.

Paul had a keen eye, and he strove to make timeless, meaningful images—portraits, cityscapes, architectural views, and landscapes from riverine meditations to sweeping mountain vistas, and so forth—in a manner attuned to the best of mid-twentieth-century photography. While some may regard him as an accomplished amateur, he was passionate and persistent, with an excellent eye, and his work holds up in the company of his more exalted contemporaries, many of whom he knew both personally and professionally.

Paul was a prolific picture taker, who rarely left the house without at least one camera slung over his shoulder. In the course of his adult life he shot thousands of images across the country and around the world, in black and white and in color. By the end, the archive he amassed was broad and deep. For the sake of clarity, we have largely limited this volume to his black-and-white images taken between 1948 and 1954, a body of work which has a distinct look and feel to it.

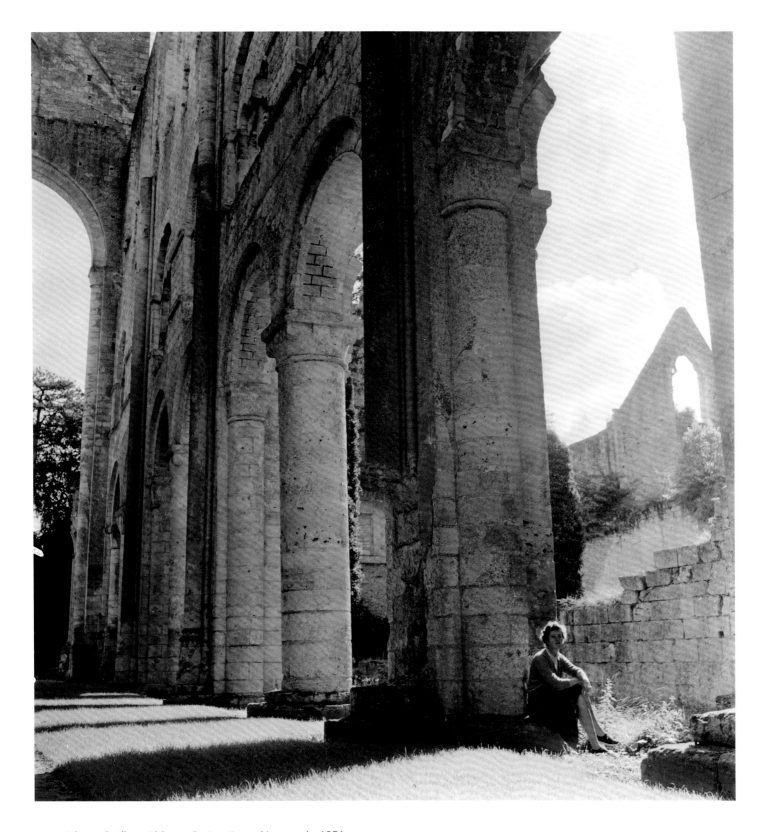

Julia and pillars, Abbaye de Jumièges, Normandy, 1951

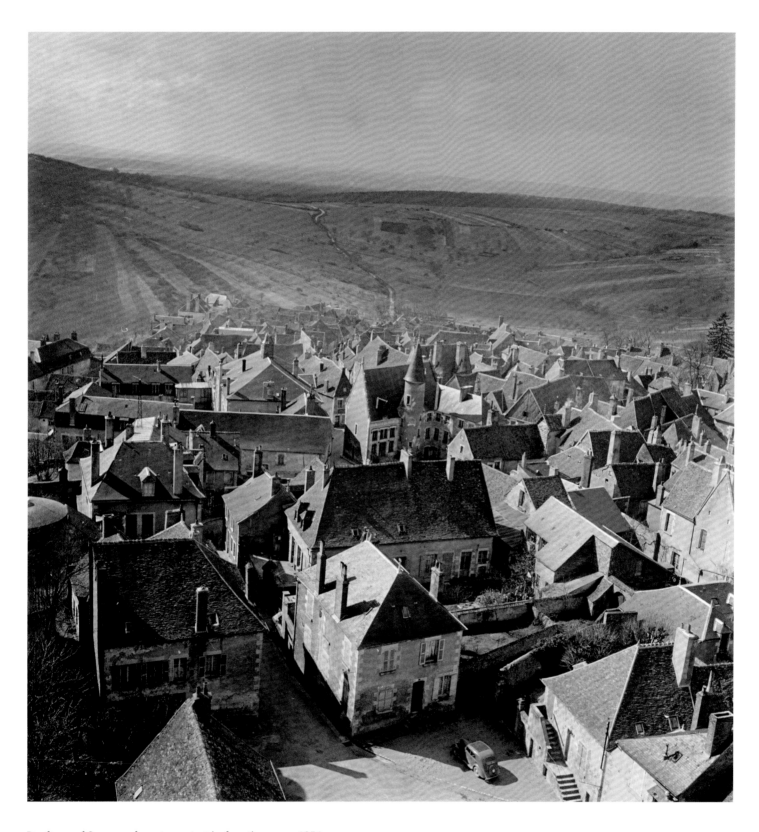

Rooftops of Sancerre from tower just before the snow, 1951

Though Paul was stubbornly independent-minded, no artist works in a vacuum, and he was inevitably affected by the people and events swirling around him. In the post–Second World War years, people from around the globe congregated in Paris, filling the cafés, sidewalks, and galleries with their fizzy ideas, artistic experiments, and unsettled energy. As chief of the Visual Presentation Department at the U.S. Embassy, Paul was in the thick of this cultural ferment, working simultaneously as an organizer, curator, and promoter of American cultural exhibitions in France. He was engaged in what amounted to a "soft power" propaganda effort (in contrast to the "hard" power of military force) to forestall a Communist takeover and build friendly relations between the United States and its European allies during the Cold War. These external tensions and pressures undoubtedly influenced Paul's worldview, and thus his art, if only obliquely.

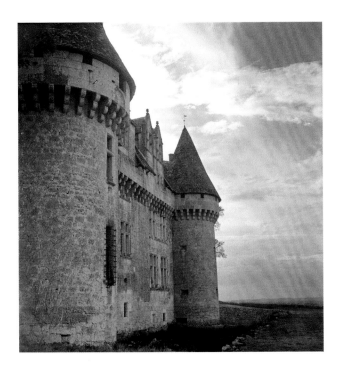

And then there was Paul's wife: Julia McWilliams Child. She was ten years younger than Paul, and not well known at the time, but she was a sunny, questing, powerful personality who had a profound impact on her husband's evolution. He adored her and photographed her constantly; without realizing it at the time, he was chronicling her rise from a fumbling know-nothing in the kitchen to an accomplished cook and author, and America's first celebrity TV chef.

Paul could be mercurial: charming one minute and prickly the next. A born intellectual, he attended Columbia University only briefly (1921–1922) due to financial constraints, but compensated by reading deeply and traveling widely throughout his life. A high-school teacher for many years, he had a strong pedagogical bent. He was thoughtful and sensitive, and often very funny, but at times he could appear to be brooding, judgmental, or snobbish.

Julia was the opposite sort of personality: a tall, loud Californian (as she described herself) whose warm, plainspokenness hid a subtle mind. She softened Paul's edges and encouraged his humor; she adored his fortitude, creativity, and knowledge; she understood his emotional neediness, and she pushed him to try new things.

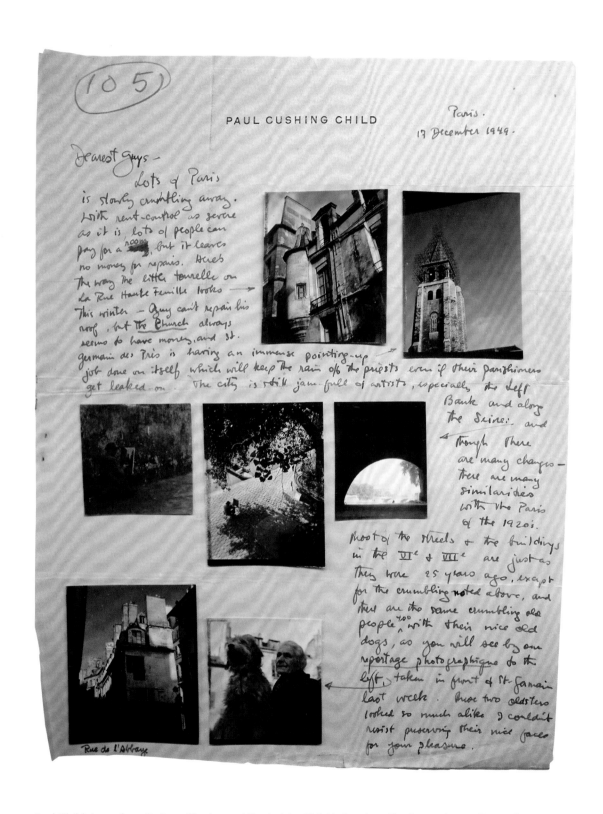

Paul Child, letter from Paris to Charles and Fredericka Child in Lumberville, Pennsylvania, December 17, 1949

"Without her, I'd probably be a miserable misanthrope," he'd write, knowingly.

At the start of their marriage, Paul was the senior partner in their relationship, an older, worldly man who tutored Julia about travel, art, food, literature, music, politics, economics, and sex. He enjoyed her "long gams" and good-natured inquisitiveness, which he called *la Juliafication des gens* (the Juliafication of people). He marveled as she warmed up the coldest policeman, grumpiest waiter, and most shrewish fishwife, and employed her bright eyes and welcoming smile to elicit carefully guarded recipes from tight-lipped restaurateurs. "She could charm a polecat," he chuckled.

In France, Paul and Julia were deeply in love—with each other, with photography and food, with the people and the places they encountered. They were each other's best company, and spent hours exploring, looking, and tasting together. Their years living in France were a high point in their eventful lives, a tremendously invigorating personal, professional, and cultural adventure.

"I was so excited" to be in that place at that time, Julia recalled, "that I sometimes forgot to breathe."

Paul felt the same way. In February 1949, after taking Julia and some friends on a five-day car trip from Paris to the Mediterranean and back, via Grenoble (this was Julia's first extended view of the country), he wrote in a kind of ecstasy:

[France] was really a sort of dream . . . if it wasn't a beautiful castle then it was bands of mist in the peach-orchards, and if it wasn't a 14th-century bridge then it was a deep valley with a brook at the bottom made of quicksilver. We went from cloud to cloud in our 5-day Heaven. . . . Nougat de Montélimar was as good as ever and so was the smell of sage at Avignon. We sang "Sur le Pont d'Avignon" under the first arch of the bridge itself, and drank Pouilly outside of Aix on a lovely hillside. . . . After coffee at a little town in a deep valley we climbed up and up, the air sparkling cold and the sky a deep blue with hot sun pouring down—over and through a series of grand passes, then into the non-Mediterranean world on the other side, with evergreens and snow on the slopes . . . with more wonderful towns clustered periwinkle-like in the cracks. . . . [In Grenoble] we came into fog and dramatic giant clouds wrestling with the mountain-tops . . . [at the Hospices de Beaune] the blue nuns! The wine we drank: Nuits Cailloux! The snails! The courtyards and the streets! . . . The evening ended . . . with armloads of Mimosa and sparkling faces and little exploding rockets of remembrance lighting up the talk. I really feel as though I'd performed at last a deep-seated duty to Julie—she loved it so much. We all did. It was a brimming cup.

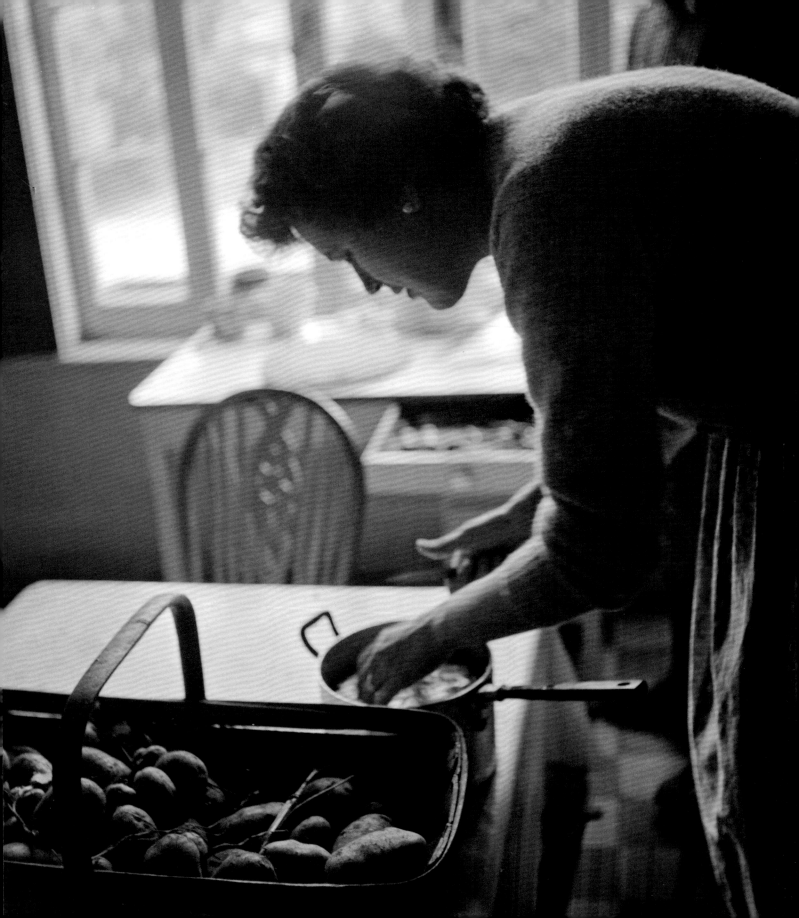

Paris, 1948–1953

UNEXPECTED TREASURES

One overcast Sunday morning in November 1949, Paul and Julia Child walked along the Seine, the great green river that serpentines through central Paris. They admired the city's stately buildings and arched bridges, artists painting at their easels, fishermen intently watching the tips of their bamboo poles, women sewing pink underwear. Paul and Julia didn't speak much on their expeditions through the city, but walked in tandem and communicated with a raised eyebrow or a murmur.

Paul's eye continually roved the streets and buildings, looking for a piquant face or architectural detail. On the Île de la Cité, the island in the middle of the river where Notre-Dame Cathedral rises, his eye framed a tableau: a receding line of double-ended *chaloupes*, or rowboats, tethered to the embankment, their cigar-like shapes reflected by the water and abstracted to dashed brushstrokes; looming overhead was the silhouetted limb of a tree; in the distance, the swooping forms of a bridge and its dark reflection in the Seine.

Lifting his boxy Rolleiflex, Paul looked down into the viewfinder and instructed Julia to lift her arm. She stood about six-foot-two inches tall, four inches taller than he, and used her long arms and fingers to shield the muted sun from Paul's lens. He carefully composed his shot, moving this way and that to enhance the contrast between light and shadow. He made a final check of his light meter, stilled his breathing so as to hold the camera as steady as possible, then pushed his thumb down on the plunger. The camera's shutter flicked open and closed—click!—capturing that serene moment, a harmonious arrangement of forms that

Julia in the kitchen, London, 1952

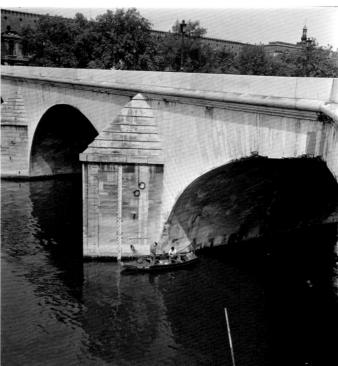

CLOCKWISE FROM TOP LEFT: Madeleine pillars, Paris, 1949; Along the Seine, 1949; Fisherman at the Pont Royal, 1950; Notre-Dame from the Seine, 1949

Rococo façade, Paris, 1949

encompassed, as Paul would say, "the rhythmic relation of geometric shapes." Then he pulled a pen and spiral-bound logbook from his bag. In a flowing hand, he jotted down a description of the photograph, the date, location, time of day, film speed, lens magnification, and notes about how he might improve the picture, or shoot the same scene at a different time and in different light.

Linking arms, Paul and Julia continued their leisurely promenade. They preferred to navigate by instinct, exploring winding, narrow byways and avoiding large, familiar boulevards. The Childs had been in Paris for about a year at that point. Paul walked deliberately, eyes alert for his favorite subjects: cats, remarkable faces, laundry, shafts of sunlight, reflections, storefronts, signs, and buildings against backdrops of more buildings. Julia often launched ahead of him, loping on her long legs, in order to poke her nose into cheese shops and charcuteries, practice her rudimentary French on the *boulanger*, and wonder what she should do with her life. She loved to eat—"I was born hungry, not a cook," she'd say years later—and had been attending classes at the famed Cordon Bleu cooking school for just a month. They didn't know it at the time, but the Childs had just embarked on the grand adventure that would define their lives for the next four decades.

Eventually Paul and Julia made their way to the Buttes-Chaumont. Wandering up to the faux temple, they looked across to the Sacré-Cœur. Later, they dined in a bistro with sleeping cats, chirping birds, and miniature poodles in ladies' bags. Paul ordered braised kidneys with fried potatoes and watercress, while Julia enjoyed *moules marinières*. They finished with a ripe slice of Brie. The wine included, the bill came to about four dollars.

This account is a pastiche of Paul's descriptions of the long, unstructured walks he and

Posters and wet sidewalk, Rue de l'Université, 1950

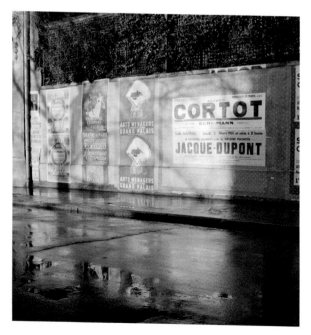

Julia took in Paris. It was a ritual that the Childs instituted almost from the moment they arrived in November 1948. It was one of their greatest pleasures: exploring Paris together, led by their curious eyes, ears, noses, and stomachs, with help from their trusty guidebook, *Paris par Arrondissement*. "Julia and I continued to maintain what by now is almost a tradition for Sunday mornings—we explored a section of Paris we hadn't seen before," Paul wrote to Charlie, in Pennsylvania.

Saint-Germain-des-Prés, 1949

"We keep a special map of the city which we are filling in with black where we've walked and looked and photographed."

Years later, Julia recalled: "Paris was wonderfully walkable, and it was a natural subject for Paul. . . . [He] knew Paris because he had lived there as a young man, and it was part of his life. It was a wonderful place with everything you could want as a photographer —romance, practicality, and people that were colorful and lively. Also, the pace of life was conducive to working there. Nothing was rushed, and Paul had plenty of time to take his photographs."

There is no doubt that living in France in the postwar years helped to shape Paul's aesthetic sensibility and informed his technical skills. Paris was an artistic hotbed at the time. Many of the leading photographers of the day—Henri Cartier-Bresson, Robert Capa, Dorothea Lange, Walker Evans, and Ansel Adams, among others—lived in or passed through Paris in the late 1940s and early 1950s. There was great public interest in photography, a vibrant market for photos in newspapers and magazines, and so many exhibitions and shows that it was impossible to keep up. At least as important as the culture, however, was Paris itself: an endlessly fascinating, revealing, confounding, stimulating, and rewarding subject.

"When one follows the artist's eye, one sees unexpected treasures in so many seemingly ordinary scenes. I always enjoyed going on a shoot with Paul because I saw more than I would have on my own," Julia said. "He was interested in every aspect [of Paris], and taught me to appreciate things that I would have otherwise just skimmed over or missed. . . . He caught the spirit of the city, and you could feel his love for the subjects."

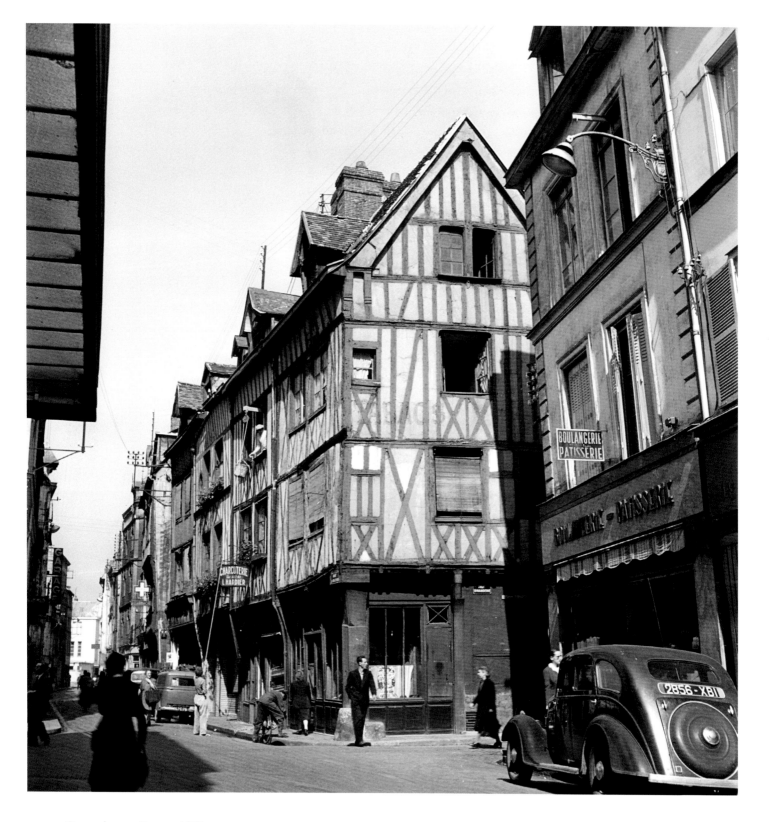

Corner house, Rouen, 1951

LA BELLE FRANCE

The Childs had arrived in France at dawn on November 3, 1948. They crossed the Atlantic from New York, through a fierce gale, aboard the SS *America* (equipped with "cast-iron stomachs," they were among a handful of passengers who were not debilitated by seasickness), to the port of Le Havre. Unloading their bags and a large Buick station wagon, "the Blue Flash," they drove to Paris through a beautiful countryside still ravaged by the Second World War. Along the way, Paul turned off the highway in Rouen, the medieval town where Joan of Arc was burned at the stake. There, he took Julia to La Couronne (The Crown), the oldest restaurant in the country, for her first meal in France.

Julia spoke just a few words of French, but Paul fluently chatted with the waiter, then ordered a lunch of oysters, *sole meunière* (a Dover sole "in a sputtering butter sauce"), with green salad, wine, *fromage blanc*, and *café filtre*. The meal was superb, and for Julia it was an epiphany. It altered her preconceptions, defined her raison d'être, and ultimately set in motion her career as a celebrity author, television personality, and live performer. In the 1960s and 1970s, Julia Child would prove to be one of the key instigators—if not *the* key instigator—of the American food revolution; its impact is still being felt today. That lunch at La Couronne in 1948, she said, "was the most important meal of my life." But, of course, the Childs had no inkling of her trajectory at the time.

After lunch, Paul and Julia continued driving southwest, and arrived in Paris at dusk. In 1948, the City of Light was a place of deprivation and opportunity. While largely preserved from the bombing raids that leveled so many European cities during the war, Paris had been the scene of intense fighting by the Resistance against

Resistance Plaque, Paris, 1950

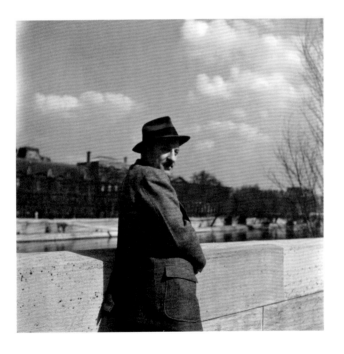

Paul by the Seine, 1949

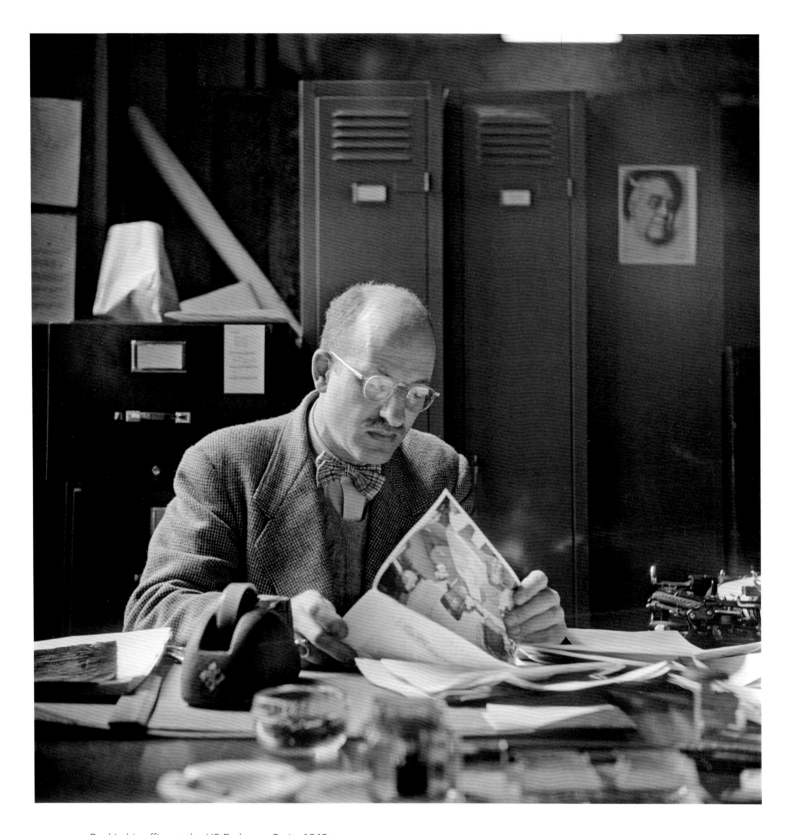

Paul in his office at the US Embassy, Paris, 1949

the Nazis. When Paul and Julia arrived, the war had been over for only three years and bullet holes riddled walls, some buildings had been reduced to piles of rubble, and wall plaques memorialized sites where Resistance fighters had been killed in action or executed by the Germans. (Some of those plaques are extant today.)

As France struggled to recover from the war, gas, electricity, and food shortages were common. Americans were welcomed by Parisians as liberators but resented as overbearing and culturally insensitive. A strong labor movement fomented protests and strikes, and as France reckoned with the collapse of its colonial empire in Africa and Asia, an air of social unease prevailed. Moreover, the Cold War was underway: the Russians were establishing the Soviet bloc in Eastern Europe; the Berlin Airlift had begun that summer, just a few months before the Childs arrived in France. And the threat of nuclear war or a Communist invasion of Western Europe was considered very real. All of which made Paris an exciting, if not always easy, place to live.

Paul and Julia at an exhibition reception, c. 1950

Notices designed by Paul for art exhibitions sponsored by the US Embassy, 1951

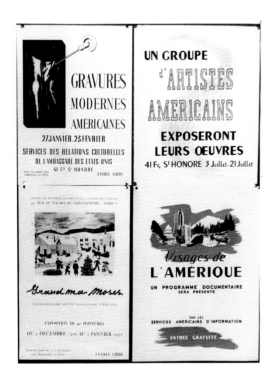

❧

In 1948 Paul was forty-six years old, and Paris was his first diplomatic posting. His title was Attaché, Exhibits Officer. Working for the US Information Service (USIS) at the Embassy was a prestigious, pressurized job that entailed managing a staff of ten and mounting a constant stream of exhibitions about American arts and industry in support of the Marshall Plan and to promote the United States as a trusted ally to France and her neighbors.

Paul's task was, in part, to promote American culture to win over the hearts and minds of the often skeptical French. As a result of his experience in Asia

during the Second World War (discussed later), he had become a "specialist in the field of communicating ideas by other than purely verbal means," as he characterized it. This meant using photographs, cartoons, posters, models, movies, sound recordings, diagrams, charts, and the like to further the American political and propaganda effort in Europe.

Though Paul was happiest when alone with Julia or his camera, he was adept at interpersonal politics, and he was a keen student of global power dynamics. He hated and feared the Soviets and confided to his brother, "I would not be surprised to see Russian tanks rolling down the Champs-Élysées any day now." In December 1950 he wrote: "It's hard to concentrate on office-work these days. I find I'm often thinking instead . . . about Communism's aggressive drives toward changing our world, and about the lack of necessary measures almost everywhere to counteract them. The 'counter-measures' of the [USIS] have a sort of Sunday School innocence . . . the kind and amount of work we are doing has become trivial and senseless to me as the world-context has shifted, and the ordinary routines and habits of more normal days have begun to change their color the way leaves do at the approach of a tornado."

Yet he would equally loathe the heavy-handed, anti-Communist witch-hunters at home led by "the bastard from Wisconsin," Senator Joseph McCarthy. A number of the Childs' friends in the Foreign Service saw their careers destroyed by McCarthyism. And in 1955, by which point the Childs were posted to Germany, Paul was falsely accused of being a Communist and a homosexual by McCarthy's henchmen.

LEFT: Paul and Julia with Abe and Rosemary Manell at a USIS exhibition reception, c. 1950

RIGHT: At a cocktail party, c. 1950

exchange. but don't bother me with such trifles. It's 12:30, so to walk home for lunch. I notice 5 barges stuffed with coal and all hitched together, as I go over the bridge. notice that girls on bikes have bright pink legs, because of cold air. Notice that sea-gulls in the Seine squawk with the same sound as sea-gulls in Lopaus Bay, Maine. It's giving me an unexpected back-lash of memory right on the Quai d'Orsay. Yellow smoke blowing down from chimneys — I can feel a storm coming. Our house feels warm as I go up in the elevator. a smiling Julie at Salon door lets out war-whoop as I come in. I smell coffee + cigarette smoke. She tells me about her morning at the Berlitz school, at 2 garages trying to get broken thermostat fixed, at Dépôt Nicholas buying wine. I begin reading TIME, almost 2 weeks old, can't seem to keep up with them. J. brings me a Cinzano with lemon peel + we drink + chat. The pussy leaps into the room, wild-eyed, ready to play. Julie yells, "Whish!" at him + he turns + scampers out with a sound like a herd of miniature sheep. Fréda says, "Madame est servie." at the door (mental reservation: "Well, she's learned that, anyway") Julie turns to me and says, "Now Paul — put down that maggie — you mustn't let the soup get cold." I reply, "Look, I've only got 2 more paragraphs." Lunch: potage de potiron, salt herrings in oil, cold potato salad, chestnut palé with chocolate sauce, Moselle wine, coffee. Then back across the river + the Place de la Concorde. I am struck by the number of big, shiny, American automobiles with Corps Diplomatique licenses, by the photographic quality of the black bronze dolphins on the fountains as seen against the misty roof-tops on the Rue de Rivoli, the beauty of the small granite

Paul Child letter, page of a letter to Charles Child, January 15, 1949

Despite the tensions, Paris was still the ever-dazzling City of Light, a cultural capital with few rivals, a place that inspired Paul and Julia Child like no other. Since he had first visited in the 1920s Paris had been Paul's favorite city, and his diplomatic posting there in 1948 was a dream realized.

By then, there was a large American military and diplomatic presence in the city, and the US Embassy was a beehive of activity. Paul—who was not a naturally social creature, as Julia decidedly was—gamely hosted a near-constant series of art exhibitions, readings, concerts, dance recitals, film showings, and cocktail parties. At the embassy, in rented storefronts or galleries in Paris, or in traveling exhibits that were displayed in cities and towns across France, Paul curated popular exhibitions of the architecture of Frank Lloyd Wright, the poetry of Robert Frost, the futurist designs of Buckminster Fuller, and the paintings of Grandma Moses, among others, though he would complain of the boring, egocentric, "old man harangues" he was subjected to by Frost, Wright, and, especially, Fuller. "Bucky, give it a rest, for God's sake!," Paul wrote Charlie. He was especially proud of his well-attended exhibitions of work by leading American photographers, notably Edward Weston. Besides exhibiting photographs, Paul also befriended photographers, such as Brassaï and Edward Steichen.

Paul worked hard and took his job seriously, but he was not conventionally ambitious. While his embassy colleagues made sure to have lunch with the "right" people—those who could advance their Foreign Service careers—Paul preferred to eat lunch at home with Julia, or alone with his camera and sketchbook. And though he tolerated working long hours and occasional weekends, he was "off like a shot" the minute his official duties ended, "to do what I *really* like to do."

Once sprung from the embassy, Paul would dive into various artistic projects, socialize with friends (most of whom were French, which was unusual for American diplomats), attend the theater, or go "truffle-hunting" for wonderful restaurants, cookware markets, or wine stores with his wife.

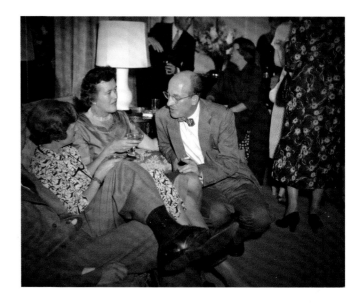

Julia and Paul at cocktail party, Paris, c. 1951

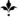

Julia and Minette, 81 Rue de l'Université, 1951

In 1948 Julia was thirty-six, and described herself as "a rather loud and unformed social butterfly." Raised in a wealthy Pasadena, California, household with a cook, and educated at Smith College, Julia had no professional direction, and knew hardly anything about food or France. Yet deep down she sensed that she was destined to do something special in life. The question was: what would that be, and how would she achieve it?

In her first months in Paris, Julia took French classes, worked part-time organizing the USIS files for Paul, and tentatively began to shop at local outdoor markets, and at Les Halles, the teeming marketplace in the center of the city. It was there, and in Paris's famous restaurants, that she first discovered a passion for "good food, carefully prepared."

Wandering the city, the Childs discovered places like La Truite, a snug restaurant off the Faubourg Saint-Honoré, which specialized in what Julia called "really chickeny-chicken"—a flavorful bird from Bresse that was suspended by a string and roasted before an electric grill. Or Chez la Mère Michel, a hole-in-the-wall bistro on the Right Bank that specialized in fish napped with a *beurre blanc* "wonder-sauce." Or Le Grand Véfour, an ornate three-star restaurant dating to 1750, tucked in behind the gardens of the Palais Royal. There, Paul and Julia were *bouleversé*—bowled over—by the staff's cordiality, the "deft and understated" service, the "spectacular" food, and even their fellow patrons, who included the novelist Colette. "You are so hypnotized by everything there that you feel grateful as you pay the bill," Paul quipped of Le Grand Véfour.

Sampling her way through the *délices* of Paris, with Paul's enthusiastic encouragement, Julia began to develop a sophisticated palate. And

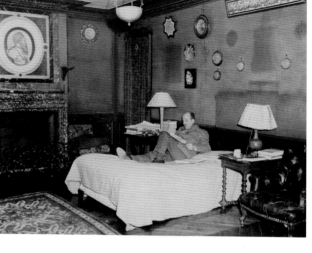

Paul, 81 Rue de l'Université, aka "Rue de Loo," 1950

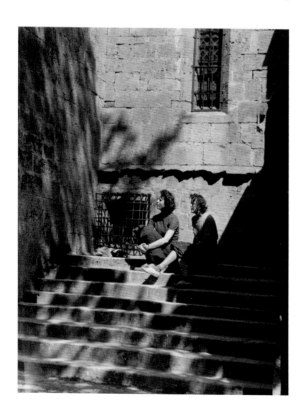

Dort and Julia, Flavigny, 1949

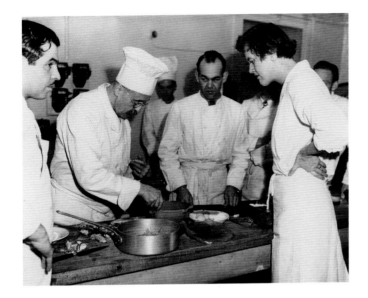

before long she felt the urge to learn how to cook *coq au vin*, *bœuf bourguignon*, and *coquilles Saint-Jacques* herself.

Paul and Julia settled into a multistoried apartment at 81 Rue de l'Université (which they nicknamed the "Roo de Loo"), on the Left Bank, next to the National Assembly and across the Seine from the American embassy. Their landlords were the Du Couédics, a genteel family of the fading aristocracy. Their *femme de ménage* (housekeeper) was called *Jeanne-la-folle* (crazy Jeanne). Their *poussiquette* was named Minette.

Before long, Julia's sister Dorothy, known as "Dort," came to visit and then moved in nearby. (Their brother, John McWilliams, remained in the States.) An inch taller and five years younger than Julia, Dort worked at the American Club Theater of Paris. She jumped into the expat social scene with both size-twelve feet, and eventually met her husband, Ivan Cousins, a Marshall Plan administrator, at the theater.

While Paul toiled in the semi-chaotic Visual Presentation Department at the embassy during the week, Julia decided it was high time she learned how to cook. In October 1949 she enrolled in the Cordon Bleu cooking school. The school's ill-tempered director, Madame Élisabeth Brassart, first placed her in a "housewives" class in a sunlit room at the top of the building. When Julia complained that the class was too expensive and too simple, she was sent to the basement, to join a class of GIs learning to cook on the GI Bill. The Army men were not entirely pleased to have a tall Smith grad in pearls enter their classroom. But Julia soon distinguished herself as the hardest-working student in the basement.

Her mentor at the Cordon Bleu was Chef Max Bugnard, who taught her some of the same

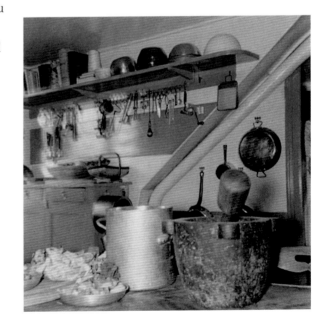

lessons that Paul had learned about photography—that mastering technique is essential, that it is "always worth taking time, and care, to do things right. And have fun—yes *fun*, Madame Scheeld," Bugnard would say. "Cooking is joy!" Bugnard was a kindred spirit to the Childs. Paul approved of his humanistic and careful approach to food, and life. Julia internalized Bugnard's lessons, and would repeat them to her students and audiences for the rest of her career.

Learning to cook *la cuisine bourgeoise*—delicious, carefully prepared, middle-class food—Julia experienced a "flowering of the soul" in Paris. Not only was French cuisine the best-tasting food she had ever had, she declared, it was easy to learn because it was built on a set of clearly established rules (first codified by Georges-Auguste Escoffier, the legendary chef and father of *la Grande Cuisine*). This latter aspect of French cooking appealed to the Childs' respect for scientific rigor, combined with passion. "In France," Paul liked to say, "good cooking is a combination of high art and competitive sport."

One could say the same of photography.

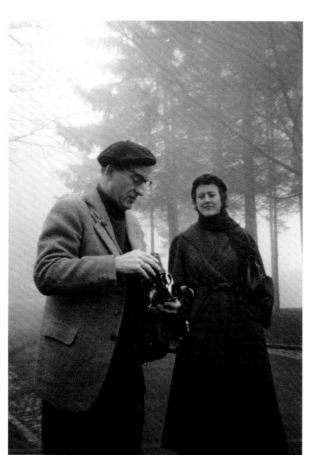

Paul and Julia, c. 1950

THE MAD PHOTOGRAPHER

Paul Child was an inveterate, even obsessive picture-taker. He usually left the house armed with at least one but sometimes two or three cameras: a Rolleiflex and a Graflex at first, then a Hasselblad, and later a Nikon. He also armed himself with a monocle, a photographic logbook, a sketchbook, pens and pencils, his watch, sunglasses, and other accoutrements. He kept this kit in a battered L.L. Bean shoulder bag that had traveled the globe and survived World War Two. As he headed into the streets of Paris with equipment jangling around his body, a beret on his head, and an avid look in his eye, Julia approvingly called him "the Mad Photographer."

Paul first discovered photography at Avon Old Farms, a Connecticut prep school where he taught in the 1930s and 1940s. It was an exciting medium that

combined his central interests: technology and aesthetics, graphics and art theory, physical and intellectual exploration. Photography seemed to grip him immediately, and, as was his wont, he studied it intensively, "training myself," he'd say, as an artist and technician. In those early photos, such as "Dynamo Base in Avon Power House," from 1935, he shot industrial components and staircases in much the way that Charles Sheeler or Paul Strand would.

Julia changing clothes on the moors, Pennine Hills, England, 1952

Paul methodically taught himself the basics of lighting, framing, shooting, and developing photographs. The son of an engineer, he had a special affinity for the equipment and paraphernalia required—different types of camera bodies, lenses, tripods, reflectors, light meters, enlargers, and the like intrigued him. He bolstered this practical knowledge with hours of reading and thinking about the medium, and developed a great passion for its technical challenges. In his detailed logbooks he made careful notes on the film he used, the light, time of day, exposure time, and aperture settings. But Paul was not entirely cerebral: a physical man, he enjoyed the challenge of moving in and out of space to compose images, the need to react quickly to capture moments and freeze them in time.

Making photographs became a daily habit, a means of distilling and cataloguing experience, an escape, and an adventure. He had an instinct for the medium from the start. When he lived in Paris in 1927–1928 as a young man, Paul began experimenting with photographs of reflective surfaces—reflections of people, buildings and trees in puddles, or store windows, for instance. Later, he experimented with multiple, overlapping images—such as "Montage of Copper and Pewter" (1935)—at the same time that artists like Man Ray and Edward Steichen were exploring similar subjects.

Though he had little formal schooling in photography, Paul had trained as a painter, a technical draftsman, an advertising illustrator, and a lithographer. He

brought a painterly eye to composing photographs, and waxed rhapsodic about the shifting qualities of light he found at different times of day, and the way a scene was transformed by the seasons. Not surprisingly, he pursued similar themes in different ways in his graphic art and his photographic work. This was a logical and common progression for many artists.

Henri Cartier-Bresson, one of the masters of twentieth-century photography, first trained as a painter in Paris—most notably with the sculptor and painter André Lhote, who aimed to combine the abstract beauty of cubism with the realism of classical painting. Above all Lhote was training his pupils how to *see*: he taught what Cartier-Bresson called "photography without a camera." Paul Child was always seeing, framing, parsing images in his mind's eye. Like other artists in France in the 1920s and 1930s, he read Dostoevsky, Nietzsche, Freud, Proust, Joyce, and Marx, and also studied Renaissance masters at the Louvre and modern art in the galleries. His photographic work was significantly informed by his study of drawing and painting, and by the events of his time. His paintings and photographs were distinct bodies of work, but they shared a sensibility: they informed, commented on, and were a counterpoint to one another. Whether shooting an old woman framed in a doorway or the soaring steel trusses of the Eiffel Tower, the crenellated stone walls of a fortress, or turret-shaped hay bales in a field, fishnets hung to dry and wooden boats in Marseille, or the receding vistas of the Alpes-Maritimes mountains in southeastern France, Paul composed his images with wit, a sense of narrative, an awareness of atmosphere and depth, and visual sophistication.

Works of art link human experience, Paul said, and explore "the mysterious lands of nightmare, love, violence, and peace." He added: "I am fascinated by rhythms, by balances, by emphases, by establishing a theme and then developing it, by clarity, by organization."

Like his contemporaries, Paul paired a distinct visual sensibility with a fecund imagination and physical dexterity (an important, if little-remarked-on, aspect of

Julia reflected in the dashboard of their Buick, "the Blue Flash," 1955

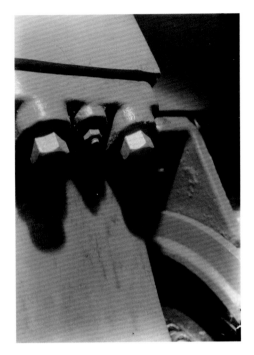

a photographer's skill set). The challenge of photography, he said, "is not unlike hunting: Gun ready, senses alert, and being so familiar with your weapon that you use it almost automatically."

Paul was not, in fact, a hunter, but this was a familiar sentiment among photographers of the day, most famously Cartier-Bresson, who coined the term "the decisive moment" in his 1952 book by that name. Armed with a small, light Leica 35mm camera, Cartier-Bresson described the visceral experience of moving through a city with all of his senses alert, his finger on the trigger, stalking images: "I prowled the streets all day, feeling very strung-up and ready to pounce, ready to 'trap' life—to preserve life in the act of living. Above all, I craved to seize the whole essence, in the confines of a single photograph, of some situation that was in the process of unrolling itself before my eyes." Paul was a contemporary of Cartier-Bresson, Kertész, Capa, Brassaï, Doisneau, and other luminary photographers in Paris. While he did not consciously model his work on theirs, he swam in the same waters as they did, as it were, and no doubt was influenced by their aesthetics. And like many of these photographers, Paul was drawn to people with distinctive features or expressions, graphic patterns, organic shapes, the play of light and shadow, or tableaux with an implied narrative. Paul frequently took portraits of the people he encountered in Paris: a man popping out of a manhole,

boys at a street circus, girls at a church, an old woman with a cat. Over and over again he recorded fishermen with their long poles bent hopefully over the Seine, and artists painting at their easels. For mysterious reasons, these (mostly male) people engaged in a solitary activity in a social context fascinated him.

While some photographers were occasionally drawn to the scatological or grotesque or urban vice, Paul tended to be more ascetic and restrained. His preference was for a combination of abstraction and representation in a single image, and he was most compelled by form. He shared an affinity with the Hungarian photographer André Kertész for depicting a bold shape against a blank sky or wall. In a series of photos of laundry drying on lines across France and Italy, entitled "Wash Day," Paul juxtaposed the smooth, blank form of a white sheet against a deep and cloud-filled sky, or contrasted to a background of gnarled trees or a carved stone fountain.

Glazed terracotta pipes, 1930s

This series could be seen as an exploration of shape, texture, and light: "Abstractly, [hanging laundry] can be beautiful," he wrote. But hidden in the depths of these images was something else: an essay on what it is to be human, and our fascination with one another. "The clothes symbolize the people that wear them, even if the people aren't IN them," Paul explained. "Studying clothes hanging on a line is a little bit like peeking through a key-hole."

In photographing cities, towns, railway tracks, country roads, fields, and the like, Paul attempted to distill the essence of an image—or, as he put it, "summarize some aspect of each place." Like Kertész and Brassaï, Paul was drawn to the curve of a street, the pattern of light and shadow on stone, the allure of steps, reflections and refractions.

Art is a highly subjective and personal endeavor, Paul understood. It can go wrong quickly, but in the right hands, almost anything can be transmuted: "Under certain circumstance a piece of flashing-lead and a scrap of old butcher's paper

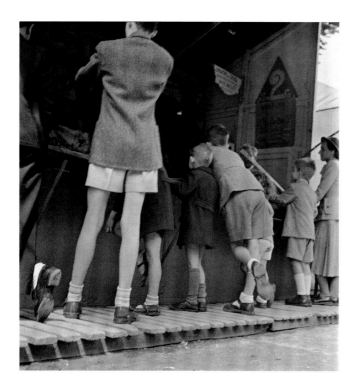

Cirque à l'Esplanade des Invalides, 1950, near the Childs' apartment

could be the physical basis for a master-drawing, and a Box Brownie could crack-off the Print of the Year."

In his own work, Paul noticed "a predilection for formal structure . . . strong contrasts, semi-abstraction, surface-textures, rhythmic repeats, the 'romantic attractiveness' of age, concentration rather than dispersion," and so on. At the end of the day, he did not believe it mattered what style an artist used—realism or abstraction, hard- or soft-edged, explosive or subdued palettes: if a viewer is attuned to the piece, he wrote, "a mysterious Other-Something can emerge from a work of art . . . and speak from heart to heart in a language whose words are still unknown." Paul also wrote: "A perceptive person can tell a great deal about me by considering what I choose to abstract out of the totality, or just out of myself."

FRENCH CULTURE

To Paul and Julia Child France was "the Center of the Universe." They were middle-aged, reasonably secure financially, childless, adventurous, and busy. "Apart from our official lives—cooking and government . . . the other things we do fall into fairly repetitive categories whose 2 main divisions are, Being entertained and Entertaining others," Paul explained to Charlie. "Sometimes when we're *being* entertained it isn't people, but just Paris herself who acts as hostess." In the course of a typical week in 1950, they attended a cinema club, went to a meeting of local art historians, hosted an embassy party, and dined at a little restaurant near their apartment and discussed painting, engraving, and typography over bottles of wine with a group of French friends. On Saturday, Paul painted and Julia wrote letters and sewed; that evening they had an intimate dinner party at home.

On Sunday, they drove to the northeastern corner of the city, where the canal from the Marne River flows into the Seine, and walked and photographed for

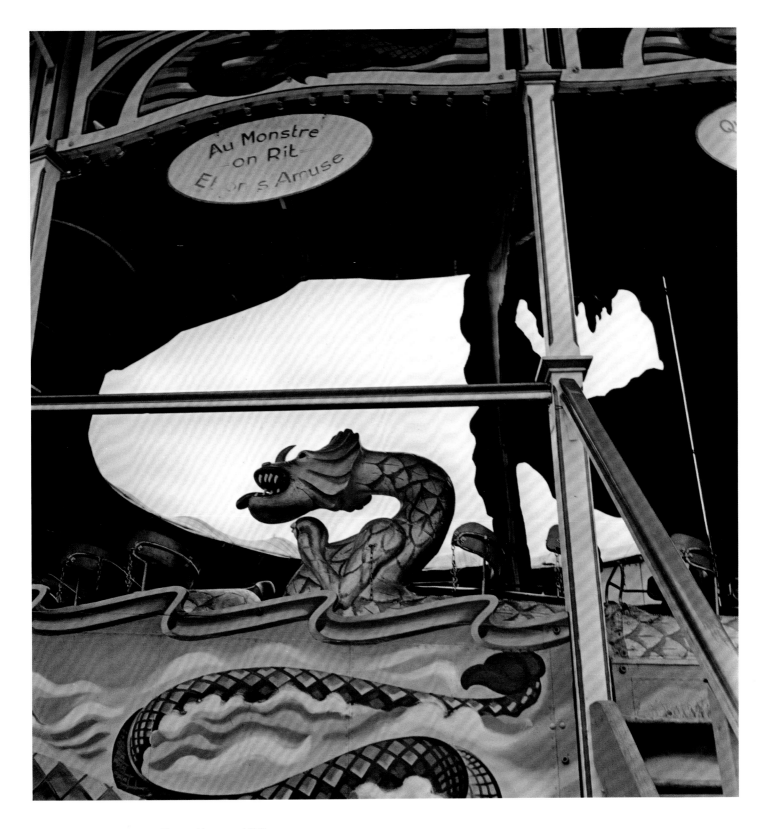

Au Monstre on Rit, Et on s'Amuse, 1950

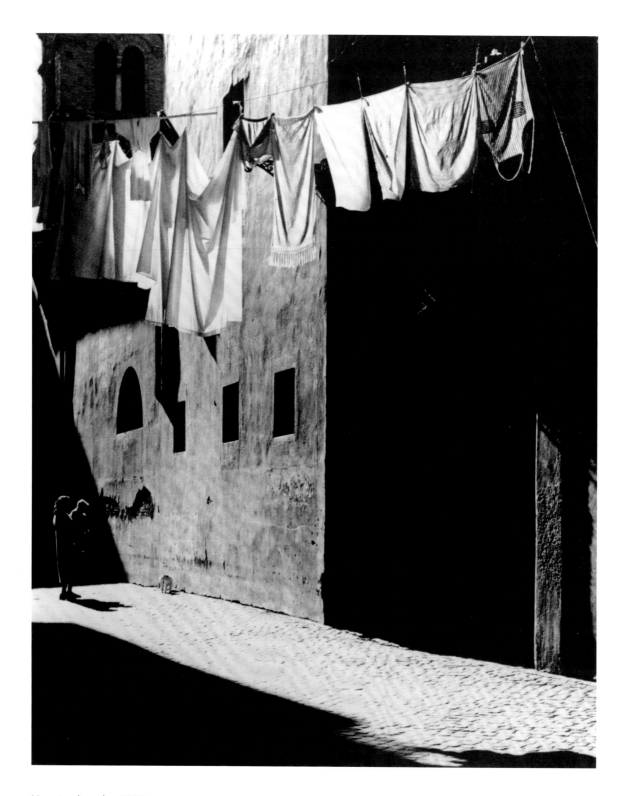

Hanging laundry, 1950s

three hours. They discovered a church with interior courtyards full of old trees, "like a Pekin palace," though Paul was sternly forbidden to take photos. As they passed through a graveyard, "a wild buffeting wind, cold air, sudden gray winter clouds [made] the city extremely photogenic." It was a challenge to hold his Rolleiflex steady in the gusts, but Paul managed to snap a dozen pictures. They ended their tour at Brasserie Lipp, for a late lunch. That evening Dort joined Paul and Julia for a quiet dinner at the Roo de Loo.

France may have been a form of paradise, but it wasn't perfect. In early 1950, Paul complained to Charlie of the "severe disease of strikes all over. The Commies are pushing hard to try and put together a general strike—we got strikes now in coal, iron, steel, autos, electricity, gas, busses and metros. The city is difficult. Our ice box is off and the pussy's food is spoiling. Only a few metro trains are running and people get in 2 hours late with frazzled nerves. . . . Traffic is wild and thick. Cooking is almost impossible."

The Childs had a lively and supportive group of French friends, and were perfectly happy in Paris; even so, they occasionally found themselves vexed by Gallic snobbism, stubbornness, and capriciousness. When, for instance, Paul took the mayor of Le Havre to lunch with a Mlle Lavery—"a woman of a certain age," Paul noted—she got into her soup and wine, then launched into a woeful monologue about the war:

> My house of 22 *pièces* [rooms], and my other little one, all that there was of the most charming, you can't yourself imagine that which there was there of furnitures and of paintings, and a library, ah! When I think of those 3,000 books given to my father by his father! And sirs, you may not know what we mean by the phrase French Culture, but I assure you when a French family has the Culture, *The Culture* I say to you, that wishes to say really something! . . . There I found myself, sirs, standing in the street one day, a woman with that great culture, and I had nothing, but absolutely nothing!

And that is war, and Americans of course don't know what war is and it was you others, you Americans, who bombarded our city, and perhaps it was necessary and perhaps it wasn't. I know nothing of that, but when you've been through what I've been through it changes the point of view.

To which Paul added, dryly: "She was so triumphantly egocentric about what must have been a truly dreadful loss that one's sympathies were not engaged." On the other hand, Paul and Julia's sympathies were most certainly engaged by another sort of Frenchman, the modest genius who developed Paul's—and Cartier-Bresson's and Man Ray's—photographs.

In the United States, before the war, Paul had enjoyed learning to print photographs in the darkroom at Avon Old Farms. But developing was a time-consuming process that took place indoors, in the dark, and with toxic chemicals. In France, Paul preferred to spend his precious free time outside, walking the streets of Paris or driving through the countryside, taking pictures.

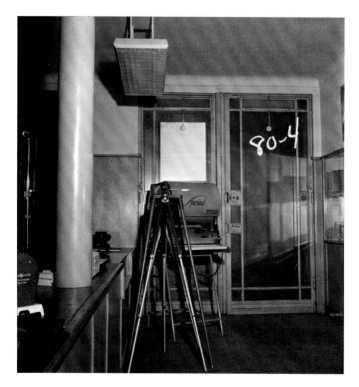

Camera shop, Paris, 1951, likely Pierre Gassmann's

In late 1948, he met Pierre Gassmann, a young Frenchman who had just started a film-developing business. At the time "Gassy," as Paul called him, lived on the seventh floor of a shabby walk-up apartment in an obscure corner of Paris. For a modest fee, he developed and printed rolls of black-and-white film in his bathroom. Gassy was a congenial sort, and he and Paul took an instant liking to one another, bonding over a love of food, wine, and photography. "Gassy is a man of enterprise and skill," Paul observed. "Apart from his ability as a photo-finisher his greater skills, I believe, are really in two other realms: business and human relations." In 1950 Paul and a group of friends pooled

enough money to help Gassmann open his business more formally in a ground-level shop at the back of a courtyard on the Rue de la Comète. There he was surrounded by other one-room ventures, including a printer, a locksmith, a carpenter, and a man who stuffed mattresses. Gassmann called his firm Pictorial Service, which he pronounced "Peek-toe-ree-*ahl* Sare-*veece*."

As its business expanded, Pictorial Service gradually took over the work-spaces of the mattress man, the carpenter, and the locksmith, until it occupied the entire courtyard. The business kept growing, and Gassmann rented more space upstairs, where he established a studio that young photographers could rent for an hour, or a day, or a night, to photograph "anything from a stack of law books to a well-stacked model wearing the latest fashions," Paul noted. Pierre Gassmann was a world-class film developer. He taught Paul a lot about technique, processed hundreds of rolls of Paul's film, and introduced him to Cartier-Bresson, Robert Capa, William Klein, and Robert Doisneau.

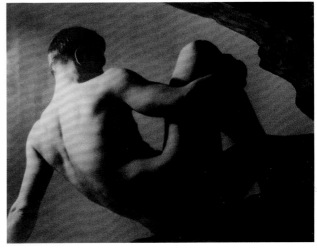

Paul and Pierre stayed in touch, and would occasionally get together for a meal in Paris. In 1970, the Childs took him to lunch at Le Pavillon Royal, an ornate restaurant in the Bois de Boulogne. "The renewal of old friendships is one of life's true pleasures," Paul wrote afterward, "especially, as in this case, when it is combined with eating excellent food."

Male nude, 1937

"WESTON AND CHILD ARE QUITE AKIN, I THINK"

Though Paul was too self-contained to heroicize another photographer, it is fair to say that the pictures of the American master Edward Weston—beautifully abstracted nudes, seashells, vegetables, and "twisted tree trunks, Death Valley mountains, sand dunes at Oceano, Big Sur eroded rocks, cats and dilapidated miner's shacks," as Paul described them—were an important influence on Paul's work.

In February 1950, Paul organized an exhibition of 122 Weston photographs in Paris. For days before the opening he had built up anticipation for the show: he placed articles about the exhibit in French and American newspapers, in the US

Embassy news, in the French cultural paper *Arts et Lettres*, and on posters around the city, and he advertised it on the radio. He sent out five hundred personal invitations, and showed a documentary film about Weston at work. At the front entrance of the exhibition hall, Paul placed a panel showing a triptych of Weston's photos, and a large arrow pointing to the exhibit. Over five hundred people attended the vernissage, "the biggest crowd they've ever had," Paul reported. "Almost everybody was astonished. 'My goodness,' they said. 'I didn't know there were that many people in Paris interested in photography.' I was one of those who were not surprised."

Though Paul thought Weston's portraits "too static" to be as fine as his other photos, he considered them "deeply honest in a sort of crystalized way." And when it came to Weston's nudes, Paul deemed them "pure as abstract marble," which was a half-compliment. Though the photographer's subject was a naked woman, he chose to shoot her in such an abstract way that "it's like algebra, or like language—you assign a value to a symbol—'let X equal 53,'" Paul observed. Weston seemed to say: "'When you look at this nude, I intend that it shall be considered as a beautiful shape.' They are extraordinarily dehumanized and one reacts to them (at least I do) as line and form rather than as women."

Others, such as certain male employees of the US Embassy, interpreted the same photographs differently: "as women-with-all-their-clothes-off—scarcely one remove from a set of dirty post cards!" Paul recounted in horror. He had been criticized as "a Bohemian, an Existentialist, and probably a Red." Given the political tenor of the time, he added wryly: "I wonder if I really have to care whether these dirty little libidos will be stirred-up by such an image. Phoo!"

The Weston show stirred a transatlantic debate between Paul and his twin over the relative value of people and backgrounds in images. Charlie was a maximalist, who believed that the background of a picture should be as interesting as the people in the foreground. Striving for simplicity, Paul argued the opposite: that when photographing people, the background should be stripped down and simplified so that the viewer's attention is focused on the human drama in the foreground. When it came to pictures about design, Paul felt, then the opposite held true: "The purity of landscape or architecture (should not be) broken by people . . . they should be only part of the design." At another moment, Paul employed Weston to drive his point home: "Look at Edward Weston, to me one of the most exciting photographers . . . almost never are people in his studies. Weston and Child are quite akin, I think."

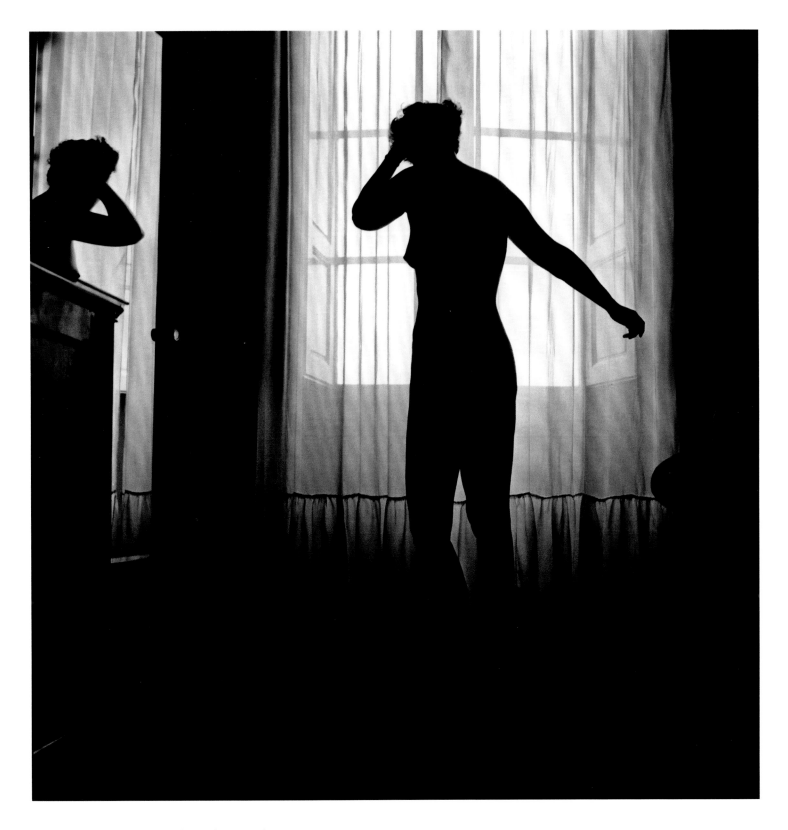

Julia in window in front of curtain Florence, 1956

ON THE TOWN AND ON THE ROAD

In February 1950, Julia was attending the Cordon Bleu every day, but was growing increasingly fed up with "that damn poorly managed school, and my group of dopey GI's." Chef Bugnard continued to inspire her, and she had impressed him enough that he began to teach Julia little professional *trucs* (tricks) on the side—how to clean, prepare, and cook fish quickly, for instance. But she was impatient with the school's methodical pace: "We are beginning to repeat and repeat, on such things as *sole normande*, *chaud-froid* of *poulet*, etc.," she wrote home.

On the other hand, she wrote, "I can at last make a decent pie crust with no trouble, and a *crêpe Suzette* pancake, and an omelette. . . . What I love about this French cooking is the immense variety of cooking potatoes, the many ways to do fish, the many ways to do chicken. Lots of them are small variants on the same theme, but there are many themes." (In her cookery teaching of the 1960s and 1970s, Julia would emphasize the importance of theme and variation: "once you have learned the coq au vin, you can make any similar type of stew, whether it be beef, lamb or lobster," she wrote in a proposal for a TV show in 1962).

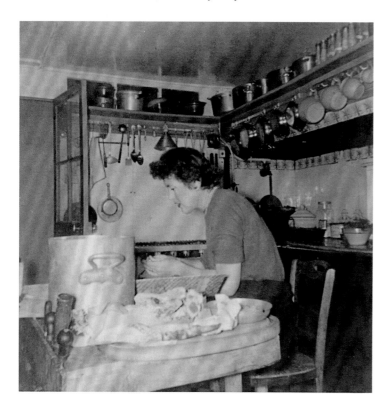

Julia in the kitchen, 1952

In November, Paul and Julia celebrated their second year as Parisians by dining at one of their favorite restaurants, in Montmartre. They hopped a metro from the Chambre des Députés to Place Pigalle, and strolled up the hill. At a *boîte* called Les Naturistes, they stopped to gaze at pictures of girls lifting their skirts to show their *derrières*, and ignored the tout trying to talk them inside. At a street-side amusement, they shot ten metal arrows at targets. Up the hill, along Rue Lepic, they found their way to Le Restaurant des Artistes.

It was a small place, with only ten tables, but the dining room was warm and suffused with the aromas of good cooking. The owner, Monsieur Caillon, and his wife, greeted the Childs with open arms. The chef, Pierre Mangelatte, was "a wonder" in the kitchen, Julia said, and one of the best teachers at the Cordon Bleu. A short, dark-haired man with burning eyes, he had trained in pastry and was now an expert all-around cook who could pluck, eviscerate, and dismember a chicken in four minutes flat.

Paul and Julia started their meal with an aperitif of Blanc de Blancs with cassis. As they chatted with a rotund Belgian couple, their first course of *loup de mer* (sea bass), stuffed with fennel and grilled, arrived. They swallowed that down with an unusual white wine from the Jura, a 1947 Château-Chalon, from Caillon's *cave* of over fifty thousand wines. Next, Paul had venison cutlets in a concentrated red wine sauce, with a chestnut puree. Julia had roasted *alouettes* (larks) with puff potatoes, and they drank a lovely Saint-Émilion 1937. They concluded with a wedge of Brie and coffee. It was, Julia said, "a perfect meal."

Mangelatte joined the Childs in the now empty dining room. The chef worried that *la cuisine française*—the art

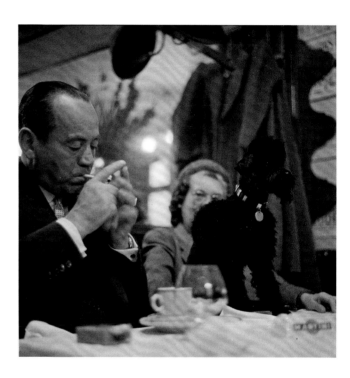

Bistro scene, Les Halles, 1956

of French cooking—was being neglected. The Cordon Bleu, said Mangelatte, was symptomatic of the problem: its head, Madame Brassart, was disorganized, constantly scrambling for money, and had lowered the school's standards. Some classes did not even have enough pepper or vinegar for him to teach with, he complained, and he had to send someone out to buy supplies with his own money. In response to this state of affairs, Mangelatte was writing a cookbook that clearly explained the range of classical dishes, had organized a group of fifty chefs to promote refined cooking, and was fundraising to establish a high-end cooking school that would rival the Cordon Bleu.

"It's sad to me to see this energetic Frenchman with a deep-seated sense of artistry and tradition trying single-handedly to keep a civilized part of this

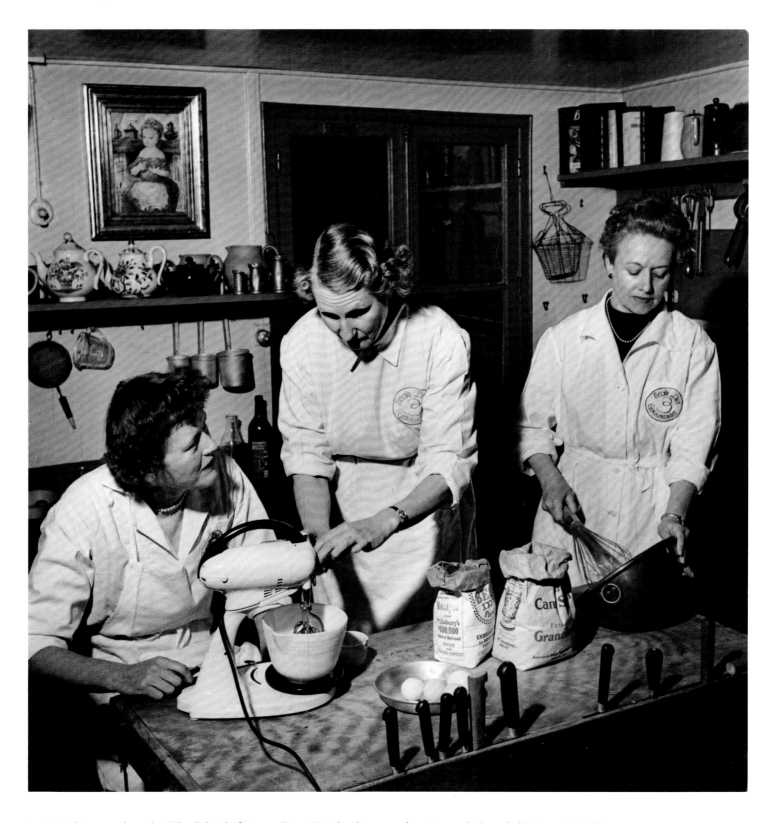

Les Trois Gourmandes, (aka "The School of Hearty Eaters"), Julia, Simca, and Louisette, 81 Rue de l'Université, 1953

country's culture alive in the face of probable Barbarian invasion," Paul wrote. "If I'd known about this . . . I could have engineered [American] financial support for him, but now with [the US government] swinging from butter to guns it's probably too late."

On another night, Paul and Julia hit the nightclubs on the Left Bank till 3:00 a.m., then wandered around Les Halles as the brawny market workers unloaded crates of fresh flowers and vegetables. It was cold and dark, but the market looked intriguing under pools of sulfurous light. As dawn lightened the sky, they joined the market men at Au Pied de Cochon for a breakfast of onion soup, glasses of red wine, and cups of coffee. They stumbled home to the Roo de Loo at 5:15, as the city was beginning its day.

After an argument with Madame Brassart—who had initially refused to graduate Julia, after giving her an exam filled with questions for which she was not prepared—Julia took another exam, and was finally awarded a (backdated) diploma from the Cordon Bleu in the summer of 1951.

By this point, she had teamed up with two French friends, Simone ("Simca") Beck Fischbacher and Louisette Bertholle, to teach cooking classes in the Childs' kitchen at 81 Roo de Loo. They dubbed themselves *L'École des Trois Gourmandes* (which Julia translated as the "School of the Three Hearty Eaters"), and their students were mostly the wives of Americans stationed in Paris. Though the *trois gourmandes* made little, if any money, the menus and lesson plans they developed would prove essential to their later success. The following year, Simca and Louisette asked Julia to help them finish a French cookbook for the American market that they had been toiling on for two years. "*Mais oui!*" Julia said, jumping at the chance. Looking over the recipes they had produced with a previous American collaborator (who had returned to the States without explanation), Julia was thrilled by the idea of the book but unimpressed by the "jumble of recipes." In a friendly way, she rethought and reworked the manuscript, and transformed each chapter into a series of master classes on French recipes for "the servantless American cook"—that is, people just like herself.

Though Julia loved Paris, Paul was determined to show her the rest of France, and every few weeks they would pack their car with a picnic and head out into the countryside. Sometimes they had a specific plan—an afternoon at Versailles, say, or a drive to Mont-Saint-Michel, or a dip down into the Loire Valley, or a trek into the Alps.

Paul viewed these mini vacations as prime photographic opportunities. Speaking of a photo he'd taken, he wrote Charlie: "The cliff in the Route des Alpes must be one of those . . . in the Vercors valley from the Alpes Maritimes. I'm planning to take about 15–20 of the best photos from all I've done so far and either blow them up big myself or have it done by Gassmann. They'll be for decorative and exhibit purposes." Paul was happy to tell his brother that the publisher of a French art magazine would publish two of the pictures: a church roof, and the magnificent door on the cathedral at Bourges.

At other times, the Childs' plans were "virtually non-existent, except to drive in a South-West direction toward the region north of the Gironde, along the coast and inland," Paul wrote. "The country's so marvelously rich that all sorts of wonders are bound to manifest themselves, from eating-food to looking-castles, and I'm praying for a touch of sun . . . so's I can exercise that weird talent I seem to have for seeing structural relationships in all sorts of unexpected places through the eye of my Rolleiflex."

STEICHEN

By the summer of 1952, Paul and Julia were growing increasingly concerned about their future. Paul's original four-year contract in Paris would end soon, and the US government hadn't decided where, when, or *if* he'd be posted somewhere else. It seemed virtually certain that he and Julia would be moved to a new city in the next six months.

It was a tense period. The Korean War had ground to a stalemate, tension between the United States and Russia was high, and fear of a Communist "fifth column" fueled McCarthy's witch hunts at home. President Harry S. Truman had decided not to run for reelection, and had backed the Democratic governor of Illinois, Adlai E. Stevenson. Running against Stevenson was Dwight D. Eisenhower, the former supreme commander of Allied forces in Europe, who had become the president of Columbia University and was a moderate Republican.

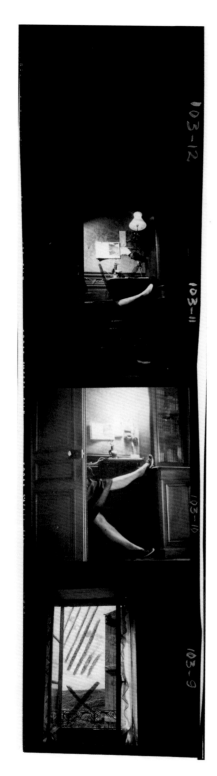

Marked contact strip, with Julia's legs at telephone Aubazine, 1952

If the Republicans were to win the White House, Paul was advised, chances were high that the USIS budget would be slashed. In that case, the Exhibits Office would be greatly reduced, or canceled. Paul had been quietly talking to friends at the embassy who were willing to help him secure a new post. Abe Manell, a gifted political insider, gave Paul a tip about the public affairs officer (PAO) job in Marseille, which Manell had previously held: "That's the best job in France! You should snap it up in a minute."

A PAO was the second-in-command to the consul general in a place like Bordeaux or Marseille. While the exhibits officer was a specialist, the PAO was a generalist who wore many hats: he was in charge of public relations, promoting Franco-American cooperation; a political officer, who promoted American interests and kept an eye on the Communists; a cultural affairs expert, who arranged for American films, sports teams, and educators to visit France; and an all-purpose diplomatic utility man, who gave speeches in small towns, unveiled statues, laid wreaths, and arranged social events for US military personnel in France. Paul and Julia looked at each other, and said: "Marseille is our second-favorite city in France. If we get the PAO job offer, why not give it a whirl?"

By October, Paris was enveloped in cold, gray mist and word came down from on high that the coveted Marseille job had melted away. Manell advised the Childs that they would be eligible for the PAO job in Bordeaux, near the coast in southwestern

France, or an exhibits job in Vienna, Austria. "I'd rather work in Bordeaux as PAO than Vienna as exhibits officer," Paul wrote Charlie. He had talked it over with Julia: "We both love being in France, we both speak French fluently, we've both made contacts which will be useful even in a new region, and I'd be emerging into a general realm (as PAO) instead of staying a specialist. I covered the southwest fairly thoroughly 25 years ago but there's still a tremendous lot of terra incognita for us to explore together." They threw their hats into the ring for Bordeaux, and hoped for the best.

A few weeks later, in November 1952, Paul met Edward Steichen, the legendary photographer who was born in Luxembourg and lived in New York, where he directed the photography department at the Museum of Modern Art. The two discussed photography, naturally.

Though he was seventy-two, Paul wrote, Steichen seemed younger because "he eats, walks, talks and gestures with gusto. He's modest, objective, penetrating and thoughtful . . . a darling man . . . full of sweetness, simplicity and goodness. . . . He appeals to me very strongly. There's a quality of nobility that exudes from him."

The following day Steichen phoned, asking when it would be convenient for him to visit the Roo de Loo to look at Paul's photos. "Why not come right now?" Paul suggested, and Steichen did. Spreading out his photographs, Paul explained them, while Julia made lunch. The great man declared that Paul was "a very good photographer," Paul reported to Charlie. "You can imagine how pleased I felt." Steichen picked out six of Paul's prints, and asked if he could have them for MoMA's collection. The photos remain there today, and include shots of a village graveyard at Hunawihr, an empty window in Paris with a memorial plaque to a Resistance fighter killed by the Nazis, a chestnut tree seen from 81 Roo de Loo, tropical plants at a friend's house in San Francisco, a large, old sycamore tree at a château in Normandy, and a façade with a swooping plaster decoration in Venice.

When Paul asked Steichen for creative advice, the older man replied: "It is clear that you have reached a point in your photographic work where you can produce practically any effect you want to. One of the virtues of your photographs is that you have reached a level where you are able not merely to *record*, but to *create*." Steichen—who had spent the first fifteen years of his career as a painter—added that in some ways creative photography is a more challenging art than painting, because its raw materials are more intractable. In a photograph,

Vétheuil church
door, 1952

there is always so much information to deal with, and to eliminate; while in painting, one starts with a blank surface and every mark one makes becomes part of the eventual creation.

He advised Paul not to disperse his creativity over the whole visual field, but rather to devote himself to a *pénétration en profondeur* (profound penetration) by limiting his photography to one subject, and trying to squeeze it dry. In other words, limits don't harm creativity, they force it.

The advice was oddly well timed. Paul had been thinking along the same lines, and had taken no photographs since mid-August while he tested a new idea as he walked the city: to simply shoot reflections (store windows, puddles, mirrors, etc.). After experimenting, he decided to broaden it to include "All Sorts of Things Reflected in Something."

"For example, as I sit here writing I can see a weird mating: my alarm-clock face reflected in the polished silver cover of a Cinghalese cigarette-box on which is engraved the Royal Lion of Ceylon," Paul wrote Charlie. "It's these fleeting, unlikely, dreamlike juxtapositions (which everybody sees all the time, half-consciously) which give this concept creative scope . . . the world of reflections—like Alice's Wonderland—is inhabited by people as well as things. They're peculiar people admittedly, but if I am to press all the juice out of this fruit it will be bound to include those twisted Beings that live on the other side of puddles and the bowls of spoons. *Alors les gars—aux miroirs!*"

Not long after this meeting, Paul and Julia offered to drive Steichen to his native Luxembourg, for a meeting. It was foggy, and an icy rain fell, and they did not arrive till after 1:15 a.m., after eight hours, during which both Paul and Julia drove off the road. Steichen wasn't bothered a bit. The next day they met with his friend, Monsieur Stoffel, a painter whose work had become progressively more abstract over the years. He was a talented painter, but his new work had been

reduced to spare geometric designs, which irked Paul. "Damn it all, by the time you've reduced your palette to 5 primary and secondary colors, and your forms to a figure-eight with kitty-fur growing out of it—all for the sake of 'greater concentration and simplicity' . . . it seems to me that . . . you'll have reduced your vocabulary to one word, or if you're a conservative to two," Paul sputtered to Charlie.

Rosemary and Abe Manell, friends in the diplomatic service, Marseille, 1950

Steichen demurred. He noted that a large segment of the world's leading artists were painting this way now, and groping for some new means of expression; it would be a mistake to dismiss the new abstraction as a passing trend, he advised. Paul listened intently. Steichen had been the star protégé of Auguste Rodin in Paris, but then moved to New York and helped Alfred Stieglitz found 291, the pioneering art gallery that introduced art photography and Matisse, Picasso, Duchamp, and other Modernists to the New World. Steichen had been part of the great artistic revolution of the early twentieth century from the start. Though he had not bought any abstract paintings, he found them "extremely stimulating creatively," Steichen said. And "one must take this kind of work seriously."

THE ROAD NOT TAKEN

When the USIS uprooted Paul and Julia from the US Embassy in Paris and relocated them, he seriously considered quitting the Foreign Service to become a professional artist or photojournalist, like Cartier-Bresson, Weston, or Steichen. He and Julia discussed the idea at length, and Paul lost sleep over it. But after

observing working artists and journalists at close range, he saw their ulcers and understood that the profession was a lot less glamorous in reality than it appeared from the outside. Charlie Child was a talented and reasonably successful portrait painter, who nonetheless struggled at times. Agonizing over the decision, Paul concluded that the vagaries of the professional photographer's life did not suit his temperament, his bank account, his wife's burgeoning career as a cooking teacher, or the continued success of their marriage. Reluctantly, Paul turned away from that dream. But he hardly had time to lament.

On January 15, 1953, he turned fifty-one years old, and learned that he would be transferred to a new post. To the Childs' surprise and delight, they were being sent south, to Marseille—though not for the job of exhibits officer. Paul would become the new public-affairs officer at the US consulate there. It was a prime post, and far preferable to Vienna, but it gave him pause. In Marseille he would be even busier than he had been in Paris, with a tighter budget, smaller staff, reduced supplies, and less flexibility to get things done. "I don't think I'm going to like this job," he confided to Charlie. "When do you pause? When do you paint or pant? When write family, loll on moss, hear Mozart and watch the glitter of the sea? . . . Clearly, I am softened by the luxurious style of our Parisian life: comes Friday night in Paris and down comes that iron curtain between job and what I *really* like doing. Wham!, and I'm off with Julie on the flying carpet."

But the alternative was to leave France for another post, which was unthinkable. So, Paul and Julia began to pack up their lives and prepare for the next phase. "Slide's all greased, and they're almost ready to give me the Old One-Two . . . Hold yer hats, boys—here we go again!"

Paris

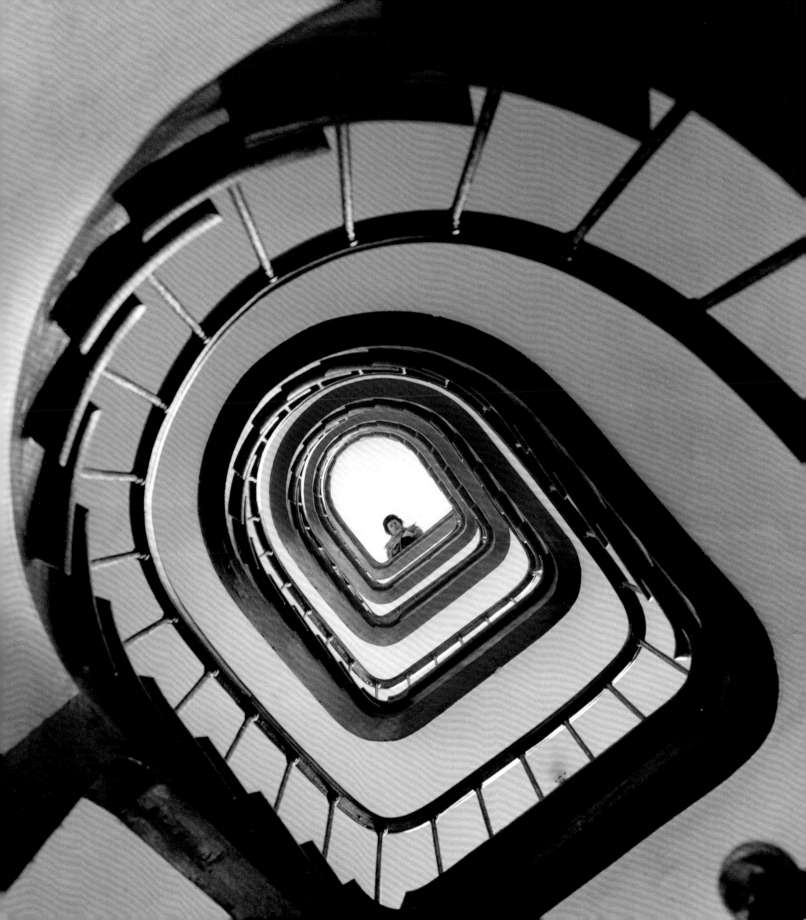

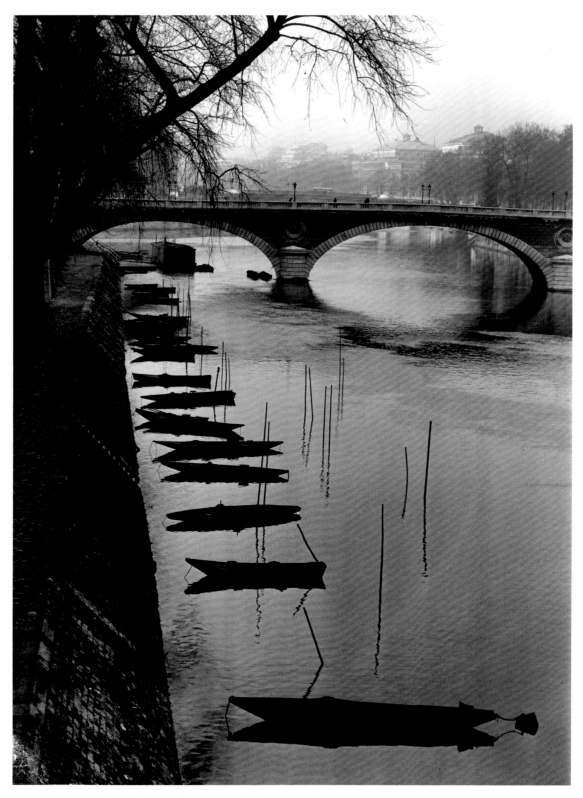

PREVIOUS PAGE: Julia at the top of the stairs, 1955
The Silver Seine, Pont Louis-Philippe, Paris, 1949

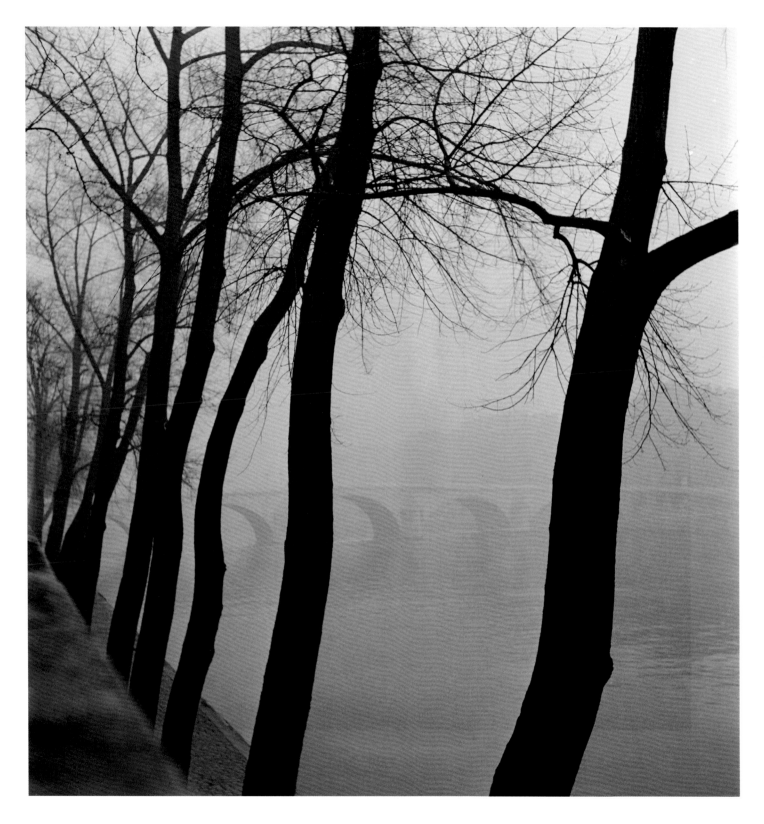

The Seine, Pont Royal (mist), 1950

Pont Neuf, 1955

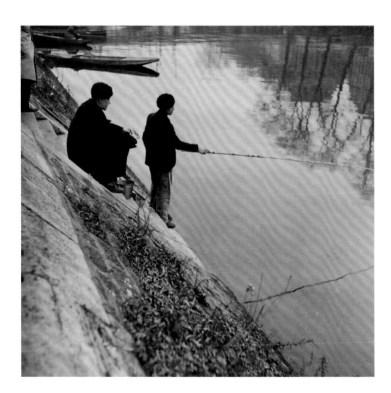
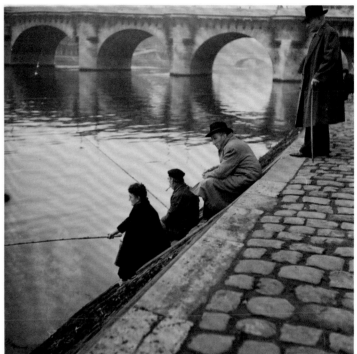

Seine fishermen, 1949

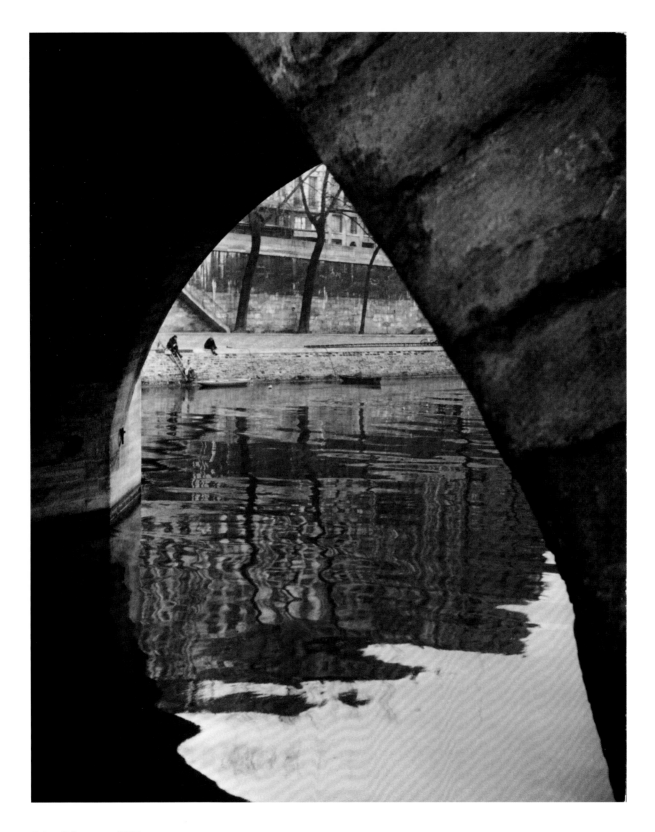

Seine fishermen, 1949

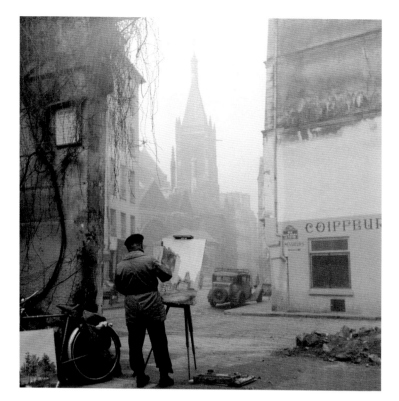
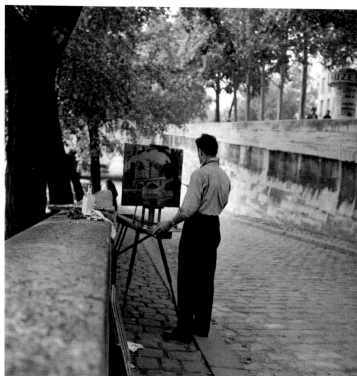
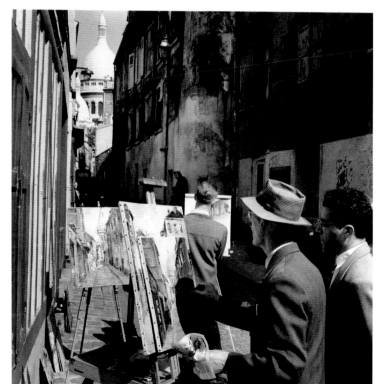
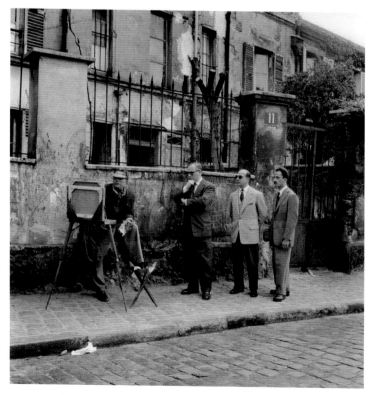

CLOCKWISE FROM TOP LEFT: Rue Saint-Julien-le-Pauvre, Saint-Séverin in the background, 1949; Paris painter, 1955; Montmartre painter and three onlookers, 1956; View of the Sacré-Cœur, 1956

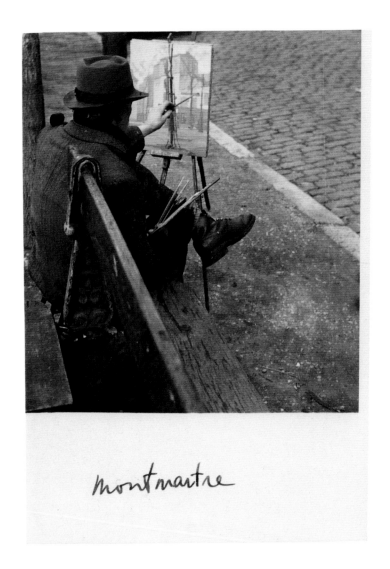

montmartre

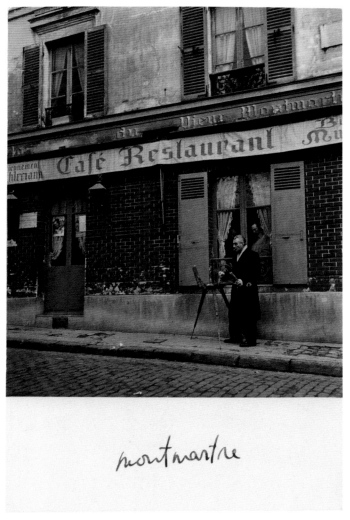

montmartre

Paris artists, Montmartre, 1949

Place des Vosges, Paris, 1950

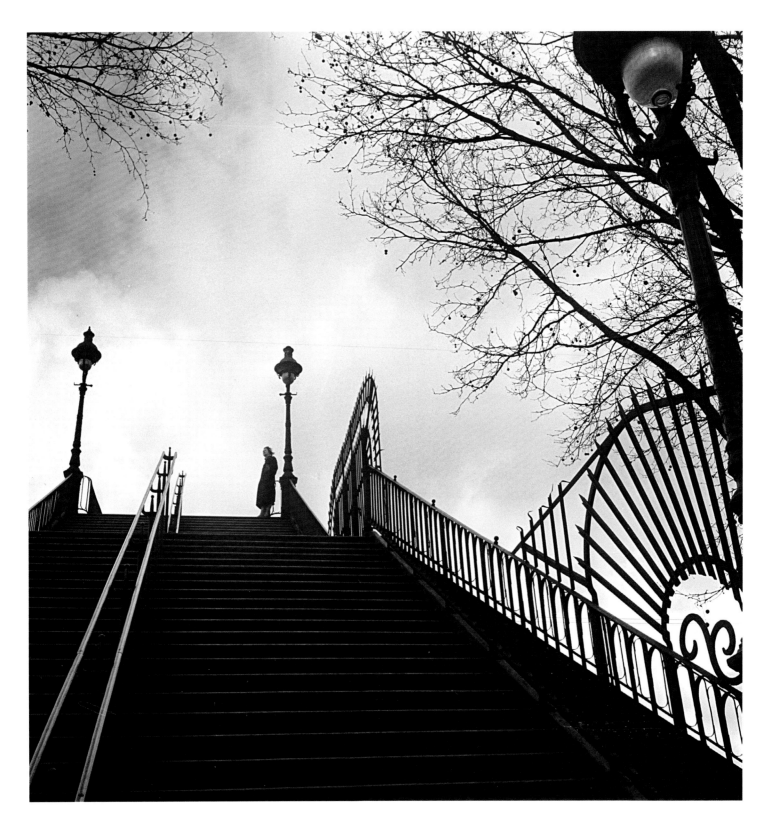

Julia, Bassin de la Villette, Quai de la Loire, 1950

Sacré-Cœur, from Rue de la Bonne, Montmartre, 1950

La Madeleine, Paris, 1949

LEFT TO RIGHT: Place Stalingrad, 1950; Hôtel de Sully, 1951

Rue Charlemagne 1949

"Paris in the Cold," Cour de Rohan, 1949

LEFT TO RIGHT: Quartier Saint-Paul, 1949; Rue Valette, 1951

Rue de la Grande Truanderie, 1951

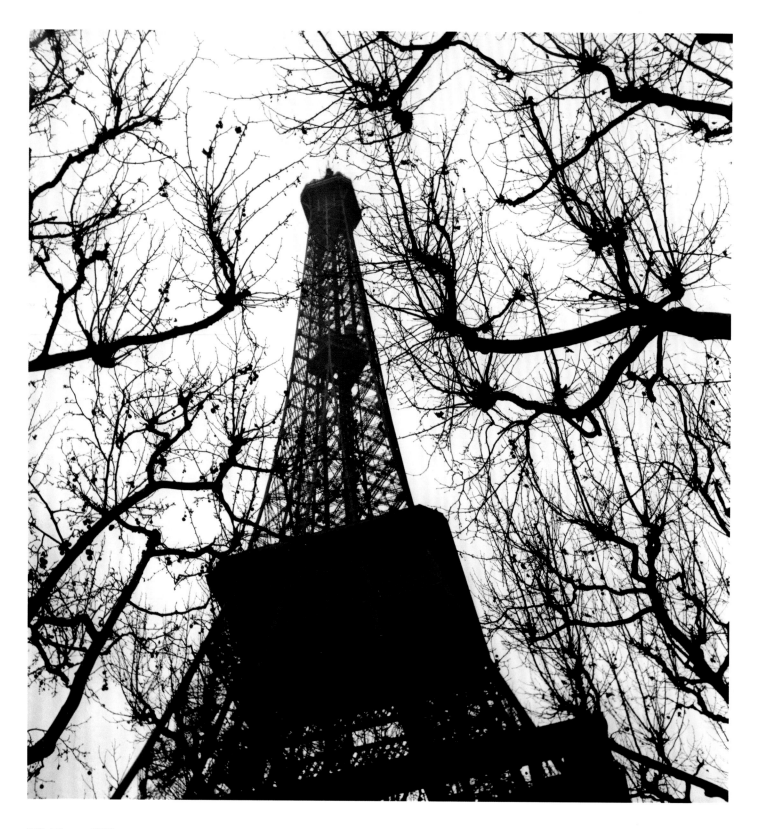

Eiffel Tower, 1950

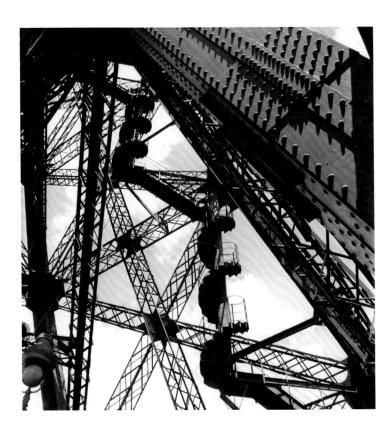 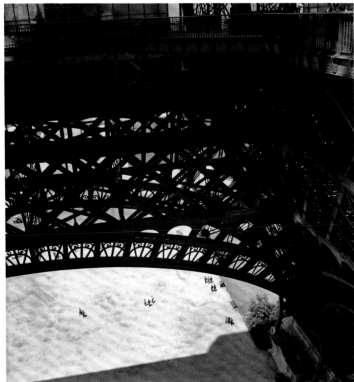

"Paris Building," Eiffel Tower, 1950

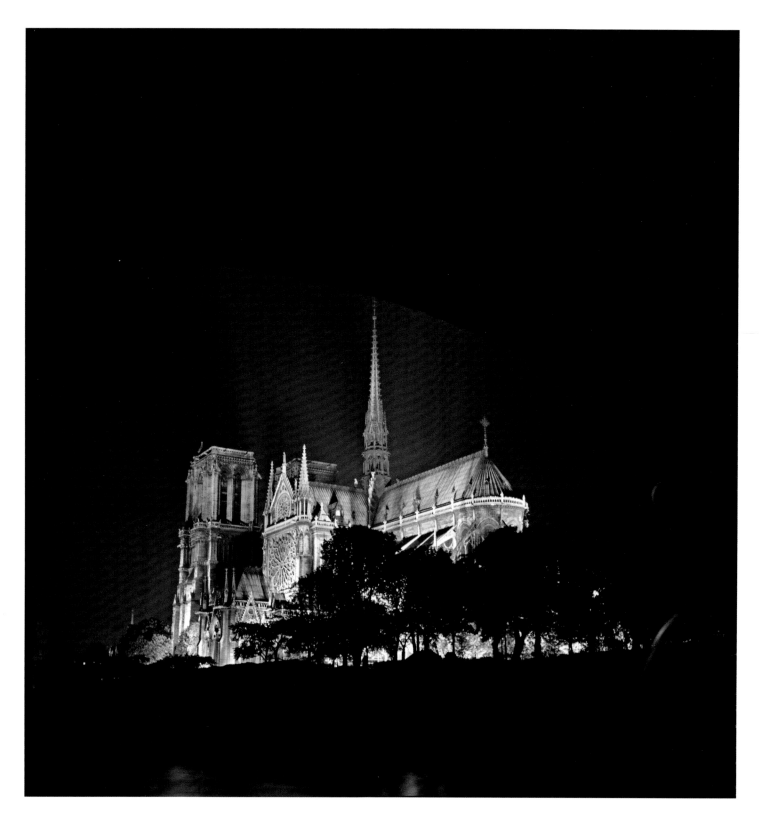

Notre-Dame at Night, 1950

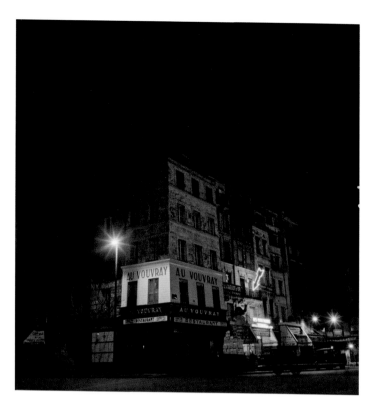

TOP: Au Vouvray, 1951; Window at night, 1950; BOTTOM: Les Halles,1951

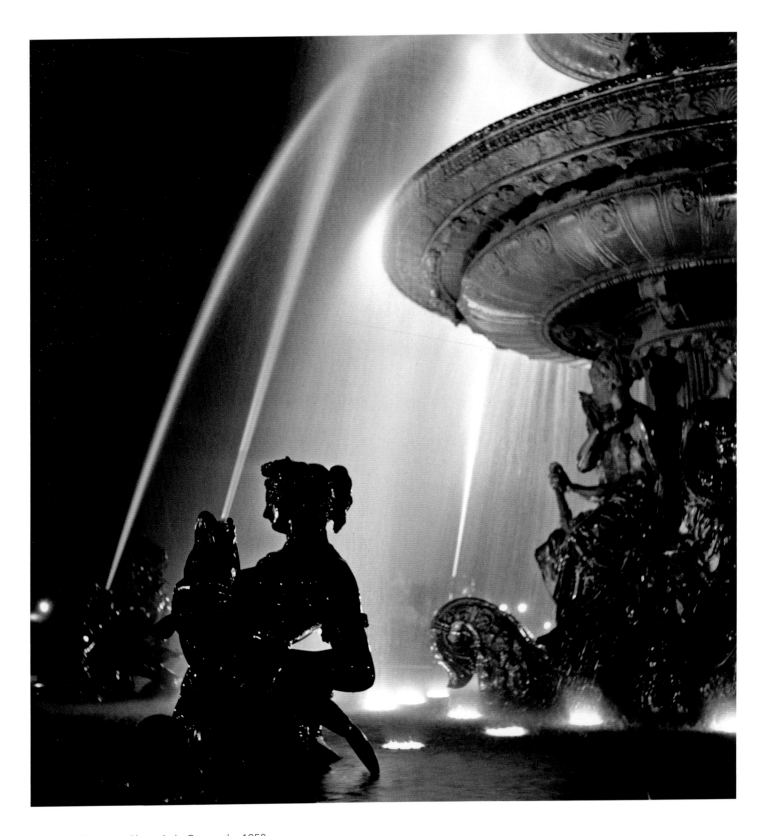

Fontaine des Mers, Place de la Concorde, 1950

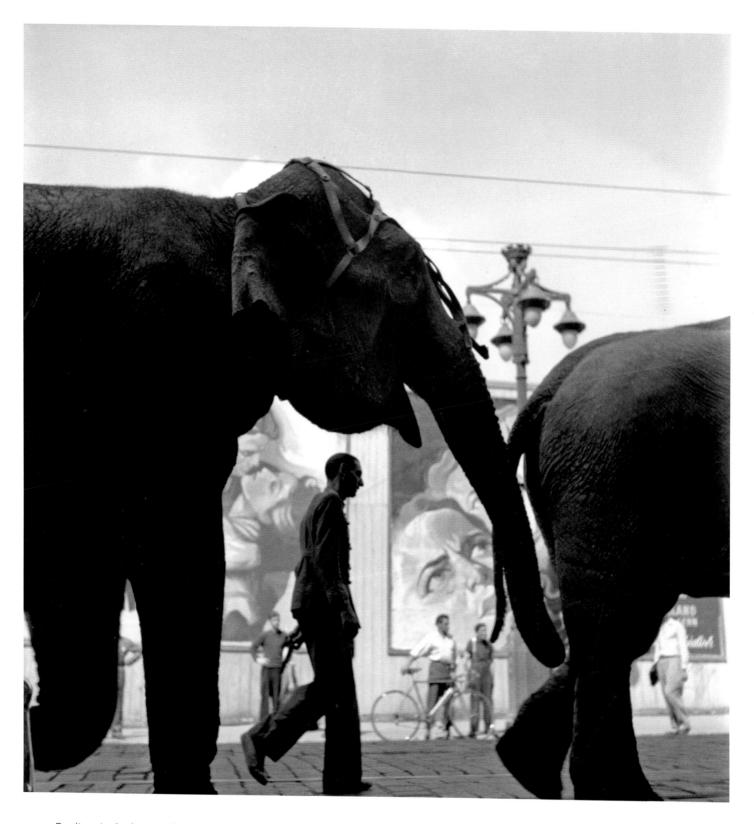

Baglione's elephants, 1949

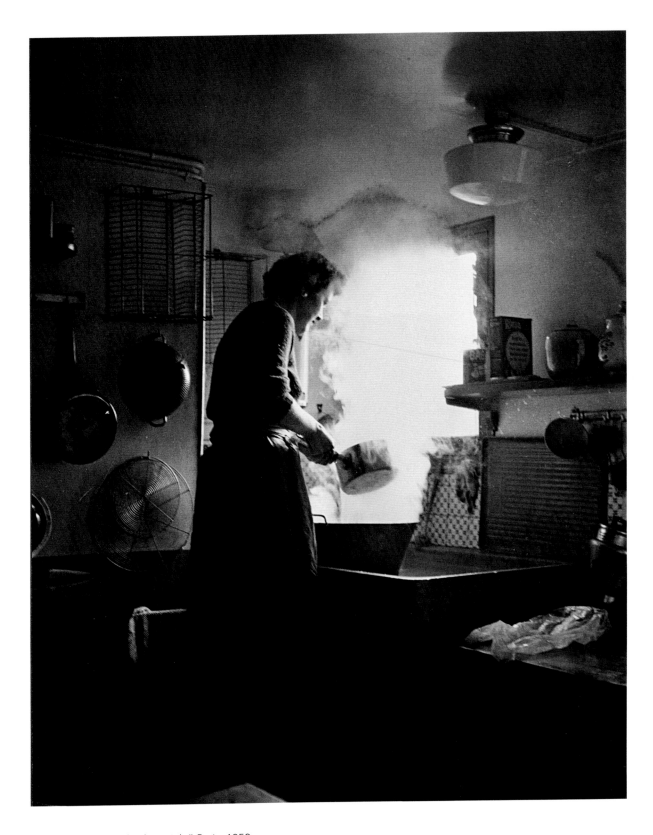

"Julia holding pot, kitchen sink," Paris, 1952

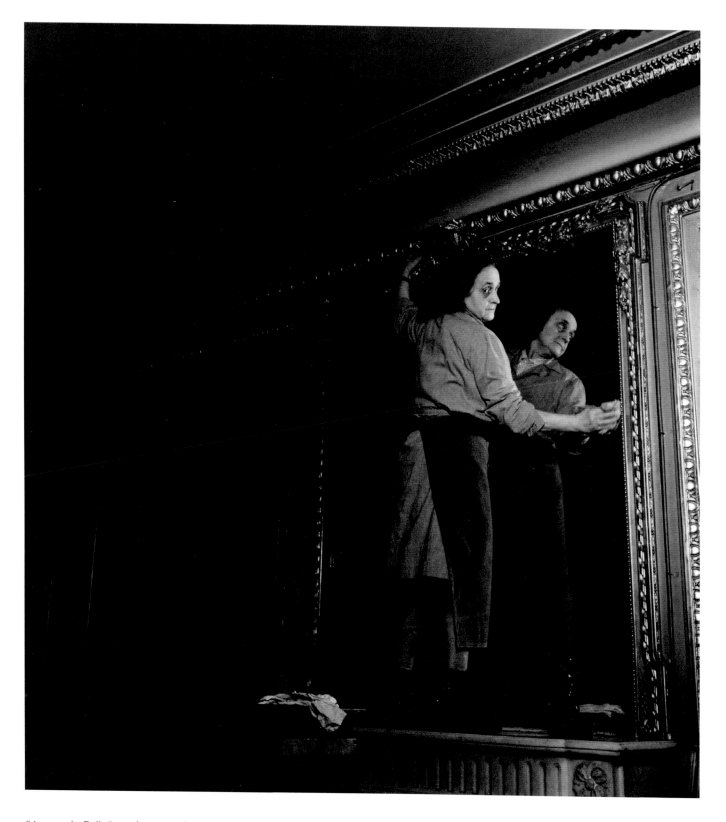

"Jeanne-la-Folle" on the mantelpiece, 1952

CLOCKWISE FROM TOP LEFT: Fur vitrine, night, 1952; Marché aux Puces, Saint-Ouen, 1952; Façade, Rue de Temple, 1950; Portrait display, 1950s

Plasterers' Storage Yard, Montmartre, 1956

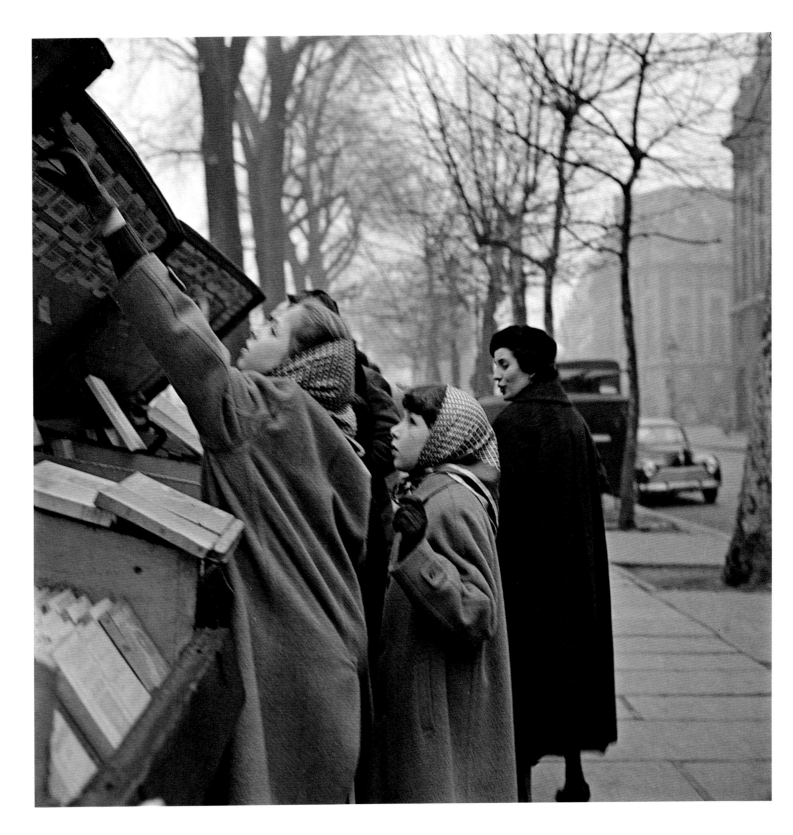

Les Bouquinistes, 1955

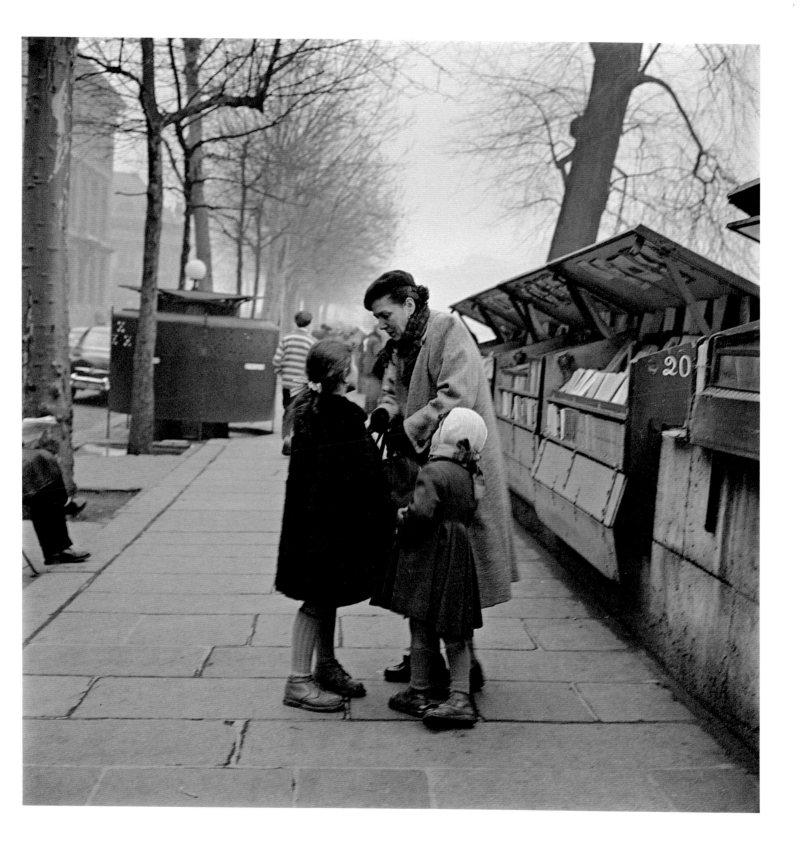

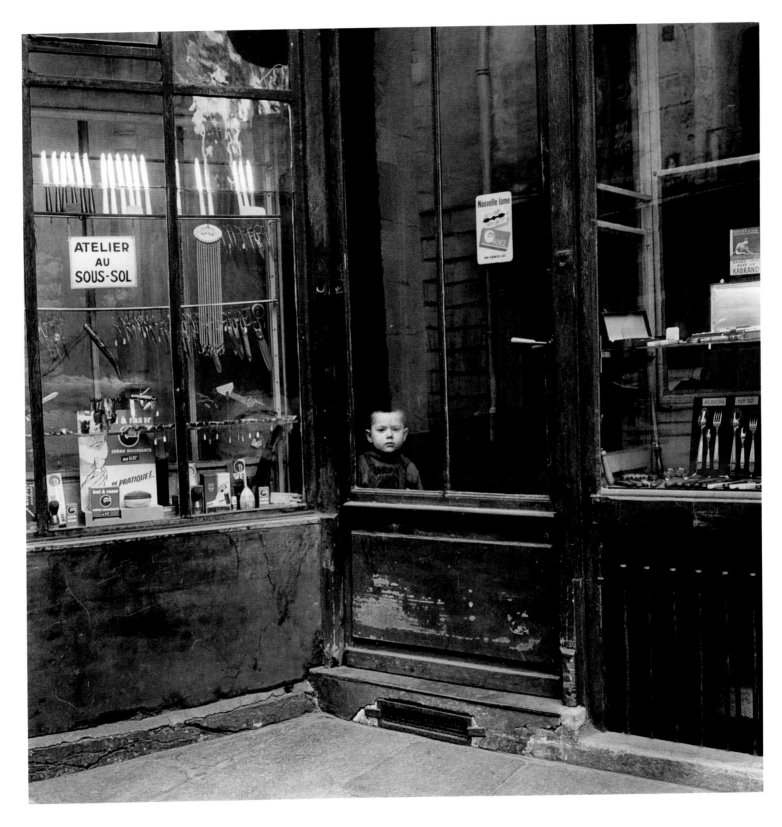

Boy's face through door, Montmartre, 1956

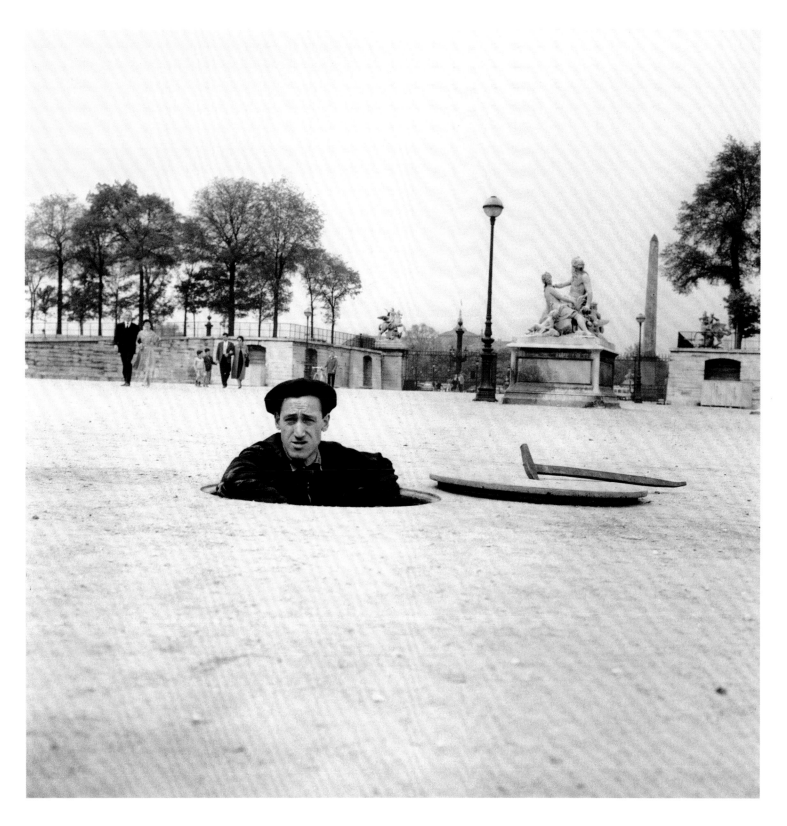

Jardin des Tuileries, 1950s

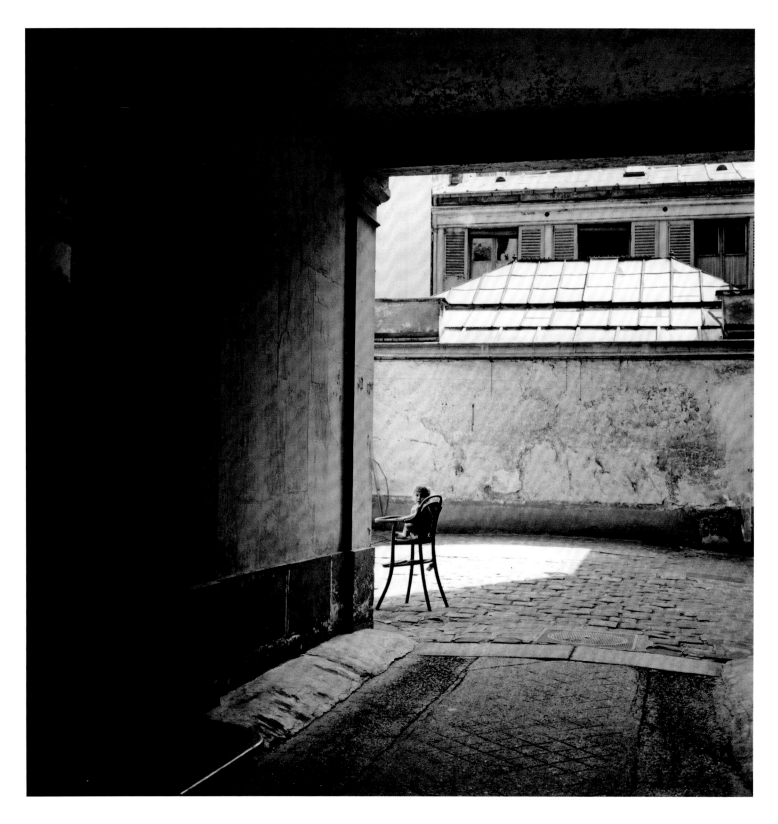

Baby in high chair in courtyard, 1956

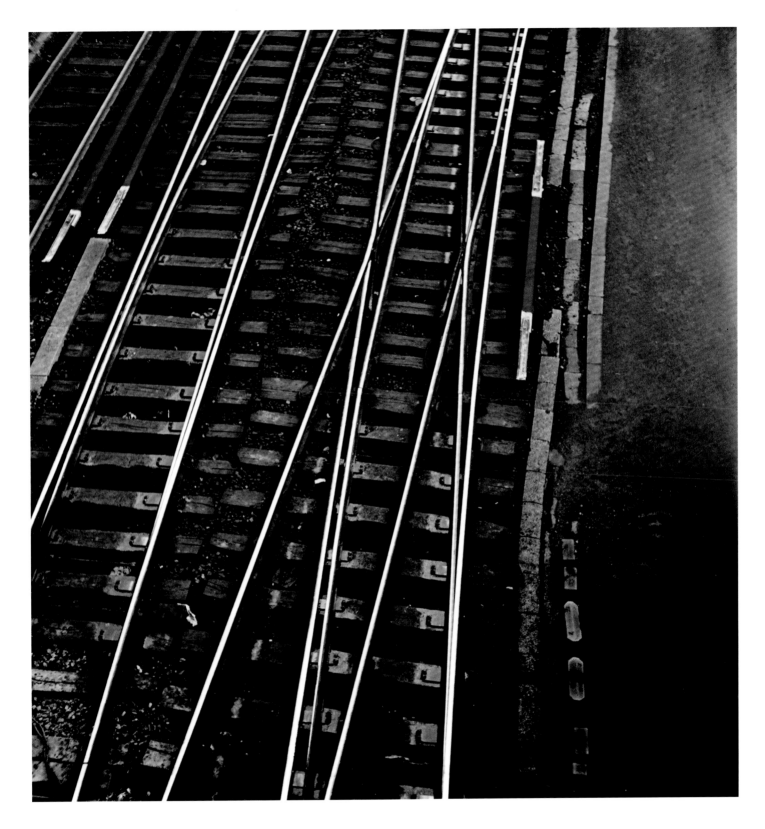

Tracks, Gare Saint-Lazare, 1950

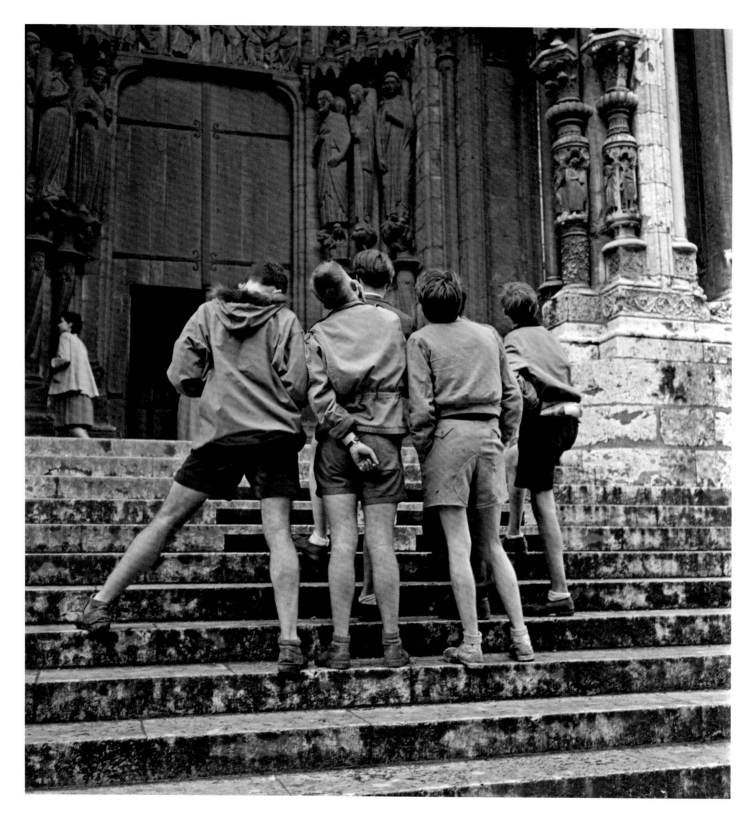

On the steps of Notre-Dame, 1950

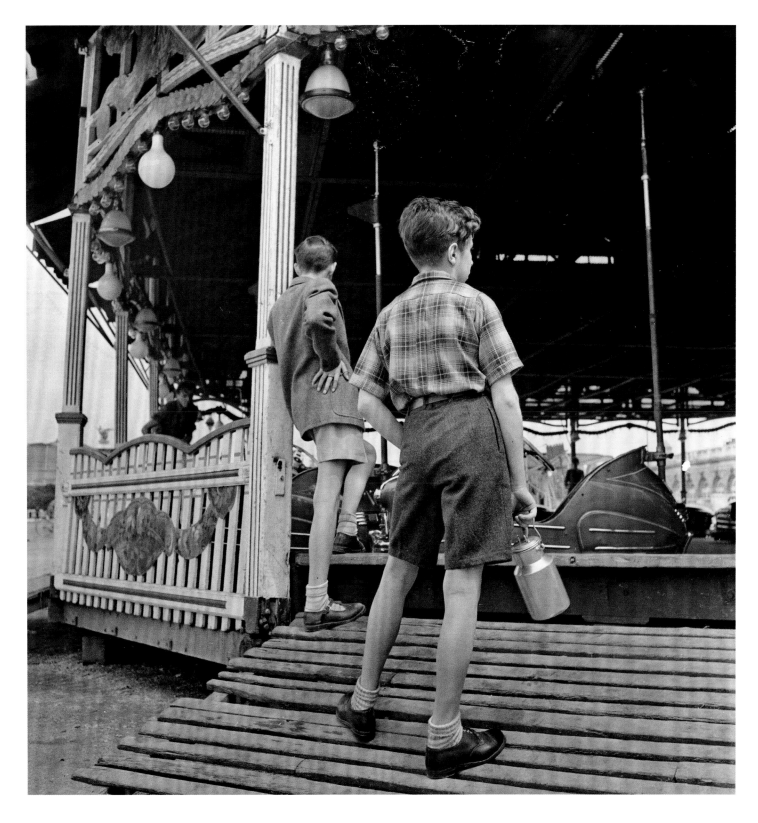

Cirque à l'Esplanade des Invalides, 1950

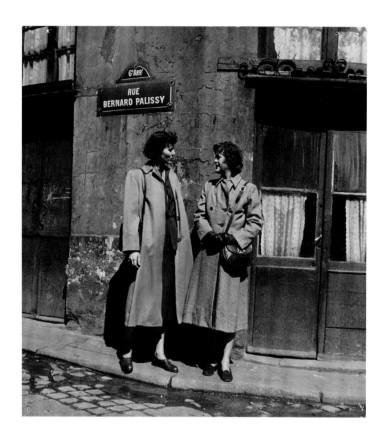

Julia and Dort, rue Bernard Palissy, 1949; Julia at the telephone, 1952

Hôtel Pont Royal, 1955

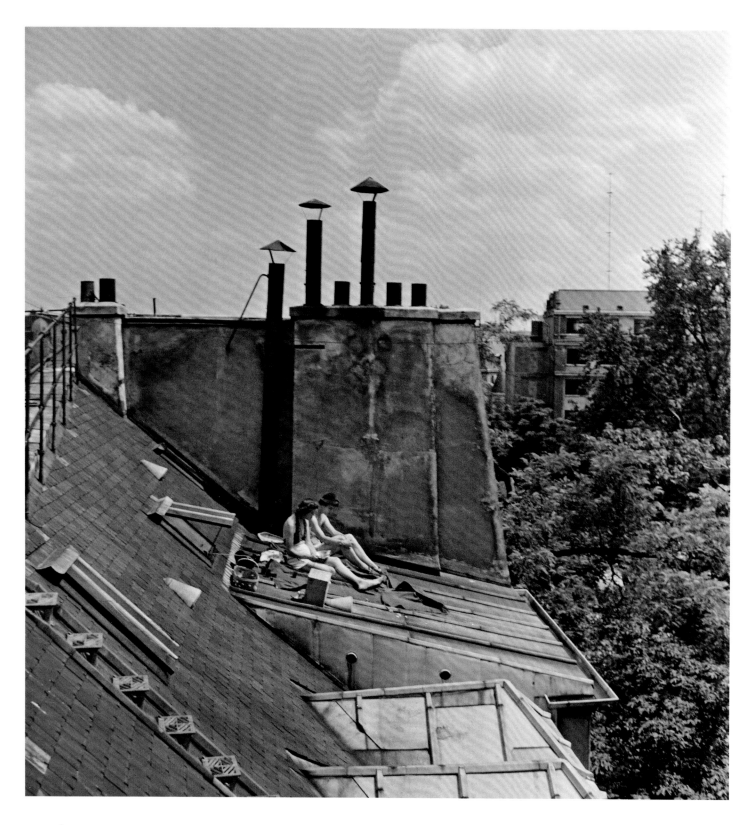

A "roofnic," 81 Rue de l'Université, 1950

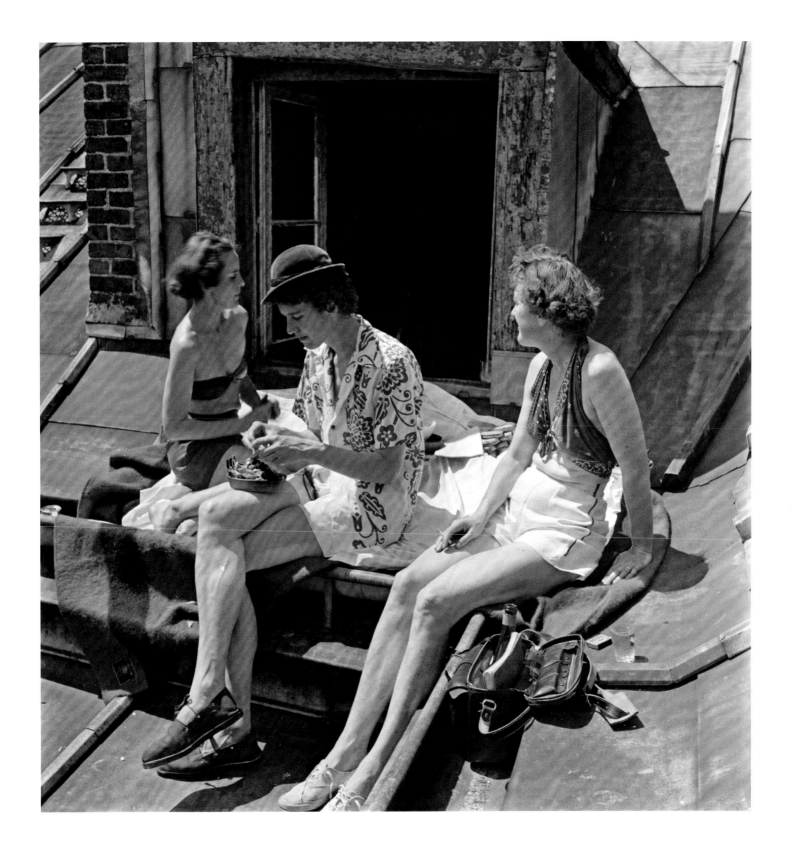

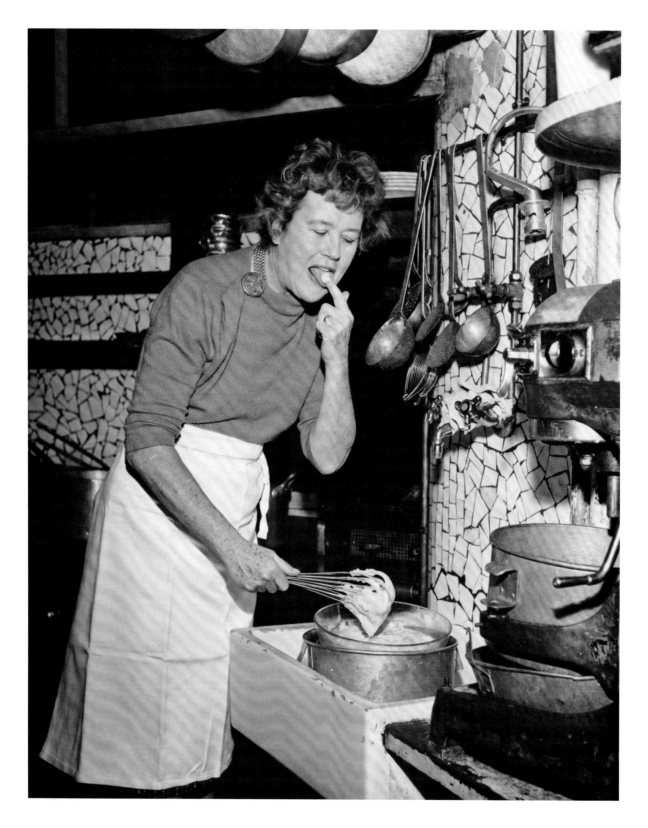

"Yum," 1950s

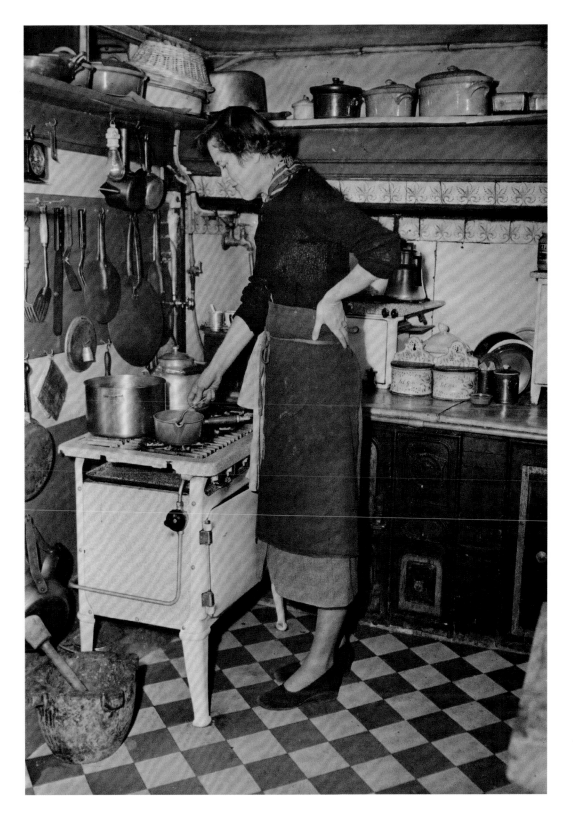

In the kitchen, Roo de Loo, 1953

The kitchen, Roo de Loo, 1953

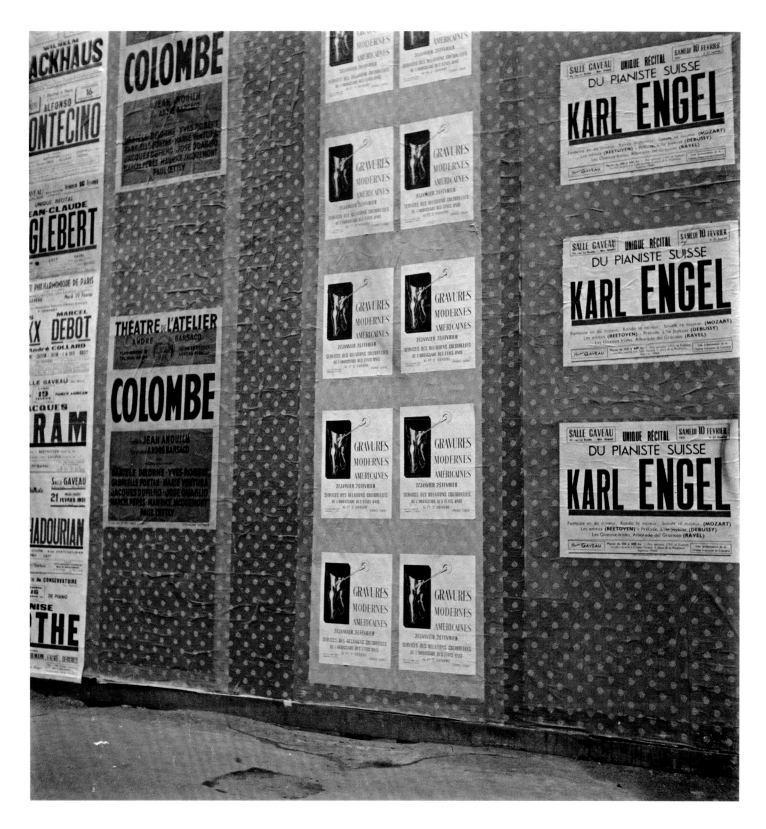

Posters, Paris, including "Gravures Modernes Américaines" designed by Paul, 1951

Parc de Sceaux, 1950

Rooftops, Île Saint-Louis, 1952

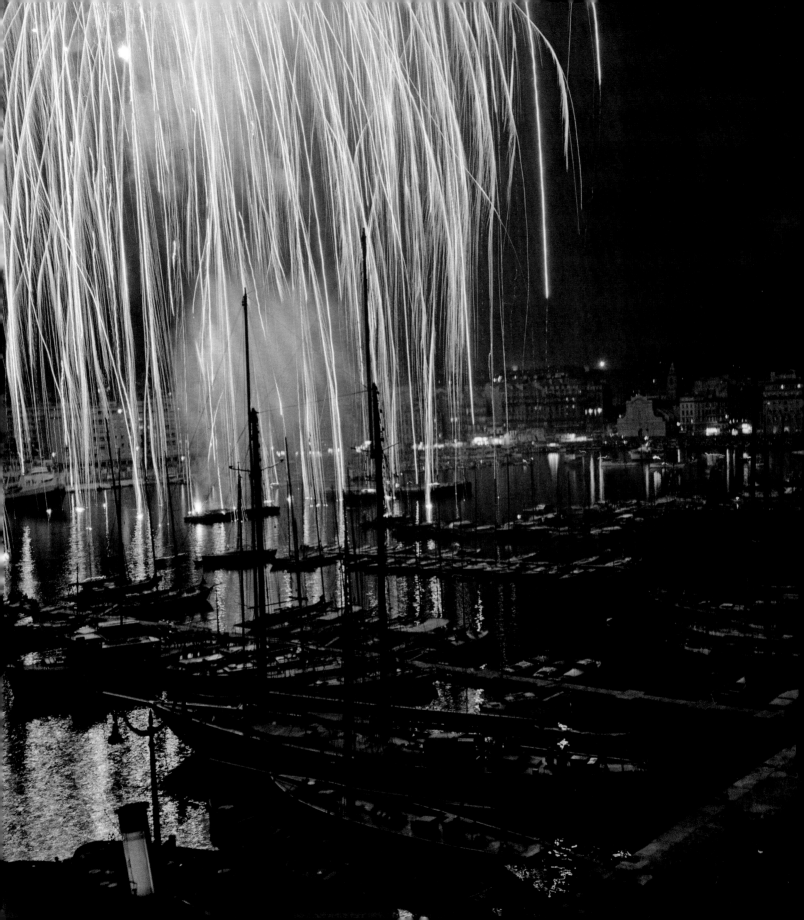

Marseille 1953–1954

THE OLD PORT

Marseille was an ancient, sunny port city built on a slanting hillside that leads down to the sparkling Mediterranean. The weather there was generally hot and dry, though the city could be buffeted by the cold mistral, a strong, northwesterly wind that occasionally blows down from inland to the sea. Its citizens were loud, idiosyncratic, and ethnically mixed; its buildings were built with yellow stucco walls and red tiled roofs; its sidewalks and gutters were cluttered with refuse; the noise was cacophonous; the garbage stupendous.

"I always forget . . . what a raucous city this is," Paul wrote. "There seems to be 10 times as much horn-blowing, gear-clashing, shouting, whistling, door-banging, dropping of lumber, breaking of glass, blaring of radios, boat whistling, gong-clanging, brake-screeching, and angry shouting as anywhere else." He called it "a bouillabaisse of a city," after its native fish stew. In many ways, Marseille was the antithesis of the cool gray stone and concrete of Paris.

Paul and Julia arrived there on March 2, 1953, and soon found a small, fifth-floor apartment that overlooked the Vieux-Port (Old Port). Paul met with the American consul general, Heywood Hill, a persnickety bureaucrat (referred to as "Hill the Pill" behind his back), and embarked on a series of meeting with local politicians, journalists, librarians, and military types in towns up and down the Côte d'Azur. He welcomed US Navy aircraft carriers, toured Monte Carlo, and attended the Cannes film festival. Julia, meanwhile, was writing the cookbook that would be published in 1961 as *Mastering the Art of French Cooking*. Uprooting from

Fireworks over the Old Port of Marseille, 1953

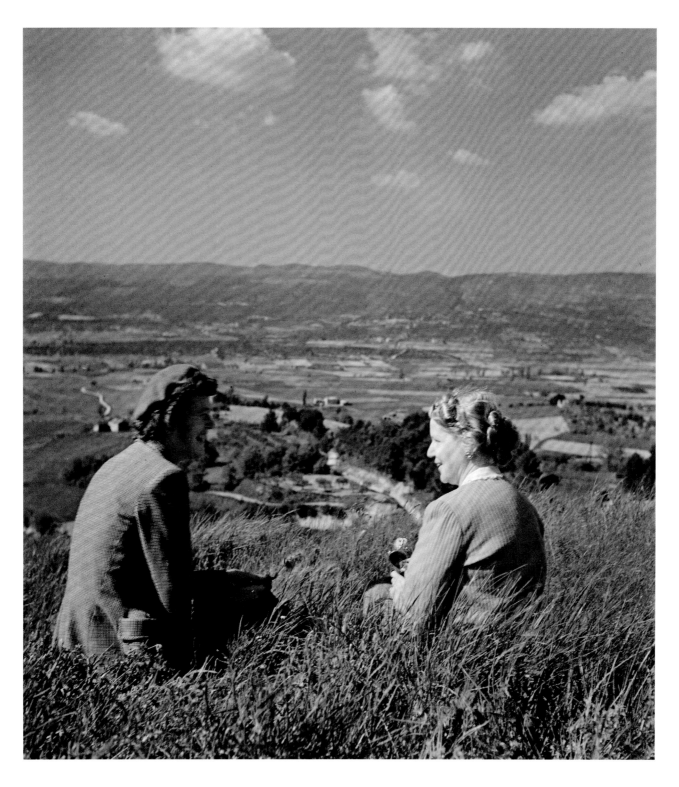

Julia with Leonie, Roussillon, 1954

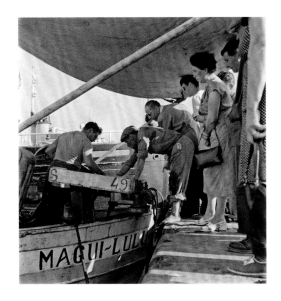

Fishmonger,
Les Goudes,
1953

Paris had been disruptive, but Marseille provided her with a valuable education in Mediterranean cuisine.

The American consulate was near the geographical center of Marseille, but the heart of the city was by the water, in what Paul called the "living theater" of the Vieux-Port. When the fishing fleet got into a big run of tuna, the men would work all day and night, filling the quay below the Childs' window with freshly caught tuna, shouting fishermen in yellow sou'westers, piles of ice, wooden pallets, and smog-belching trucks.

The food of Marseille was highly seasoned, and its wines were young and fruity. Slowly, at first, and then with increasing enthusiasm, Julia familiarized herself with the Provençal staples of fish, tomatoes, garlic, and local herbs. She undertook a lengthy investigation into the "real McCoy *bouillabaisse*" (every person she spoke to, it seemed, had their own "real" recipe for the city's most famous dish), and pecked away at the cookbook on a Royal typewriter.

Shopping in the famed *criée au poissons* market, Julia relished the loud banter of the earthy, territorial "fishwives," who screeched at customers and each other as they hawked fish with names like *chapon*, *rascassse*, *galinette*, *mustela*, and *lotte*. In his free time, Paul snapped photographs of the *quai* piled with wooden boxes of the day's catch, fishing nets strung up to dry, the waves and the gulls, and the chaos of Marseille harbor.

A FOOTHOLD IN "REALITY," THE CONSCIOUSNESS OF STRUCTURE

While he was essentially a reserved, contemplative, inward-facing man—a quiet observer who processed the world visually—Paul spent his careers in classrooms, war rooms, and diplomatic meetings: all social and verbally demanding environments. He claimed not to enjoy the public realm (though clearly he did, at times), and knew he was not naturally skilled at small talk the way Julia was. But Paul was in some ways a self-created man: aware of his shortcomings and perceived faults, he worked to correct them. Just as he forced himself to climb to great heights despite terrible vertigo, he forced himself to distill his thoughts, and talk, write, and make pictures with clarity. "Communication is the glue that holds people together . . . it's the mortar of civilization's structure," he wrote. "My whole life has been concerned with communication." Paul saw his photography

and painting as a powerful means to reach out to the world and connect to others. In a 1973 speech in Boston, he said of his artwork: "This is *me*, trying to communicate with *you*. I can only hope that we now understand each other . . . at least in some measure."

Paul's search for clear expression, and physical and intellectual self-improvement, were lifelong pursuits. In part, this can be traced to Alfred Korzybski, the Polish-American scholar who laid out his theory of general semantics in his 1933 book *Science and Sanity*. Korzybski maintained that human knowledge is limited, and therefore man can only know that which is filtered through his own mind. "The map is not the territory," he famously said, meaning many people confuse maps with territories; i.e., they confuse models of reality with reality itself.

In a similar vein, the surrealist painter René Magritte painted a picture of a pipe, titled *The Treachery of Images*, which was inscribed "*Ceci n'est pas une pipe*" (this is not a pipe). Criticized for it, Magritte replied: "It's just a representation, is it not? So if I had written on my picture "'This is a pipe,' I'd have been lying."

This line of thought struck a bell in Paul. He liked to employ the Korzybski dictum "The word is not the thing," by which Paul meant: do not accept others' words or logic at face value; "subject them to the operational proof" to determine if an idea holds up in practice. ("Operational proof" was an Office of Strategic Services [OSS] term for empirical study.) Or, as Julia put it more bluntly: "It's all theory until you see for yourself whether or not something works."

It was a lesson Julia internalized, and passed on to her audience. And it was the dictum by which Paul Child lived his own life. In 1950, he wrote: "One of my missionary goals is to reform everybody so they'll communicate more and more clearly. When I get a letter I can't read, or when someone tries to tell me how to go from Ghent to Aix in such a way that I end up in Passchendaele, I want to hit them over the head with a copy of Hayakawa's

Dort, 1949

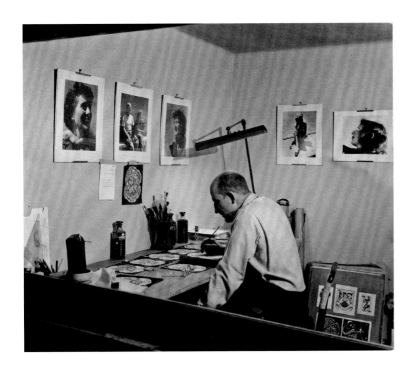

Paul in his studio, Marseille, 1953

Language in Thought and Action." (Samuel Ichiye Hayakawa was a university president, California senator, and devotee of Korzybski.)

In distilling thoughts, combatting clutter, striving to articulate, and subjecting ideas to the operational proof, Paul developed an approach to making art. It was a personal statement, and a reaction to what was in vogue at the time. In Paul's view, artists' styles and techniques were a consequence of their motivations. What were Paul's motivations to make art? While he appreciated surrealism in literature or art, and was open to raw expressions of pain, anger, and confusion, those were not themes that Paul pursued in his own work. Perhaps he found them too messy or unsettling: "There seems to be enough of it around without adding my bit to that dung heap," he wrote Charlie. Rather, Paul was drawn to making images with "at least a foothold in 'reality' as most people know it." He continued: "I am trying to communicate with my fellow human beings, and, for the most part, it is my pleasure with the world as I see, hear, touch, smell, and taste it that I am symbolizing."

He added: "Portraits are narcissus pools in which the subjects . . . can perceive the magic reflection of their secret belief in their own wonder and beauty. That's the kind of magic I want my water, or rock, or architectural paintings to produce, in a somewhat different way. I want the beholder to say to himself, subconsciously, 'Yes, by God, they really *do* have wonder, beauty, mystery, power, gloom and glory.' . . . A painting can . . . summon up the strange along with the familiar. Poems can do it too— even photographs."

Julia, 1949

Another of Paul's artistic motivations was to impose a semblance of order on the random disorder of life. While Charlie "opted for chaos," Paul preferred the "fortress-castle-square" of calm and control. Charlie painted raging storms and flowers bursting with color; Paul was drawn to architectural abstractions, simple portraits, the cool and calm of "the rhythmic relation of geometric shapes."

Julia understood the complex emotions that roiled her husband. Paul had never known his father. While his mother was fond of him, she was unable to provide her son with the warmth, attention, and security he craved; his upbringing was shambolic. Paul's sister, Meeda, was incomprehensible to him. Most poignantly, Paul's relationship with his assertive twin, Charlie, was a tangle of mutual devotion, understanding, rivalry, and antagonism. In letter after letter, Paul praised his brother's painting, compared and contrasted their artistic approaches, asked about his tools and techniques, mused on the state of the world, complained about his lack of productivity, recommended readings, and asked for feedback from his brother. "Sorry you are having such a dreadful time with the Vicky portrait," Paul wrote Charlie sympathetically. In another letter he said—hopefully or plaintively—"Enclosing little pix of 14 castles. . . . Does the continuance of this service interest you?"

Charlie sometimes responded to this almost daily blast, but often ignored it and wrote about himself instead. When Charlie—whose family nickname was "Cha"—did acknowledge him, Paul—known as "P'ski"—was thrilled: "I most especially thank Cha for individually commenting on and criticizing the photos and drawings I've sent," he wrote from Paris in 1950.

Paul was self-aware enough to recognize that his letter writing could appear obsessive. "Writing every day creates a special retentive awareness of conversations, faces, situations, ideas and scenes. I find it's becoming increasingly difficult for me to stick in my thumbs and pull out the plums—and then leave the rest of the pie untouched. The decisions to write about certain things and not others are necessarily personal to me—a sort of editing process from life's raw proof-sheets. Because I'm caught inside this P'skian circle it would be helpful to me if you'd criticize the kinds of plums I've been pulling out and the manner of their presentation."

When there was no answer from the other end, Paul grew exasperated with his doppelgänger. And so, at times, did Julia—no shrinking violet—who would rise to her husband's defense. "Charlie Child was self-absorbed, and didn't listen to his twin brother," she said. "That's why Paul wrote so much—pages and pages per day in his diary or letters to family members. It was the only way Paul could express what he needed to, and more or less be heard."

Though personally modest, Paul was ambitious for his work. Meaning he wanted his ideas to reach other people and to influence the way they saw the world, and him. He had a robust ego, but the fact that he never achieved wide fame or wealth as an artist didn't seem to bother him. He made his work because he enjoyed it and, indeed, felt compelled to make it: his was art for art's sake. Which is not to say that Paul went unrecognized. There were those cognoscenti, such as Edward Steichen and Pierre Gassmann, who appreciated his eye. And François Stahly, a German-French sculptor and an editor at *Graphis*, included twenty-three of Paul's prints in a UNESCO photo salon that traveled to Japan, England, and Norway. The striking quality of Paul's work, Stahly said, was a "consciousness of structure" in trees, architecture, mountains, the human figure, ruins, fields, leaves, and the like.

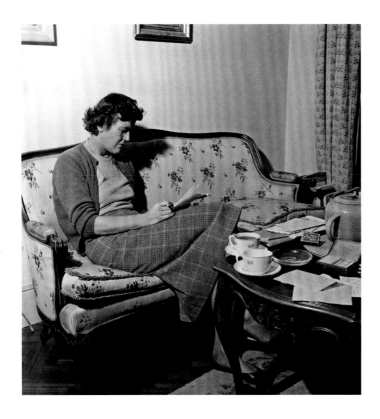

Julia reading, Marseille, 1953

Paul was deeply gratified by this insight from a knowledgeable stranger. "It's interesting that the expert from *Graphis* singled-out *that* as the most exciting and worthwhile quality in my photos because the realm of my most passionate inner convictions, my 'religious' feelings if you will . . . are based on a continuous drive toward an unverbal Something—which can be described only by such vague terms as In-balance-ness, or rhythm, clarity and precision," Paul wrote Charlie.

"Structural things, structural effects, are filled for me with the very essence of Life. A head of wavy hair, a snow-flake, the sweep of a river, a spider's web, Mozartian music, speak directly to me of Power and Glory where, say, a pile of dust, a Bowery bum, a mess of pottage with their lack of visual order, suggest disintegration and death. What I'm doing with my camera is seeing in Nature, through a very personal eye, these particular elements which excite me most

because they symbolize the realm where I find creativeness-satisfaction and peace. That's why I tend toward the 'formal' in my writing, my painting, my speech and my clothes. If you think about it you'll realize that this personal drive is one of my most dominant characteristics."

THE FRENCH CHEF

There was another aspect to Paul Child's photography, one that the wider world would come to admire even more than his artwork: he documented his wife's first, tentative stabs at cooking in France in 1948, her increasing confidence behind the stove in the 1950s, and her meteoric rise to stardom once they had returned to the States, from 1961 onward. It was natural that Paul would shoot thousands of images of Julia as she embraced France and its food, attended the Cordon Bleu, co-created a cooking school, struggled to write her books and perform on television, landed on the cover of *Time*, appeared at the White House, and helped to radically transform the culinary and cultural landscape of the United States.

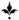

Julia began to work with Simca Beck and Louisette Bertholle on their "French Cookbook for the American Supermarket" in 1952. Months of work behind stove and typewriter turned into years. The manuscript grew steadily to some 850 pages. With help from Avis de Voto, a literary scout and the wife of essayist Bernard de Voto, the Boston publisher Houghton Mifflin accepted the book, and then rejected it as too long and complex. The authors completed a major overhaul, reduced their manuscript to 684 pages, and resubmitted it. Houghton Mifflin rejected the book a second time, concluding it was simply too long and dense for their audience. "Americans don't want an encyclopedia," one executive sniffed. "They want something quick, with a mix."

After so many years of work, Julia and her friends were heartbroken. But de Voto believed in it. She sent the book to the publisher Alfred A. Knopf, where it landed on the desk of perhaps the one editor in New York who could understand it: Judith B. Jones. Jones had lived in Paris while the Childs were there (though they never met there), and had learned to cook by osmosis and by asking for advice; back in the States she had been looking for a really good French cookbook, but could not find one. Suddenly here it was, written by three unknowns, on her desk. Judith took the manuscript home and began to cook from it—omelettes,

Julia at Les Baux-de-Provence, 1955

bœuf bourguignon, tarts—and fell in love. She convinced Alfred A. Knopf to buy the book, and in 1961 *Mastering the Art of French Cooking* was published.

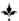

As Julia toiled in the kitchen and at the typewriter in the fifties, Paul often photographed her at work. They loved collaborating, and in this very natural way they combined talents to innovate a method of illustrating cookbooks. Cookbooks of the day showed food preparation from the spectator's perspective. But Paul and Julia thought it was more intuitive to show the process of, say, trussing a chicken, from the *cook's* point of view. While she manipulated the bird on a cutting board, he stood on a chair behind her and focused his lens on her hands. "We spent a very enjoyable two hours experimenting on this in the kitchen," Julia recalled. "We discussed light angles, camera angles, proper backgrounds, how to position my hands to show a technique properly, exposure times, and all the other variables we'd have to bring into harmony. Then Paul hoisted his Graflex and flicked on his new bright floodlights, and we shot eight exposures." The resulting photos were turned into line drawings (which were easier and cheaper to print). The shift to the cook's perspective was so practical that most contemporary cookbooks still use this approach.

Les Trois Gourmandes, Paris, 1953

Later, Paul was responsible for all of the still photos of Julia and her food for *The French Chef* television series, and several of Julia's mid-career cookbooks (she produced eighteen books altogether).

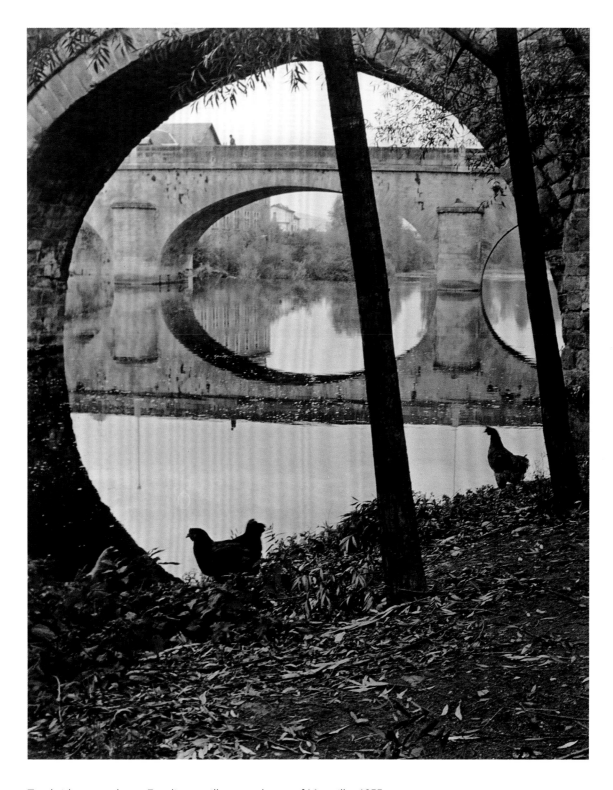

Two bridges, two hens, Espalion, a village northwest of Marseille, 1955

Paul and Julia, Marseille, 1950

ADIEU

By March 1954, Paul and Julia Child had been in Marseille for a year. They had found a second, larger apartment with views over the city, Julia was making progress on her cookbook, and Paul was happy with his new boss, Clifford Wharton, who was said to be the first African-American consul general. But Paul was on "a limited appointment" in Marseille, and his contract was due to expire in September. As budget battles and culture wars raged in Washington, DC, the Childs worried that their future in the Foreign Service was insecure. And rightly so: within weeks, Paul and Julia were informed that they would be transferred out of Marseille to make way for a new PAO by the end of June.

Where would they go? The Childs hoped for a posting to Spain or Italy, but on April Fool's Day Washington cabled: "Steps Taken Here to Effectuate Transfer of Child to Bonn as Exhibits Officer." They were going to Germany.

By this point Paul and Julia had grown cynical about the Foreign Service, and feared they would be accused of being Communists by McCarthy and his henchmen. But Bonn was a prestigious post, and the exhibits department there was even more important than Paris's in those Cold War days. It was a coup, yet the Childs wanted nothing more than to stay in *la belle France*.

It was a painful decision. Paul had lived in France for a total of eleven years, Julia for five. They were fluent in the language, had wonderful friends, knew their way around the country, and were completely comfortable in their skins there. Julia wanted to stay near her co-writers, Simca and Louisette, to finish work on their cookbook. Once again, Paul considered switching careers to become a freelance photographer. He had better connections now, but the realities of constant travel and deadline stress did not appeal any more in 1954 than they had earlier. After talking it over, he and Julia decided to stay with the Foreign Service, and see where it took them.

Marseille

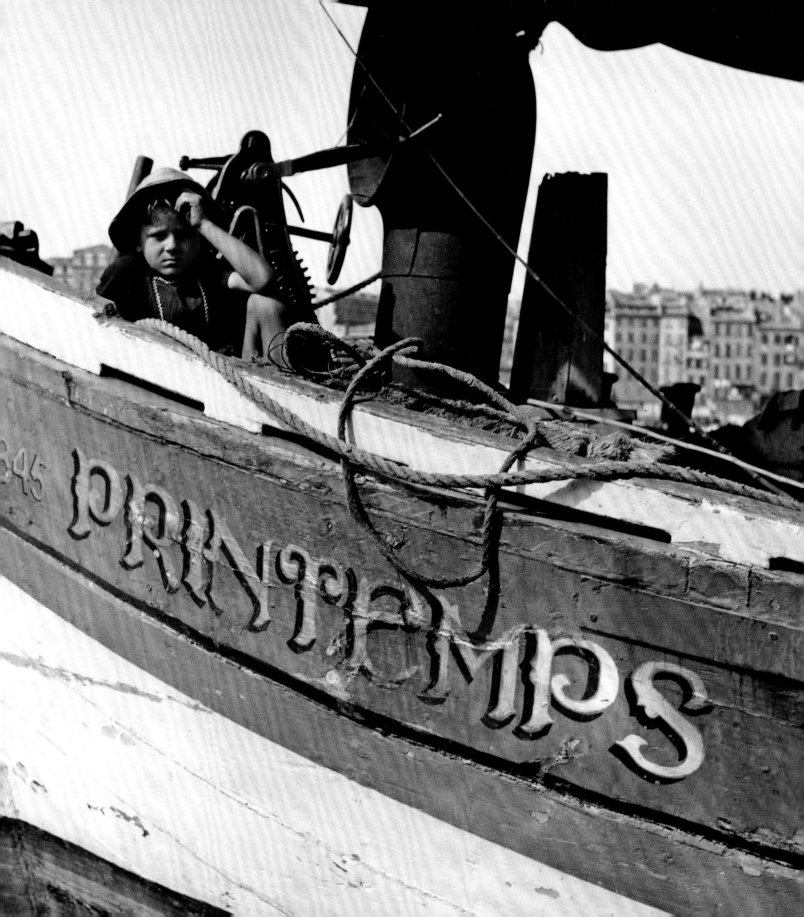

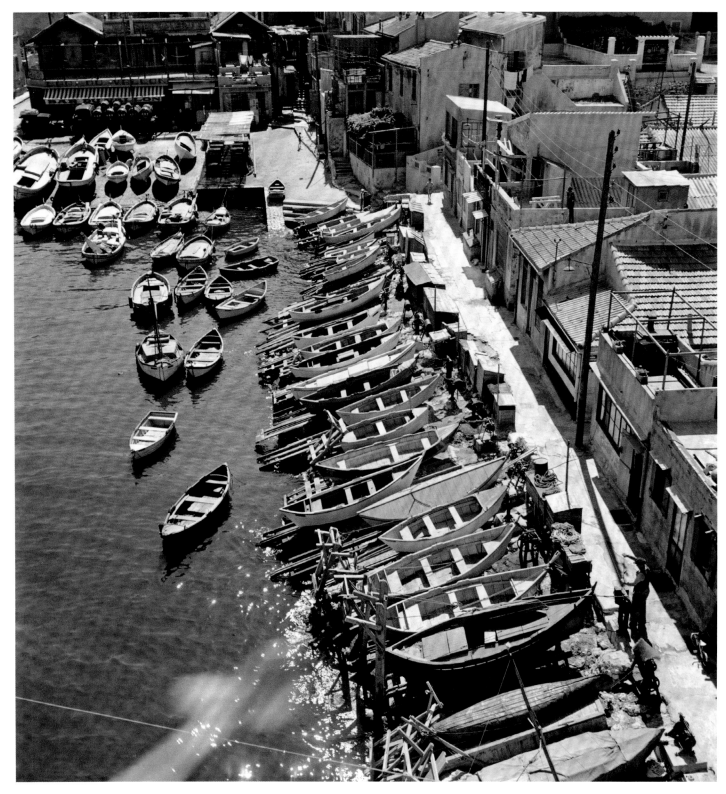

PREVIOUS PAGE: *Printemps*, Old Port, Marseille, 1949
Vallon des Auffes, Marseille, 1953

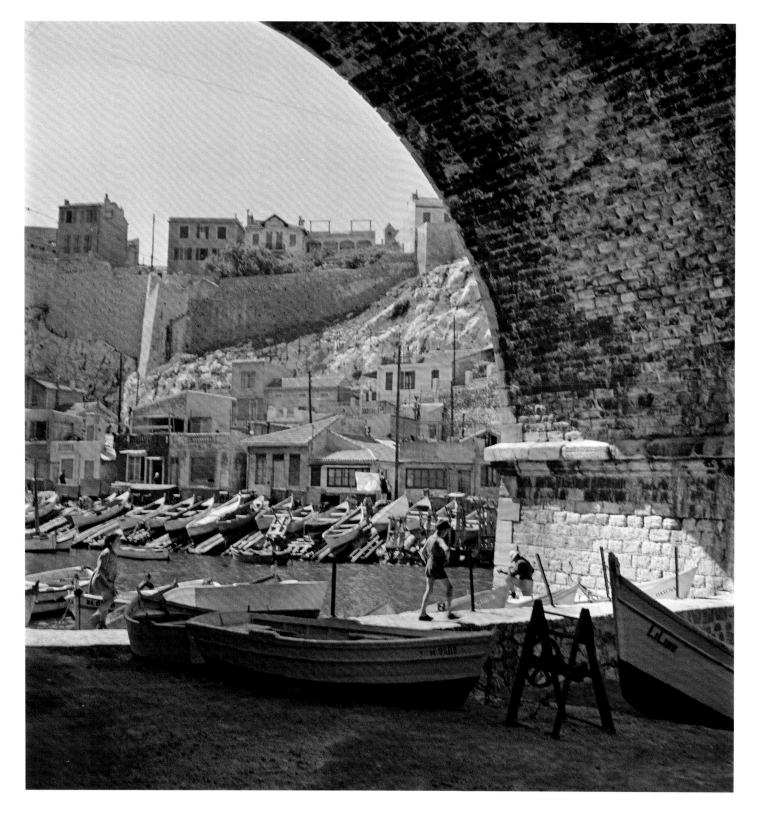

Vallon des Auffes, 1953

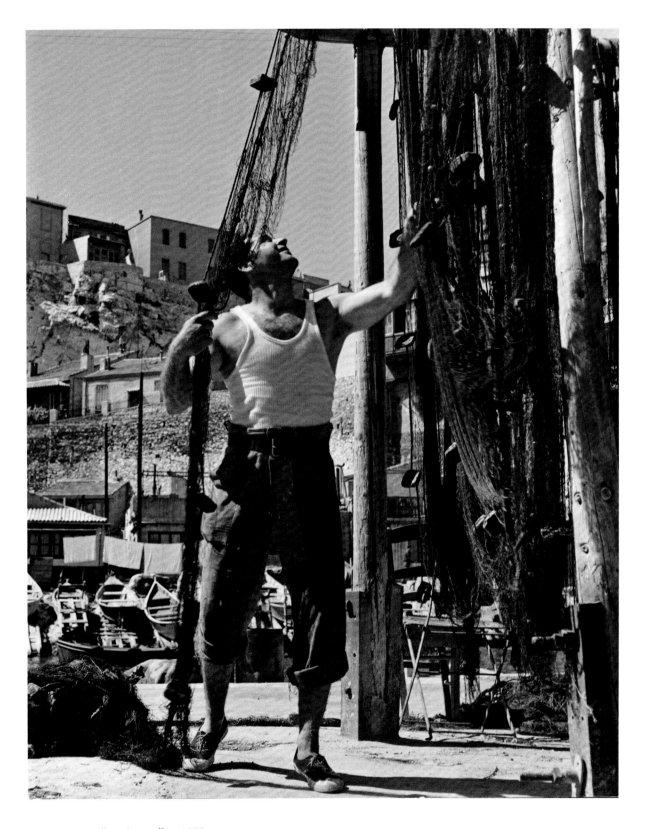

Drying nets, Vallon des Auffes, 1953

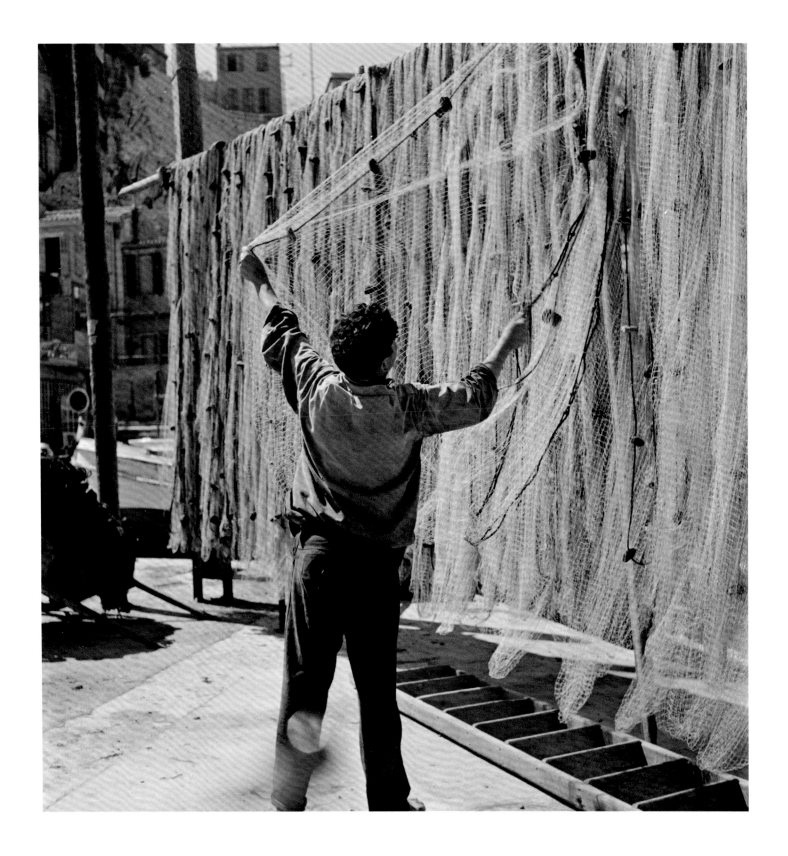

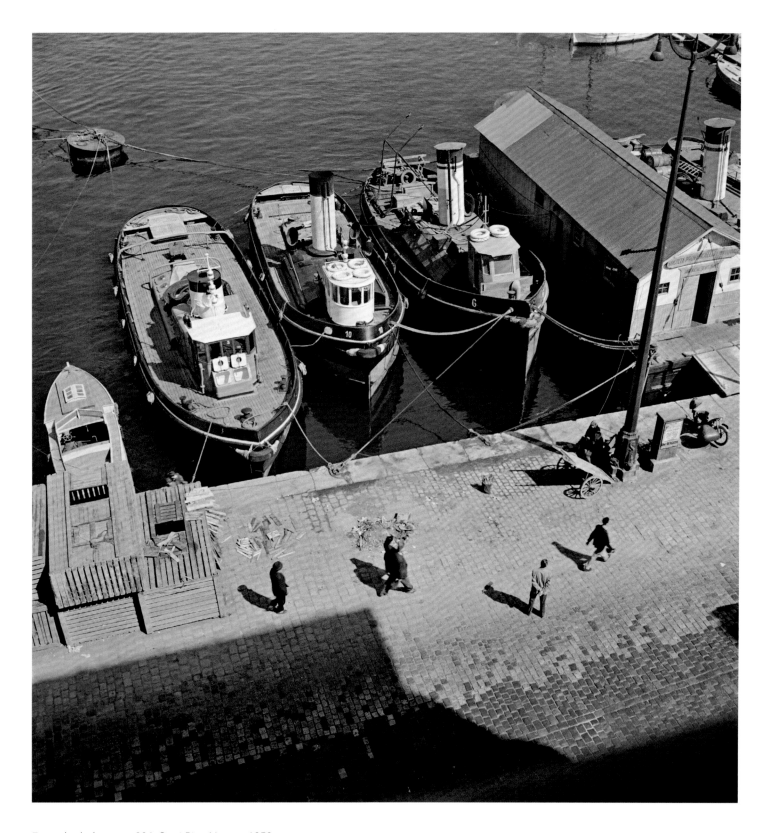

From the balcony at 28A Quai Rive Neuve, 1953

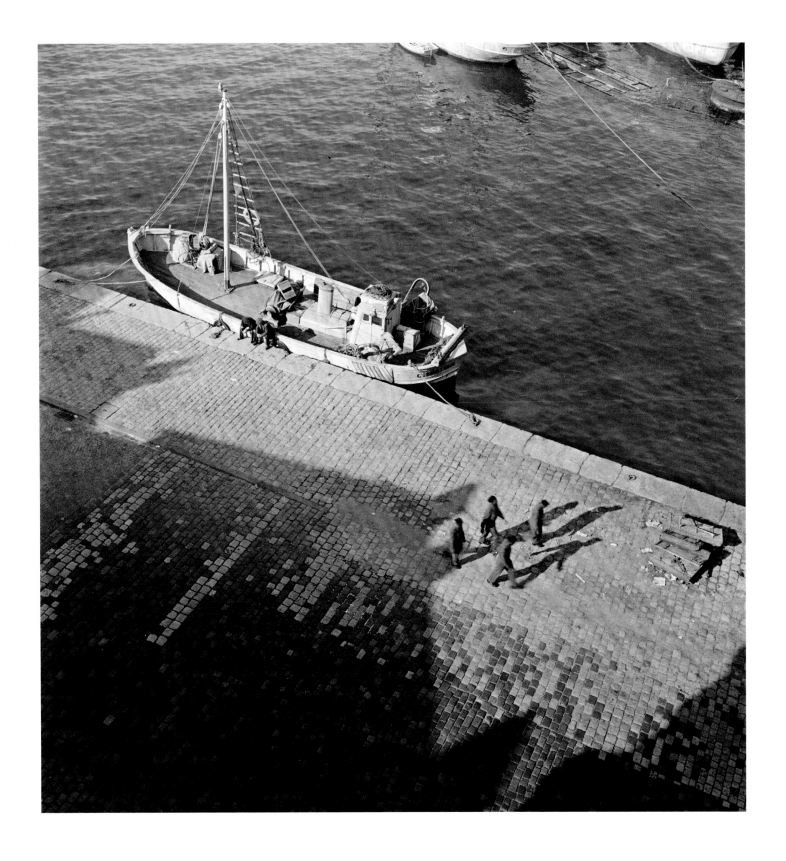

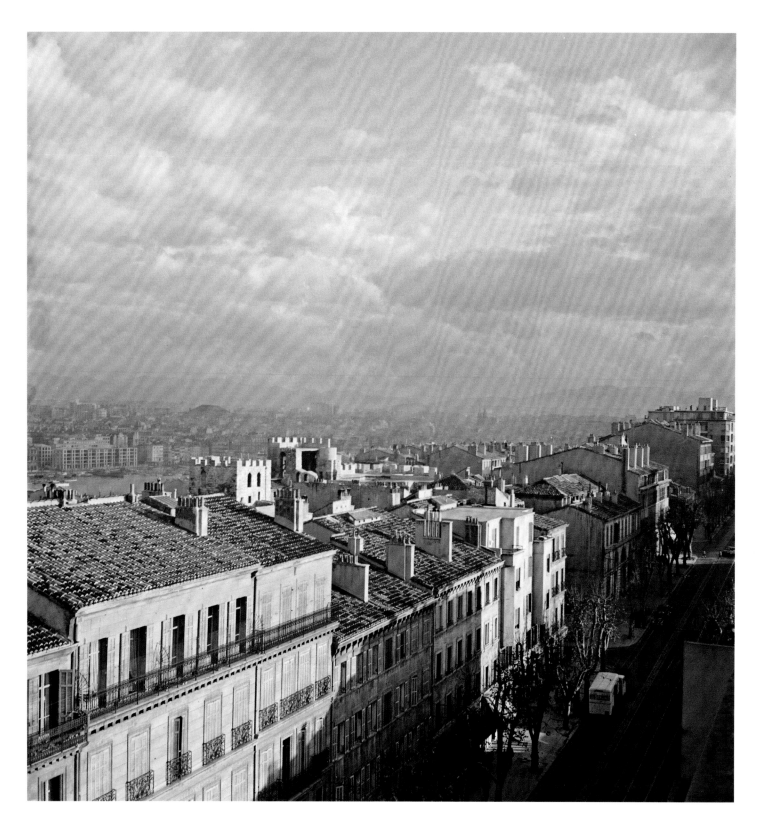

Marseille from the apartment on Boulevard de la Corderie, 1953

Marseille, 1953

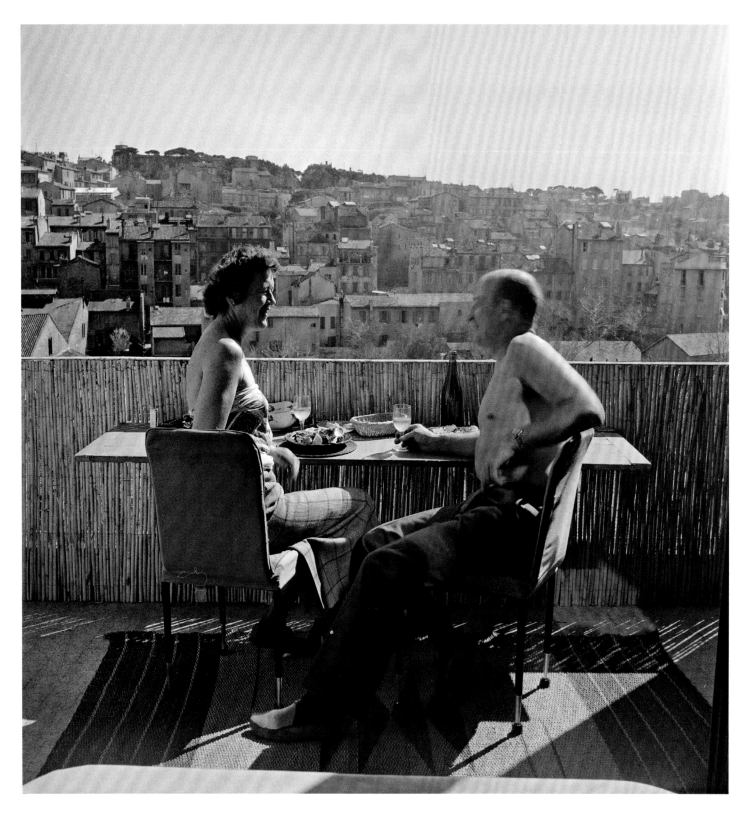

Julia and Paul lunching on the balcony, 113 Boulevard de la Corderie, 1954

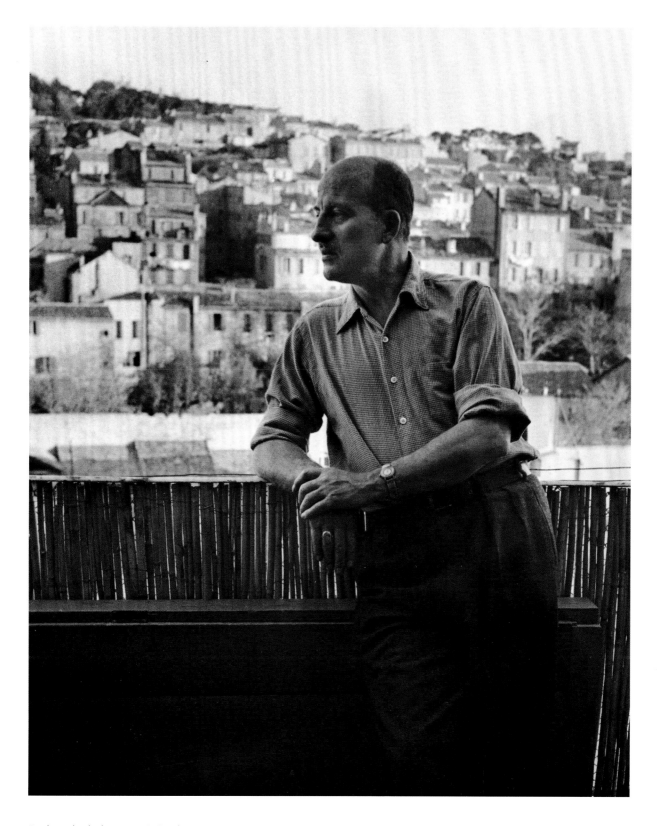

Paul on the balcony, 113 Corderie, 1954

Pouring tea, 113 Corderie, 1954

"Julia, view from Marseille apartment, the Old Port," 1953

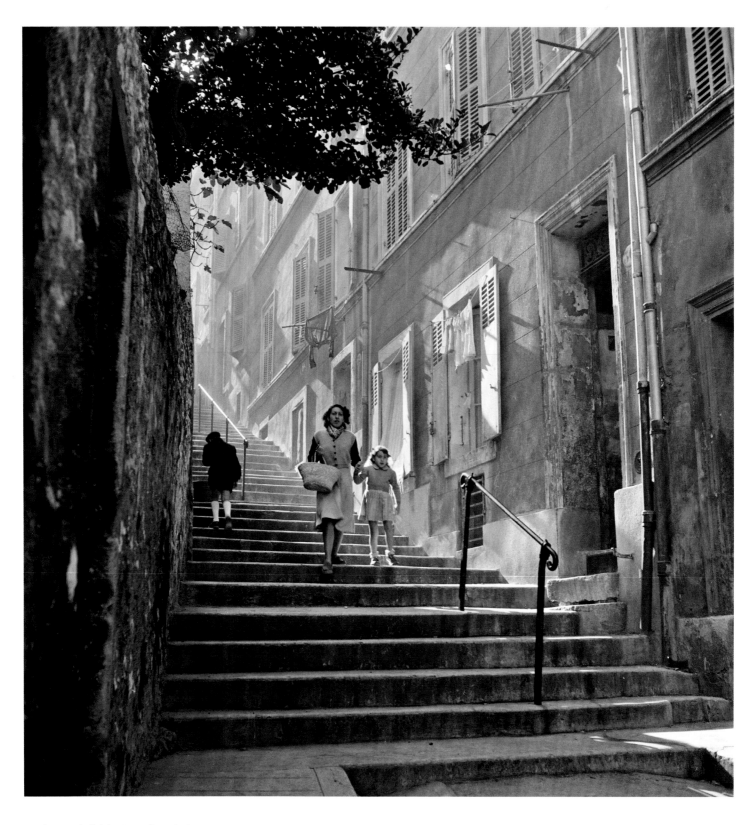

Mother and child, Marseille, 1953

Salon Léo, 1954

Julia, Cassis, 1950

Julia, chez Manell, Marseille, 1950

Paul at the chapelle Notre-Dame-de-la-Compassion, Gassin, 1953

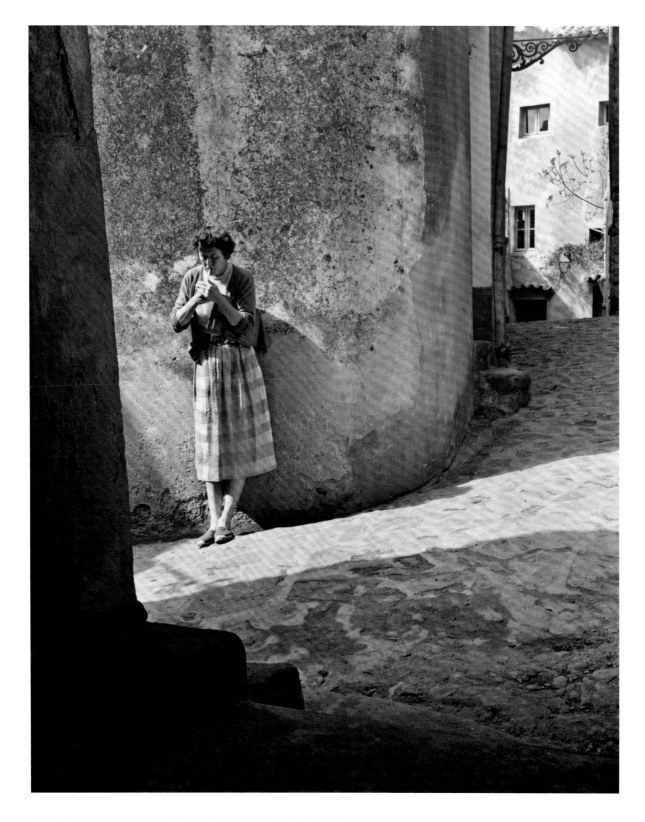

"Julia lighting cigarette outside against wall, Marseille," 1953

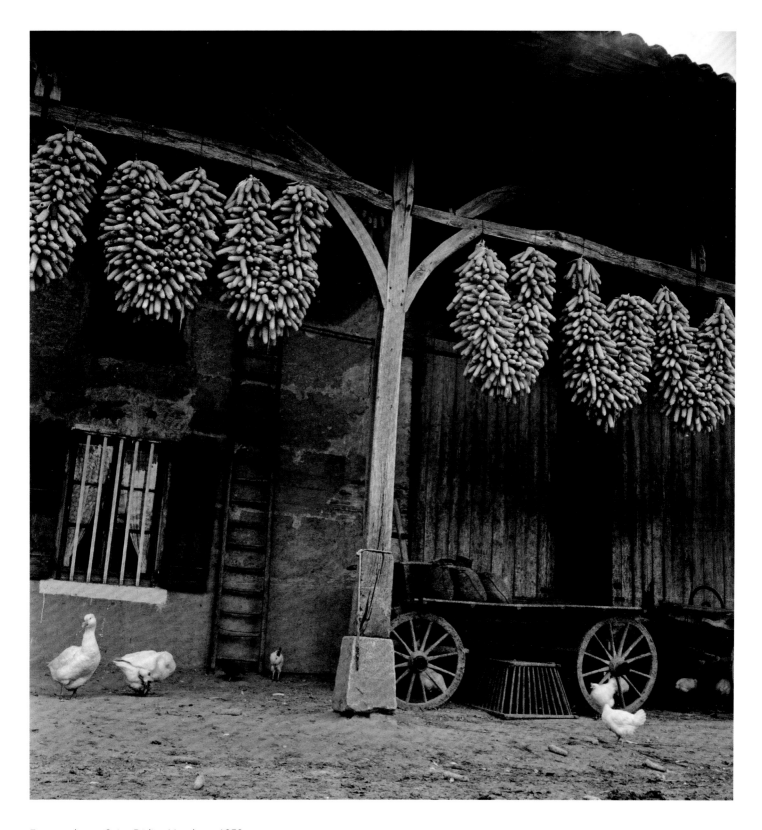

Farmyard near Saint-Didier, Vaucluse, 1953

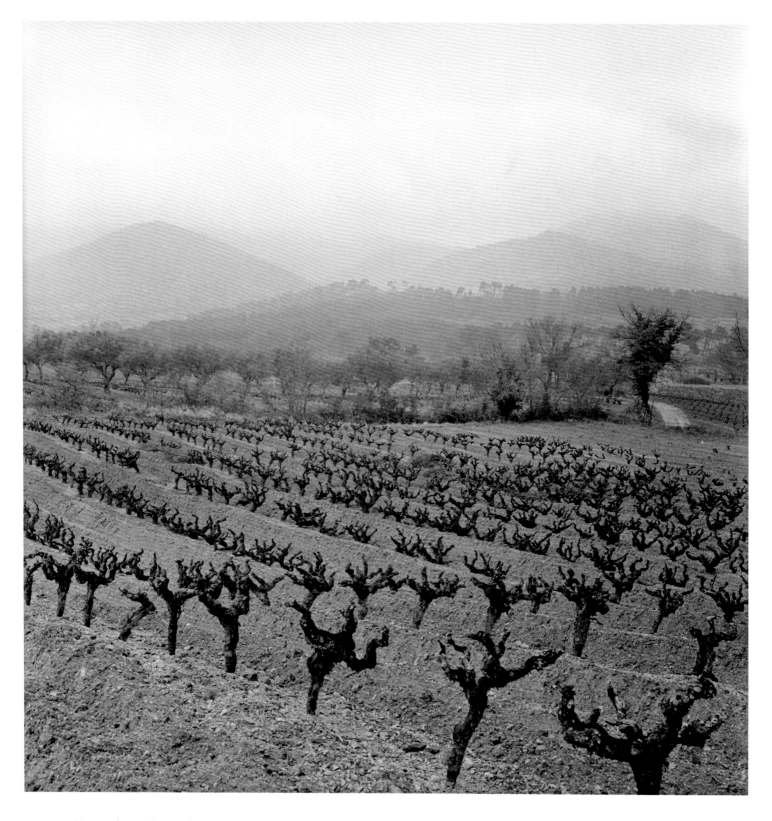

Vineyard near Grimaud, 1953

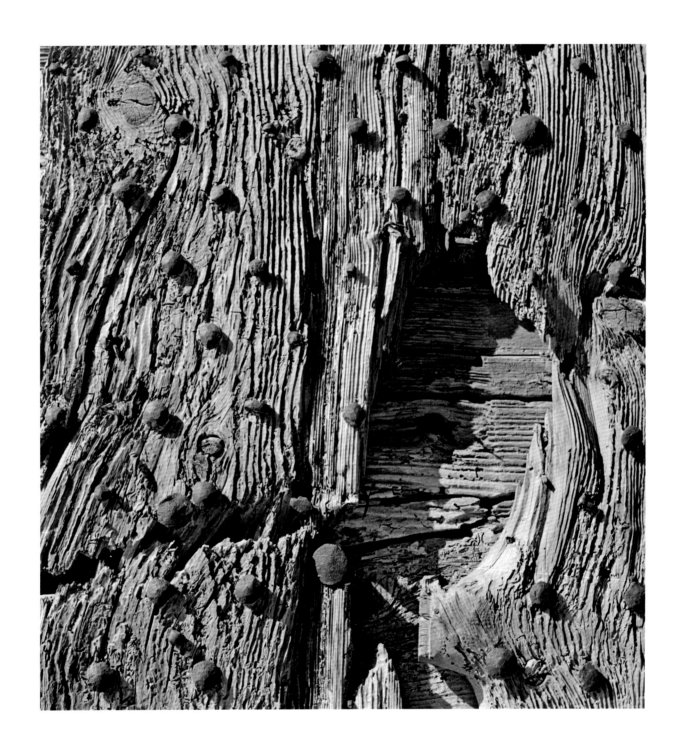

Old door, 1953

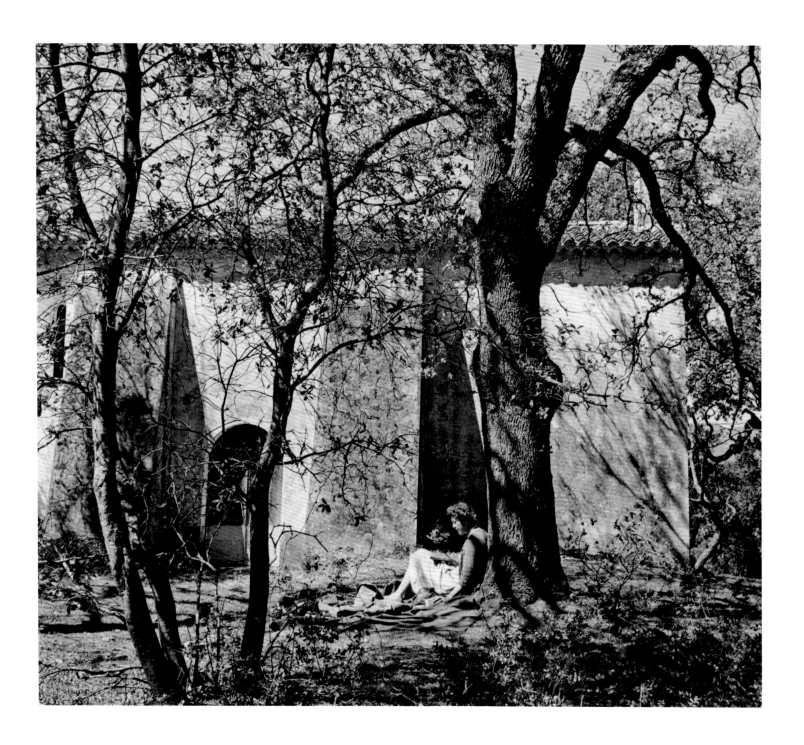

Julia at the chapelle Notre-Dame-de-la-Compassion, Gassin, 1953

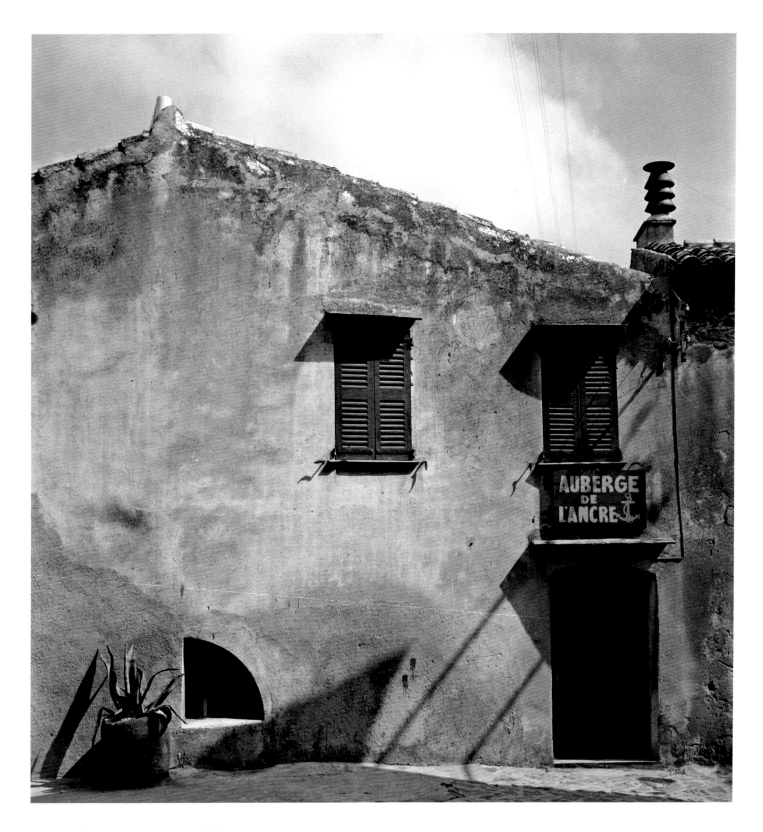

Auberge de l'Ancre, Saint-Tropez, 1953

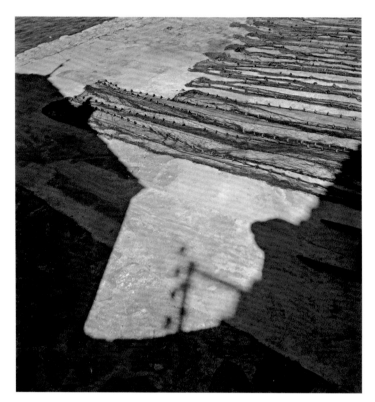 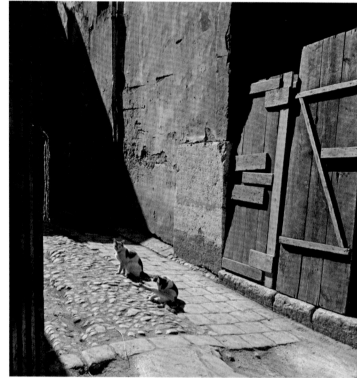

FROM LEFT TO RIGHT: Nets drying, Gassin, near Saint-Tropez, 1953; Cats, Marseille, 1953

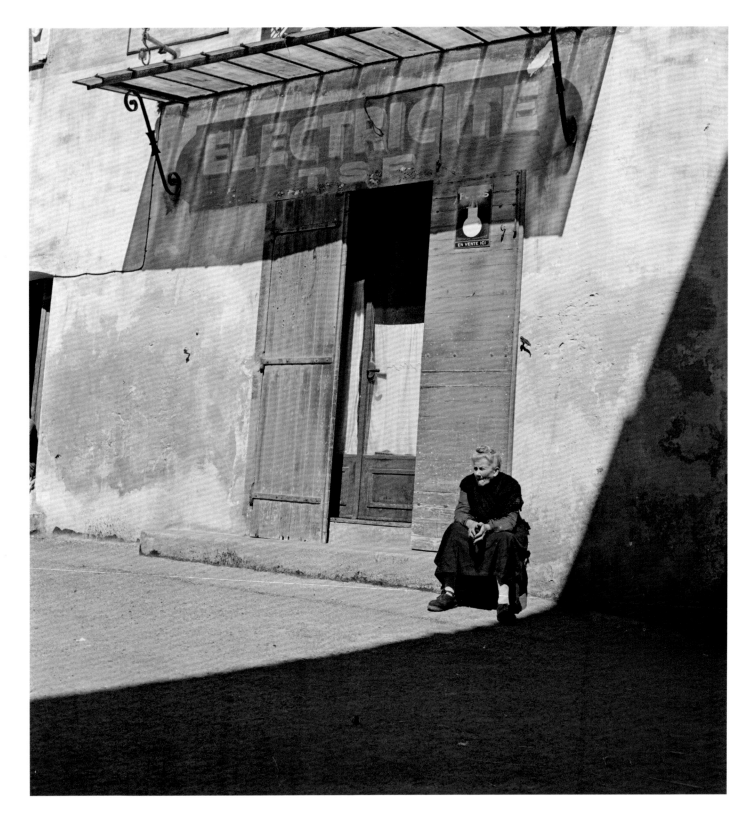

Gassin, 1953

Aigues-Mortes, 1949

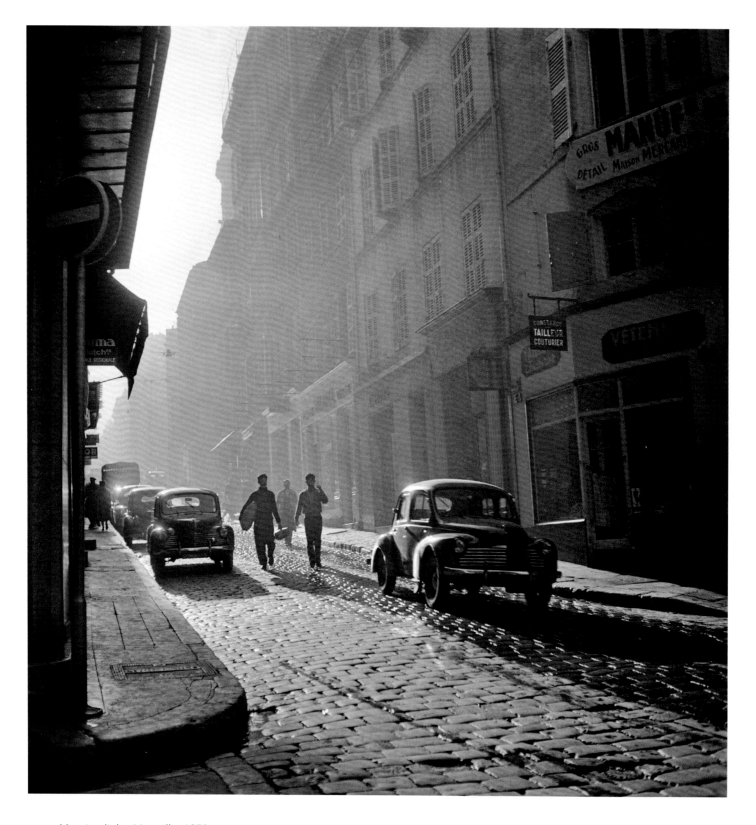

Morning light, Marseille, 1953

Three photographers, Les Baux-de-Provence, 1953

"Kids climbing Bldg, French Countryside," near Marseille, 1954

Behind the Shutter

PAUL CHILD

As mentioned at the outset, Paul educated himself about photography, practiced it almost daily for much of his adult life, thought and wrote about it, and constantly refined his attitudes and vision. In the August 1963 edition of the *Foreign Service Journal*, he pulled his thoughts together into a succinct artist's statement, entitled "Behind the Shutter," reprinted here:

The eye, the heart and the mind are what make photography—rather than the camera—just as the eye, the heart and the mind make music, painting and literature. What is a violin, a tubeful of paint, or even a pen in the hand, but an extension of the drives of some human being? Any apparatus, be it brush or handsaw, weapon or word, is nothing by itself. Each is a means to some end.

Photography is subjective expression, a reflection of the interests—but also the limitations—of the man behind the camera. If he is a professional then his photographs are influenced by the desires, the imagination, the concepts—and again the limitations—of whoever hires him. Photographers are always crystallizations of the human spirit.

The difference between amateur and professional photography is great. It lies in two realms: technique and outlook. The technical requirements of photography, although demanding, are no more complicated than those required to master a musical instrument, but neither a musical nor a photographic instrument can be mastered between breakfast and dinner. The ease with which photographs can be taken, plus critical evaluation of the results, leads to a difference in attitude between what is required to take photographs and what is required to play music. Anyone

Contact strips with images of the Abbaye de Jumièges, Normandy, 1951

can point the box, push the button, and get results, just as anyone can make sounds with a musical instrument, and run-of-the-mill snapshots are equivalent to tunes picked out on the piano with the index-finger; yet, while almost everyone is satisfied with snapshots, few are satisfied with an index finger sonata. It is unfortunate that so many are pleased with so little. Most people know that it requires long and serious practice to master the piano, but mastery of the camera can also take long and serious practice, and the best photographers have subjected themselves to it.

There are no secrets about photography, any more than there are about music or writing. The only hidden areas lie in the human being behind the camera. Too often beginners hope for a shortcut which will save them from practice. There is none. It is hard work which leads to skill. Isaac Stern, in speaking about Pablo Casals, said, "Casals is stubbornly disciplined. He has worked painstakingly through the most minute details of technique and conception . . . and it is because he has done so that in the end the details become less important than the grand design. His is a discipline in the service of liberation." Once Robert Moses was invited to West Point to address a group of future officers on matters concerned with administration and management. In his speech he made a plea to his audience that they learn to be clear and precise in their writing. In it he made the following statement: "A lady publisher complained recently that the slump in her business was due to the fact that everybody writes and nobody reads. There is, to be sure, a superstition that everybody has a story in him which, told with uninhibited sincerity and candor, will wow the world. This is sheer nonsense. The Eugene O'Neills, Scott Fitzgeralds, and Hemingways did not write easily. Theirs was a combination of talent, grinding hard work, infinite patience, triumph over discouragement and, finally, good luck."

There are three requirements for producing good photographs. The first is learning what can be done with a camera. The second is learning what can be done in the darkroom. The third is forming an eye-mind-emotion-memory-creativity nexus which uses the skills mastered in the first two categories to achieve the results one wants.

Practice discloses what can be produced with various developers, light meters and lenses; with reflex, miniature, and view cameras; with glossy prints and bromoil prints, with flash and available light, with color or black and white. Such things are part of the knowledge one must accumulate in learning to become a photographer. One also learns that no camera will do everything; that just as ultra-high-speed demons and micro-photo fiends are worlds apart subjectively, so their physical equipment will reflect their differences in outlook; that a passionate portraitist will not use the same camera as the recorder of sporting events, and that the astronomer's camera will be useless to all others.

No one can claim to be a complete photographer without darkroom experience, otherwise some unknown person will have to perform critical steps in the total process of making the print. It would be as though when one played the piano someone else always had to play the bass. The camera is the treble, the darkroom the bass, of photographic music.

Apart from the camera and the darkroom the third and most important category in photography is personal style. Photographs by Cecil Barton, Henri Cartier-Bresson, and Karsh have as clear a signature as Braque or Van Gogh do in painting. In this third category comes the series of visual relationships clustered under the heading "composition." These include balance, rhythmic repeats, architectonic structure, textures, pattern, the psychological effect of dark and light areas, of diagonal stresses, of soft versus critical focus, of realistic reporting versus abstraction, and so on. This is the personal, subjective realm. The bass and treble are only means to an end, as they are in music, the variations and combinations of the three elements are infinite in number, and it is their disciplined use which enables one to be self-expressive and to communicate with one's fellow man through photography.

In the Country

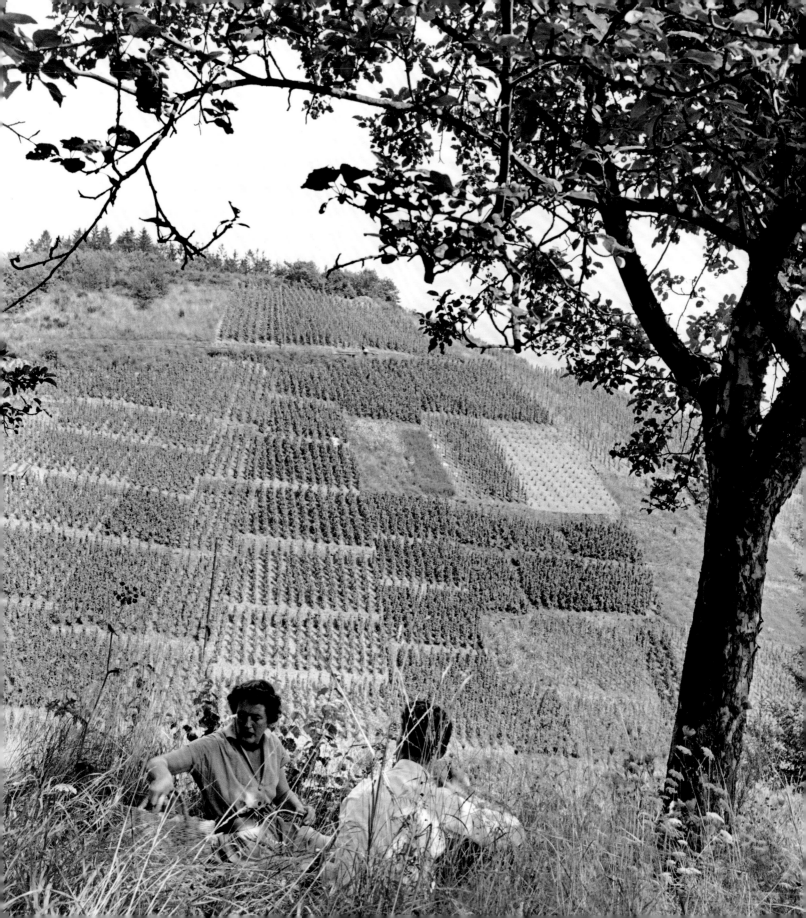

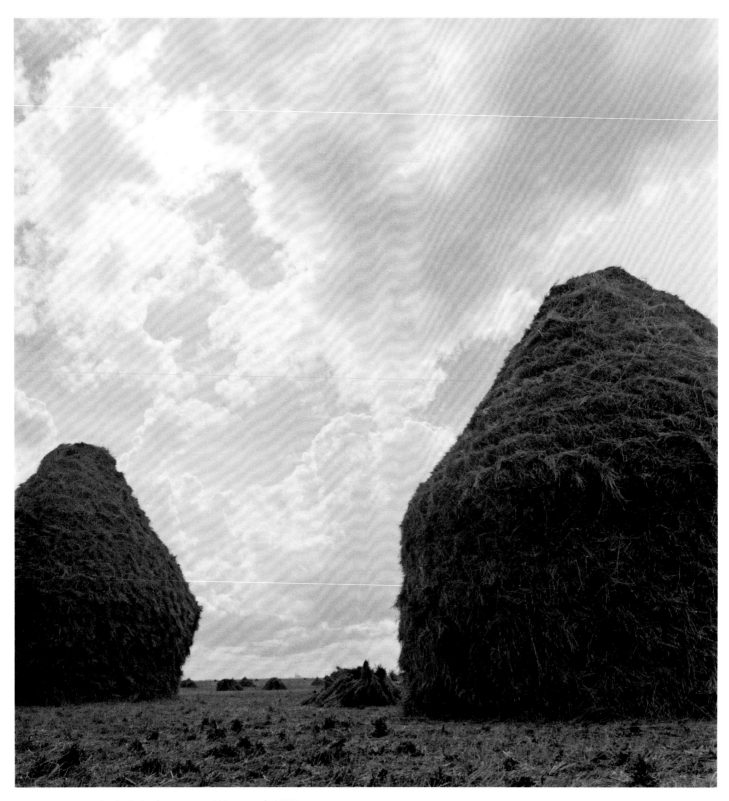

PREVIOUS PAGE: A picnic in the country, Wuppertal, 1955
Grain stacks, Chartres Cathedral on the horizon, 1951

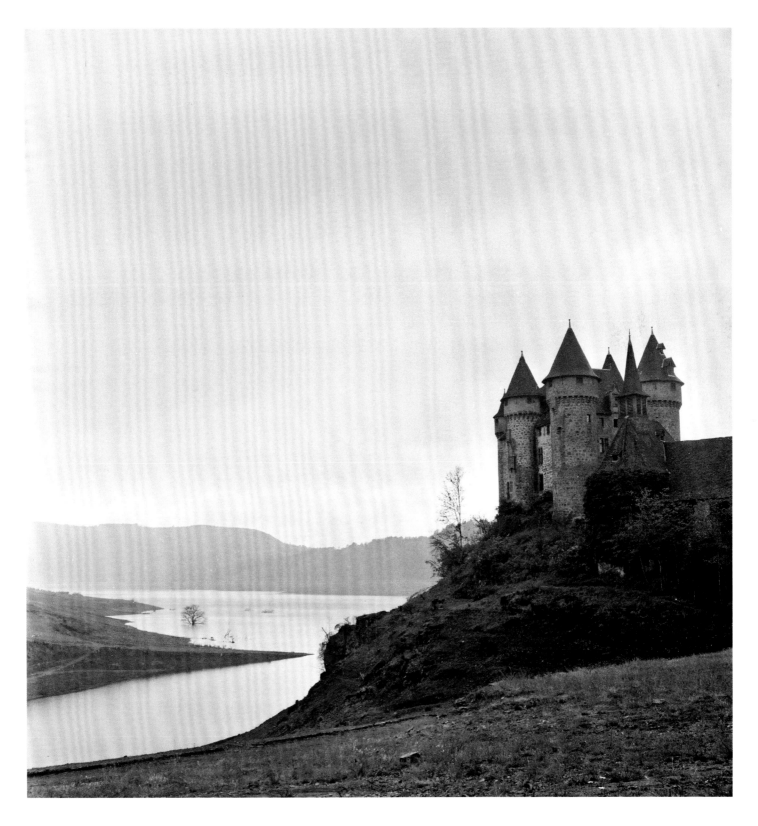

Château de Val, Lanobre, 1951

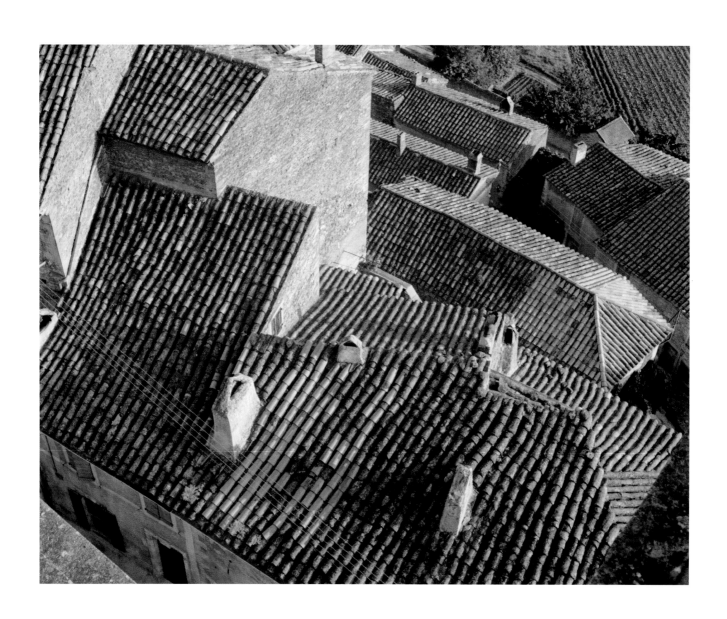

Grignon, Côte-d'Or, 1949

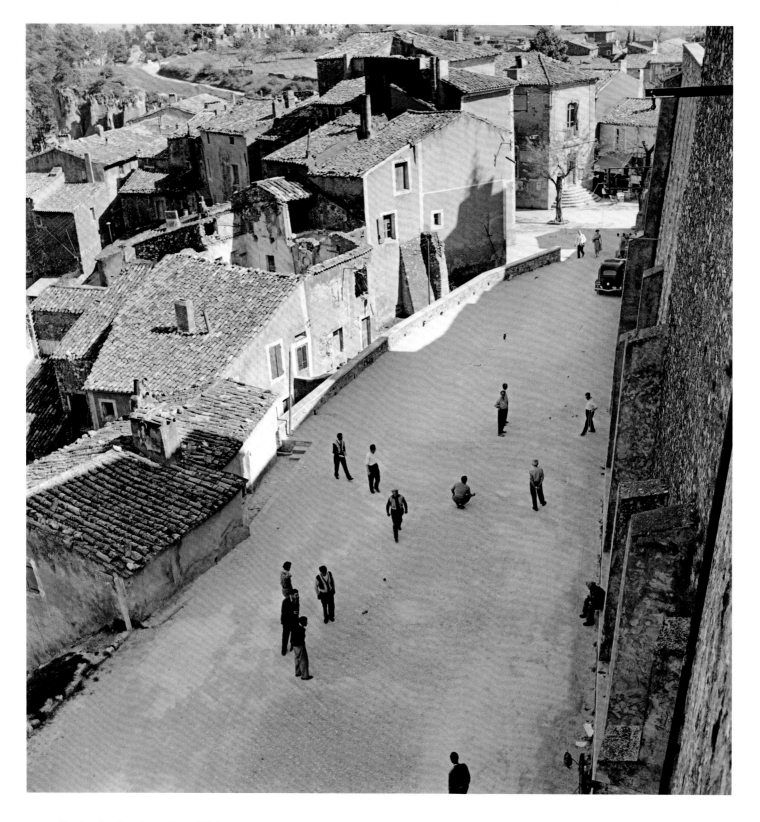

Playing boules, Roussillon, 1954

Château de Sully-sur-Loire, 1950

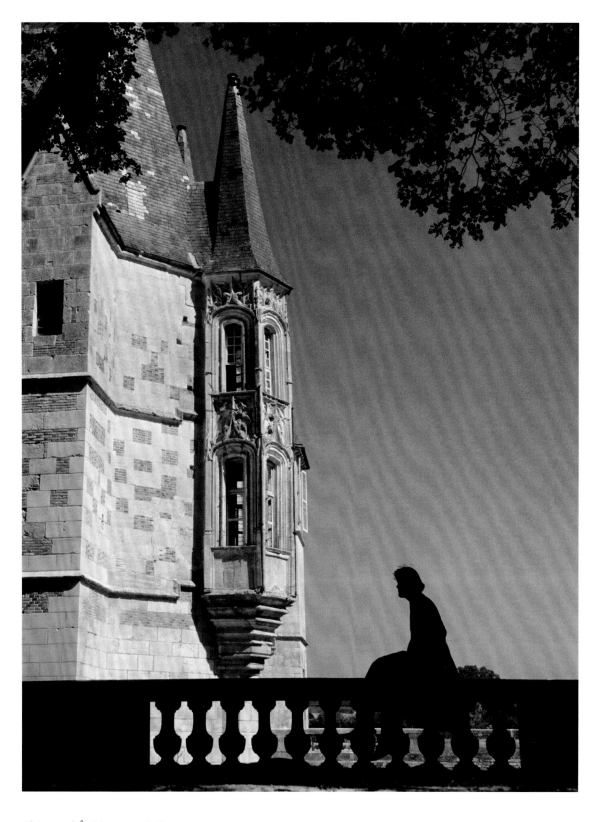

Château d'Ô, Mortrée, 1949

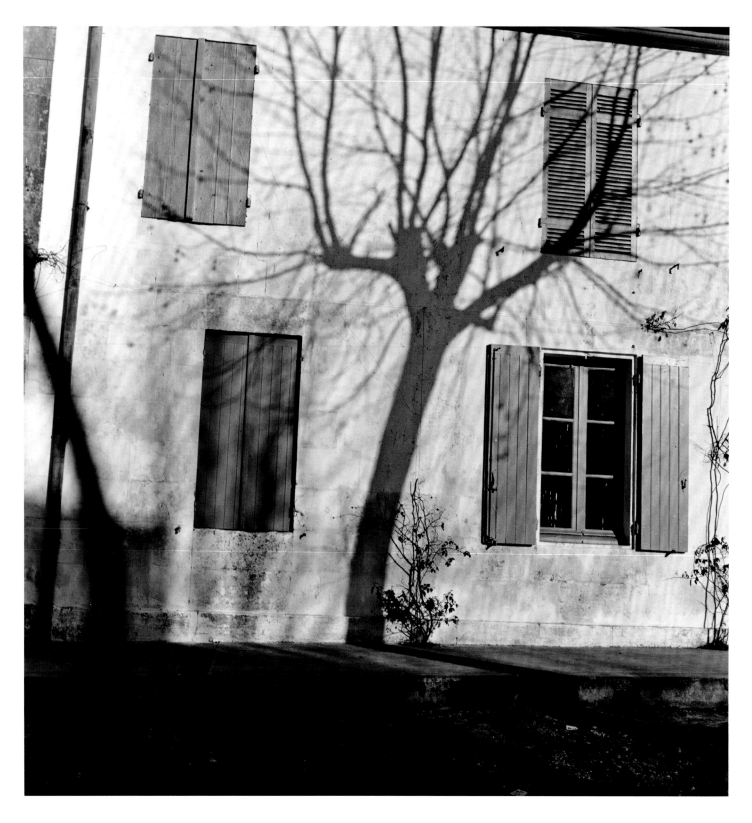

Saint-Genis-Pouilly, 1952

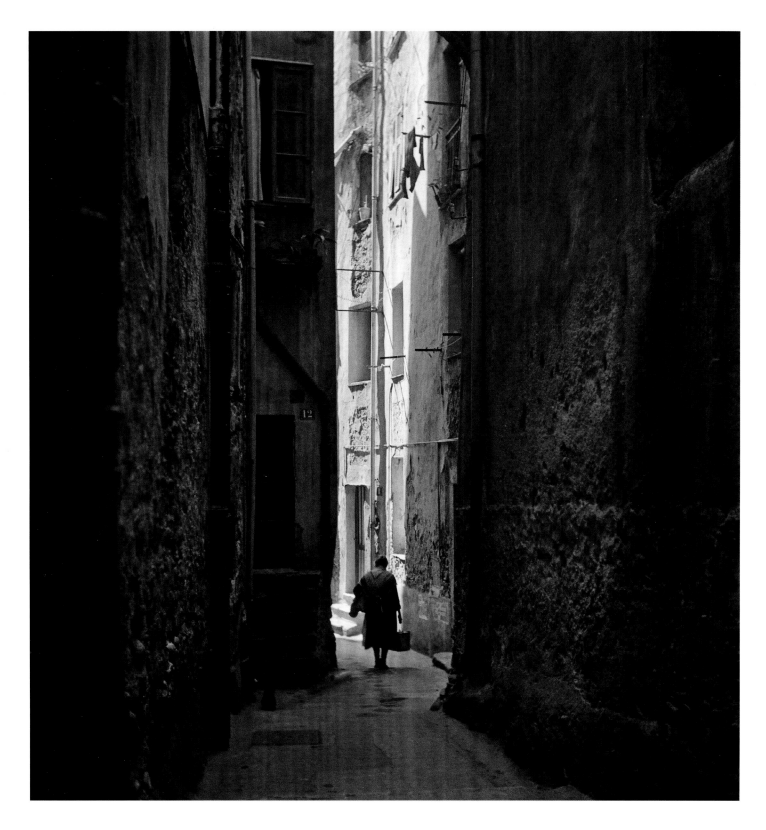

Menton, 1954

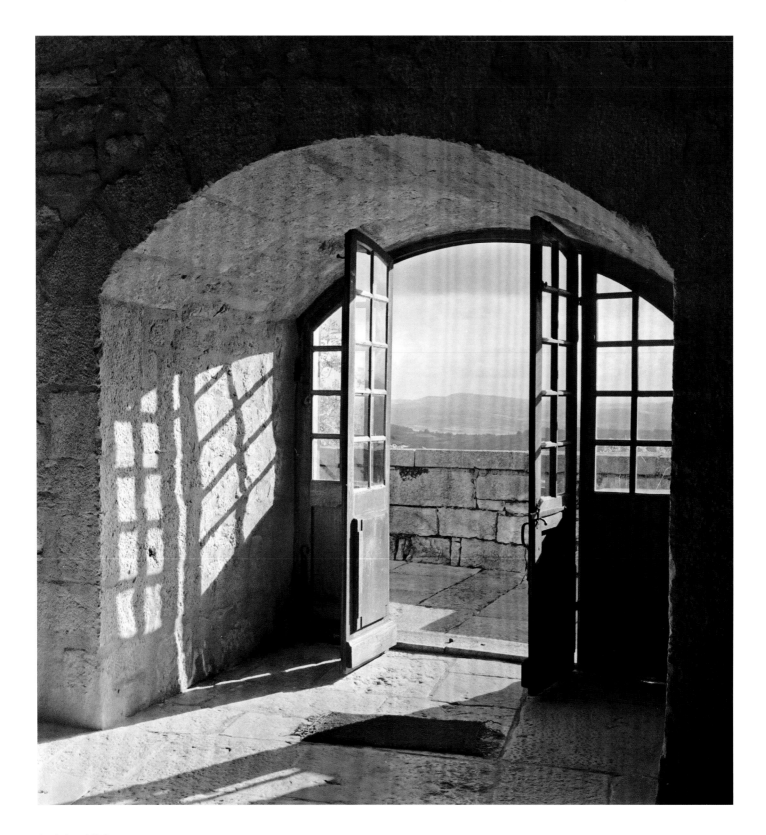

Andelot, 1952

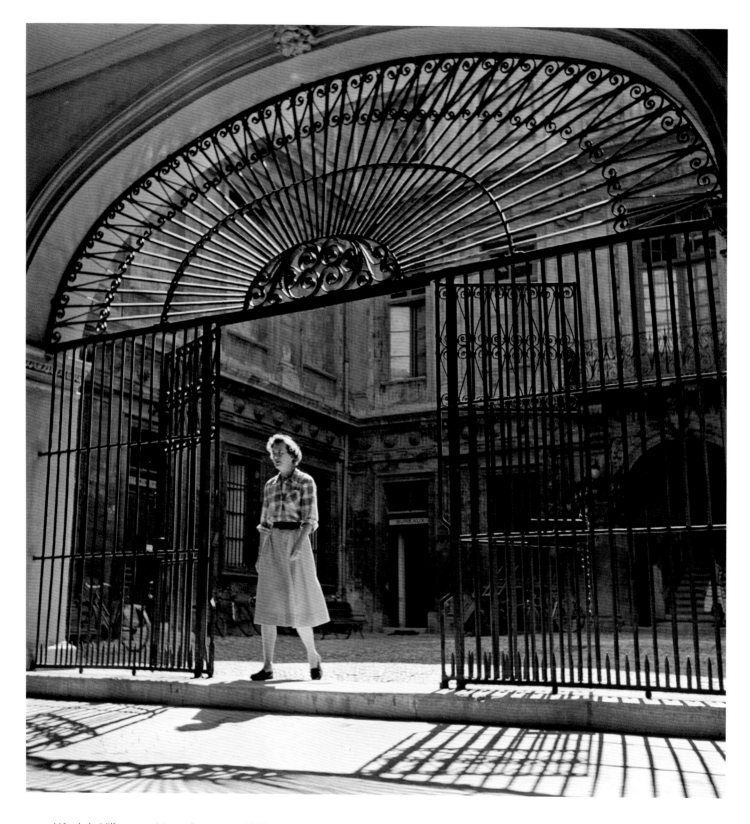

Hôtel de Ville gate, Aix-en-Provence, 1950

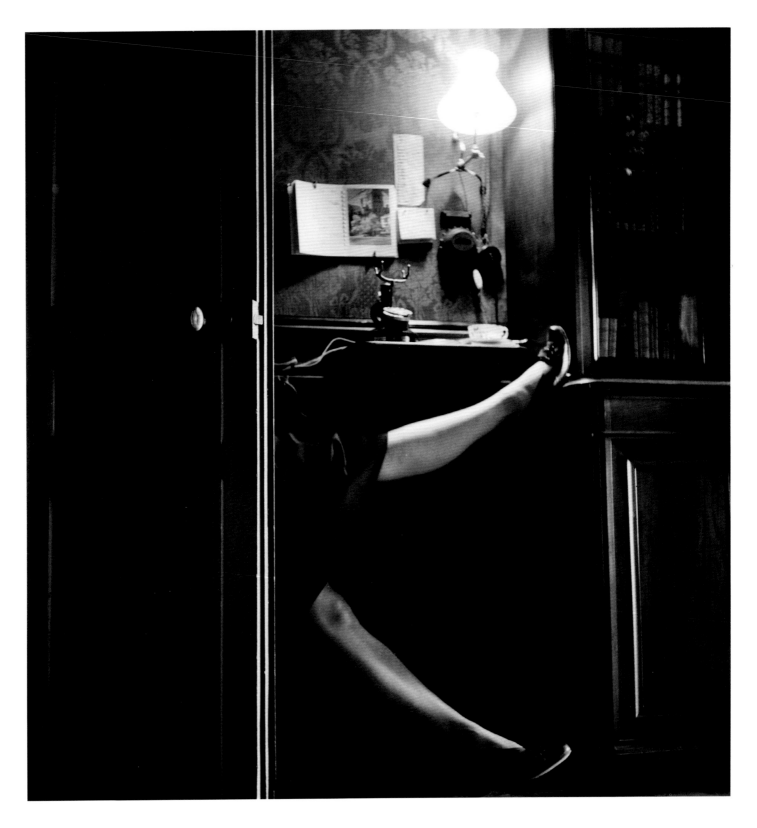

Julia on the telephone, Aubazine, 1952

Hotel room window, Aubazine, 1952

Julia studying maps, Hamburg, 1955

Paul on the terrace, Sancerre, 1951

 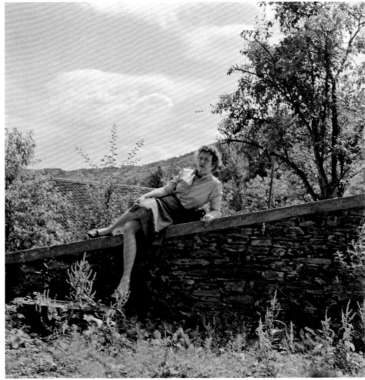

FROM LEFT TO RIGHT: Julia writing a letter, Aubazine, 1952; Julia, Moselle, 1955

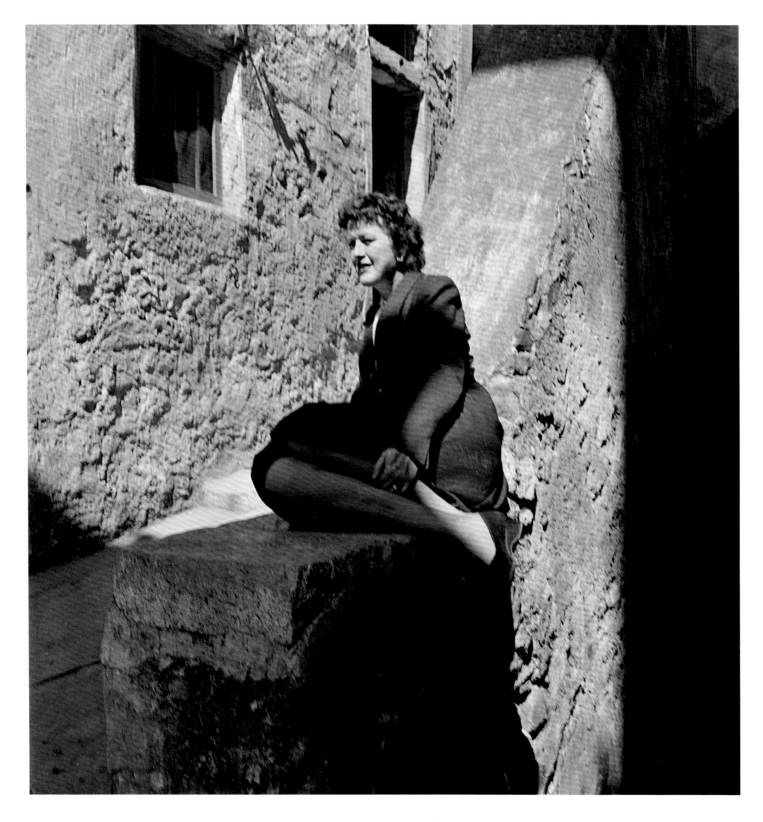

Julia, Menton, 1954

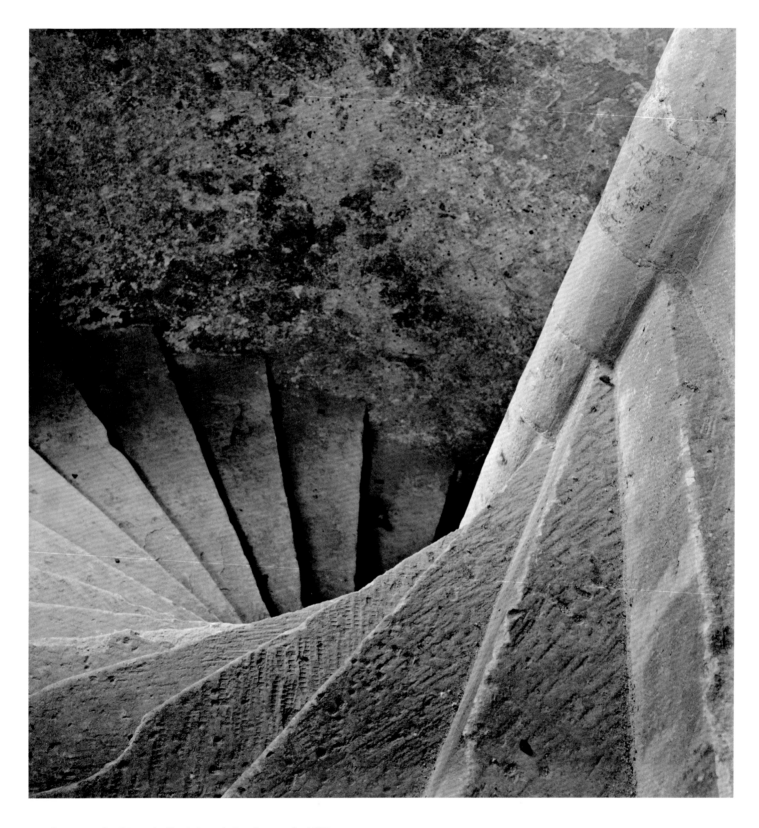

Winding stair, the Priory, la Charité-sur-Loire, Burgundy, 1951

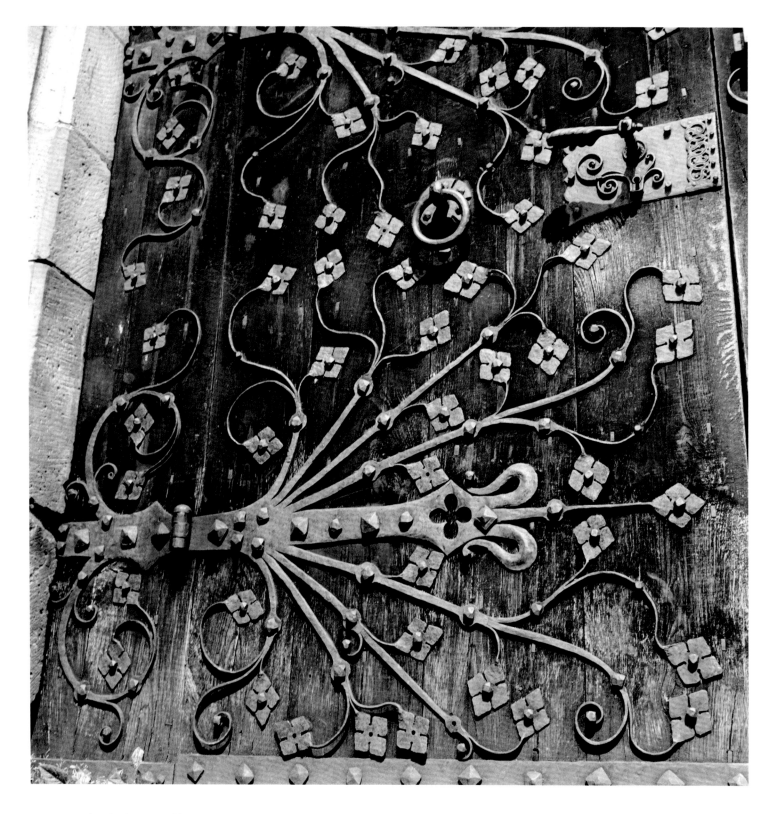

Church door, Hirschhorn, Neckar Valley, Germany, 1955

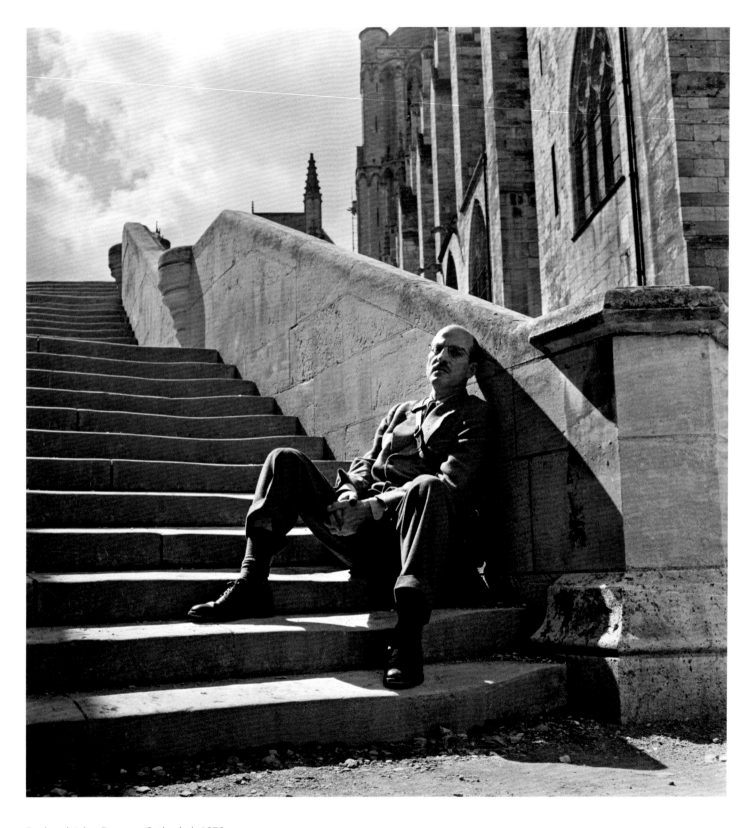

Paul and Julia, Bourges Cathedral, 1950

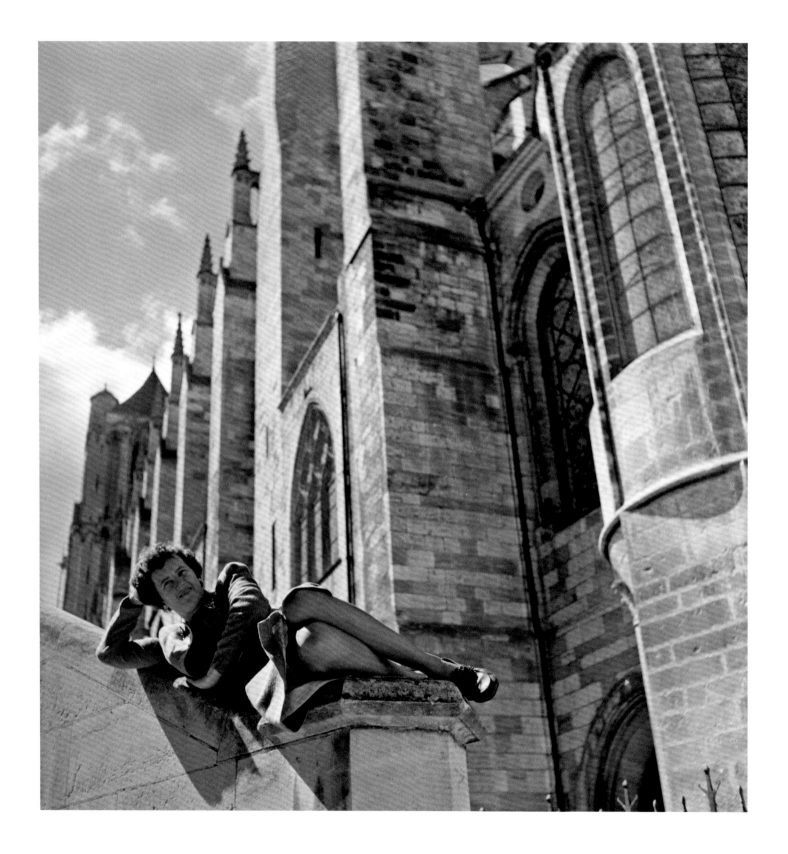

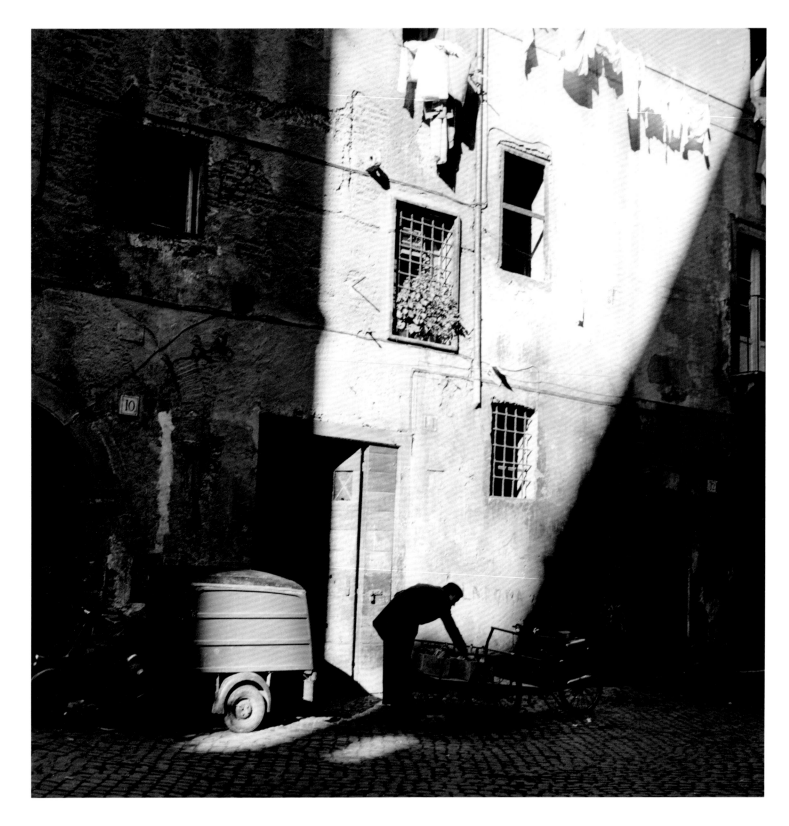

Street scene, 1950s

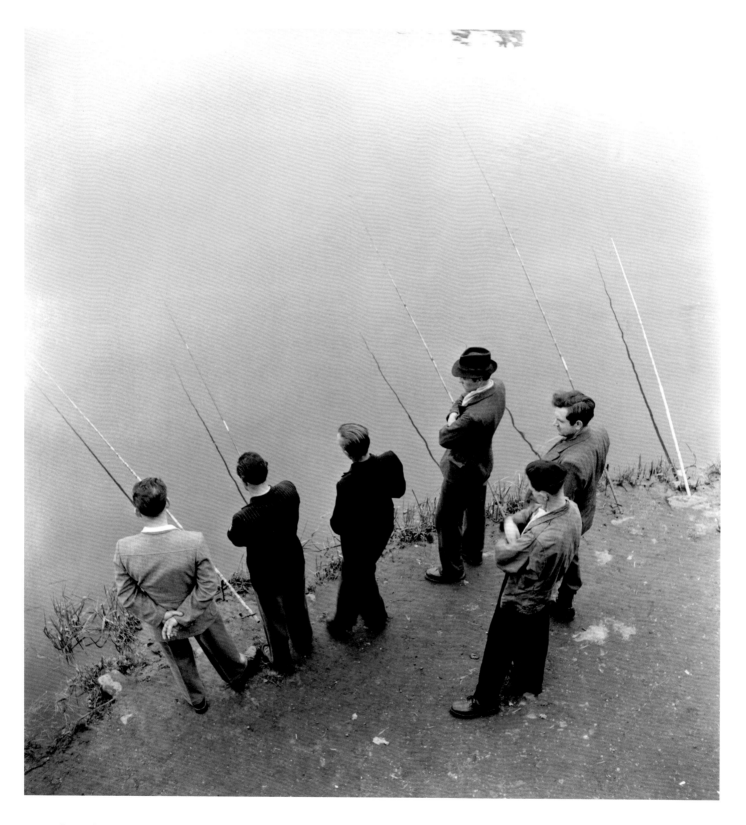

Fishing along a canal, Alsace, 1952

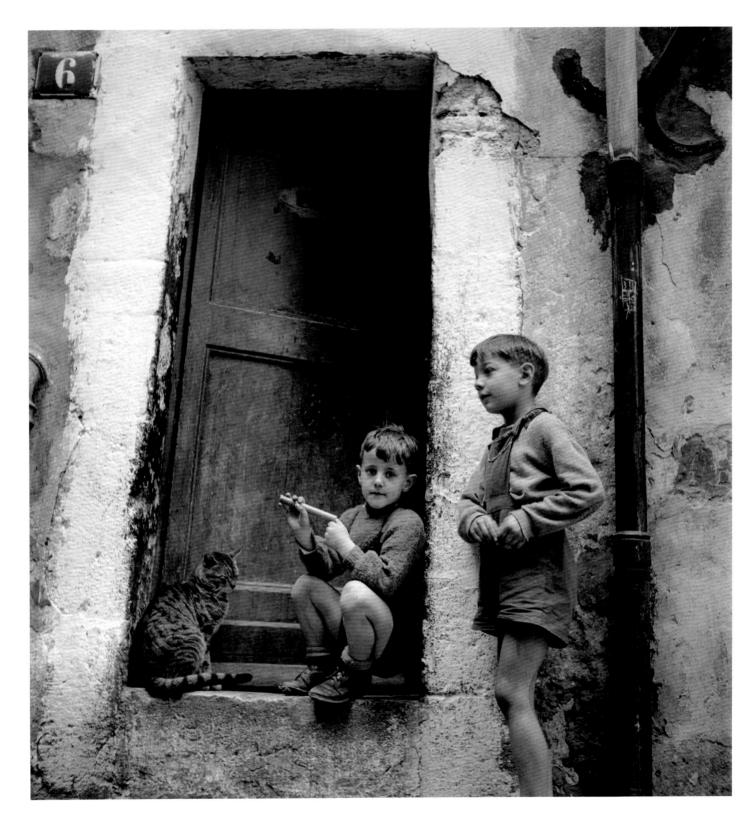

In a doorway, Menton, 1954

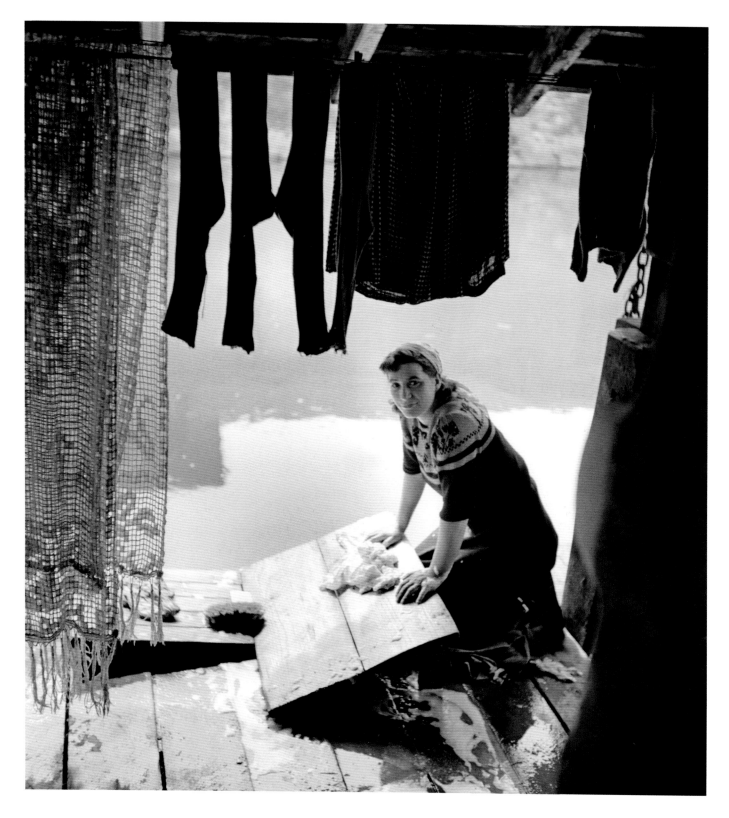

Woman washing, Strasbourg, 1952

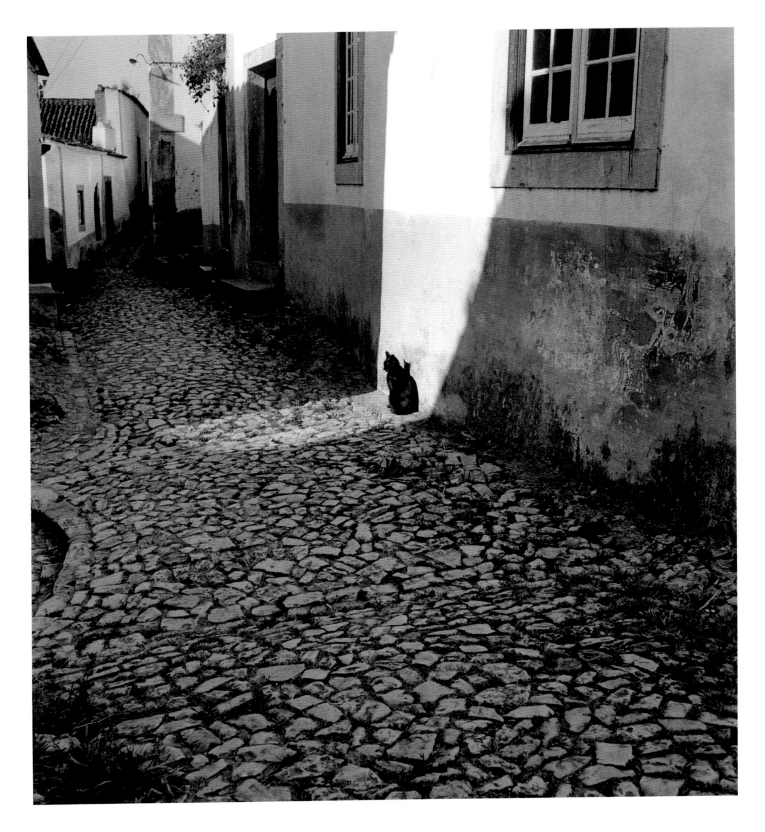

A cat in the sunlight, Óbidos, Portugal, 1953

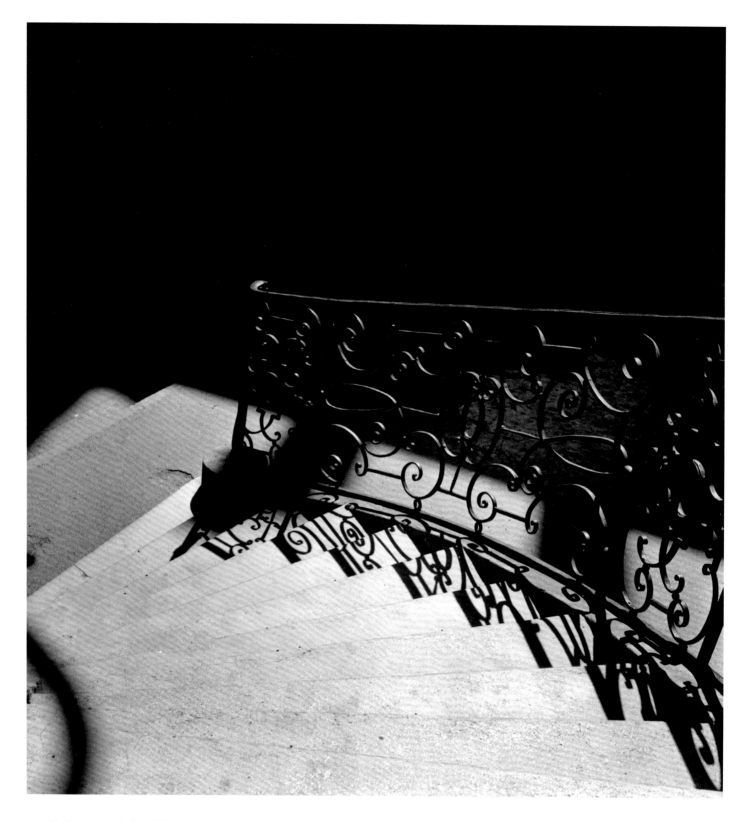

Staircase, Lunéville, 1952

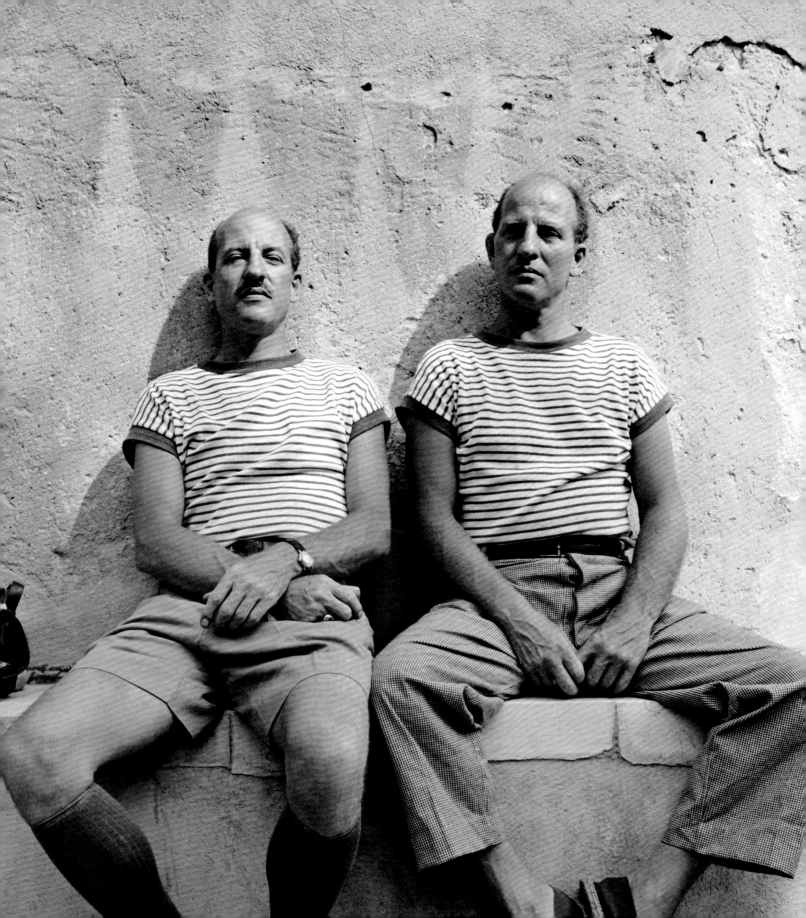

A Curry of a Life

TWINNIES

Paul Cushing Child and his fraternal twin, Charles Jesse Child, were born on January 15, 1902, in Montclair, New Jersey. Their father, Charles Triplet Child, was an accomplished electrical engineer, an editor of technical reviews, and the director of the US Astrophysical Observatory, a research center run by the Smithsonian Institution in Cambridge, Massachusetts. The boys' mother, Bertha May Cushing Child, was descended from one of Boston's grand old families, the Cushings. She was a vivacious woman with long, honey-blond hair, a splendid voice, and an interest in theosophy. She was, Paul wrote, "an ardent student of both art and music all during the years before her marriage, but had never considered using her skills professionally until my father's death, when it suddenly became necessary."

In May 1902, when the twins were just four months old, C. T. Child contracted malaria and typhoid fever, and died at age thirty-five. Paul would always regret not knowing his father, who was said to be a brilliant and level-headed man. Though Paul rarely spoke of his father, it is clear in retrospect that his death was a defining and perhaps destabilizing moment in Paul's life. Years later, he lamented to Charlie, "I keep wishing our father had lived. He was a scientific man and sure as Hell would never have let Mother get caught up by all those weirdos."

Suddenly a widow of modest means, Bertha Child moved her children—Paul, Charlie, and their sister Mary (two years older than her brothers; she was called Meeda)—from their comfortable suburb in New Jersey to the less expensive suburbs

Paul and Charles Child, Cassis, 1950

of Boston, near her family. They settled first in Newton Lower Falls, then moved to Brookline. The Child house was full of music and books, and the boys were talented draftsmen who taught themselves rudimentary carpentry. Bertha raised her children to believe, as Julia Child would later put it, that "artists are sacred."

Though it is likely that she received modest support from her family, Bertha was compelled to find work, which was no mean feat for an upper-middle-class woman who had been taken care of her entire life. Bertha had no professional skills, experience, or contacts. But she was resourceful, and she used her vocal training to build a career as a singer.

Performing as "Mrs. Child and the Children," Bertha sang private concerts at people's homes accompanied by Paul on violin, Charlie on the cello, and Meeda on piano. It was a genteel way to survive, but the twins hated it, especially when forced to wear starched white shirts, ties, and gray suits. One afternoon on the way back from a recital, Paul and Charlie were set upon by a gang of toughs on Boston Common. The twins had learned judo from the Japanese butler of a family friend, and defended themselves "like two berserk Samurai," Charlie recalled. "Twang! Went the fiddle on someone's skull . . . Whomp! Went the cello . . . we charged into the howling enemy." The Child boys triumphed in battle, but their bloody noses, torn clothes, and broken instruments marked the end of their musical performing days.

As this story indicates, Paul and Charlie were physical and high-spirited, constantly egging each other on in running, wrestling, and climbing competitions. Their boisterous exuberance apparently overwhelmed their mother at times, and she occasionally lodged the twins with relatives, or simply left them to their own devices.

Paul and Charlie referred to themselves as "the twinnies," developed their own vocabulary, including nicknames for each other, and other terms—a book was a "bokus"—and entertained each other with games. While playing "sewing," at age seven, Charlie accidentally blinded Paul's left eye by piercing it with a needle. The accident hurt Paul's depth perception and made it difficult for him to play baseball. But Paul was stoic and never complained about his blindness. As an adult, he was a capable (and very careful) driver, and compensated for his impairment so adroitly that he was able to paint, teach perspective drawing, and earn a black belt in judo.

In Boston, Bertha was courted by various powerful men—allegedly including Edward Filene, founder of the eponymous department store—and was increasingly distracted. From the ages of ten to twelve, the twins were sent to board at

Paul on the crew of the schooner *Chisholm*, 1934; from the mast of the *Chisholm*, 1935

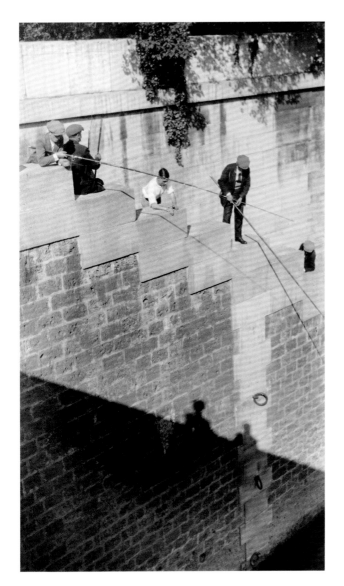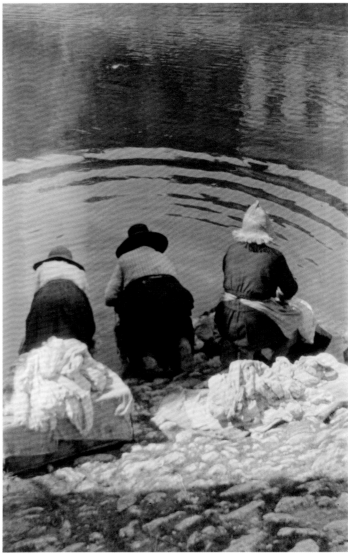

Seine fishermen, 1926; Washer women, Brantôme, 1926

St. Joseph's Academy, in Wellesley, where, Paul said, they were beaten by "sadistic" nuns. Thereafter, Paul maintained an abiding hatred of nuns and a deep mistrust of organized religion, and most orthodox thinking in general.

As teenagers, the boys lived at home, sang in church choirs, and attended the Boston Latin School. In 1917, when America entered the First World War and the Child twins were fifteen, Paul and Charlie were put to work hauling parts for artillery shells in a munitions factory. The boys were bright. Charlie attended Harvard for at least two years (or perhaps longer: the record is unclear), where his illustrations for the *Lampoon* were acclaimed in 1922, and his tuition was at least partially paid for by Mr. Filene, according to family legend. Paul attended Columbia University for a year, but when tuition money ran out, he was forced to take odd jobs. Paul had a curious mind and was a voracious reader, prolific writer, and rigorous autodidact. He picked up languages quickly, closely monitored geopolitical events of the day in newspapers, magazines, and on the radio, and enjoyed debates on politics, economics, and culture. He was adept at synthesizing complex ideas, interpreting them, and expressing his views about them clearly.

After leaving Columbia, Paul lived in an apartment on West Eighty-eighth Street in Manhattan, not far from the Hudson River. Spurred by a need for money and an instinct for adventure, he joined the crew of the training ship *Chisholm*, a three-masted schooner that plied the waters between Nova Scotia and Bermuda. One night, the ship was caught in a storm on the way south. Paul suffered from vertigo, but he willed himself to climb the rigging to the top of the mast while lightning crackled around him, the ship swayed through waves, and he was doused by sheets of rain. He hoped the experience would cure his fear of heights; instead, it only exacerbated his fear of them.

For his next adventure, Paul shipped aboard an oil tanker as a deckhand. The tanker sailed south along the East Coast, around Cuba, through the Panama Canal, then north past Mexico to California. The captain and crew were a difficult lot, and Paul was miserable. In Los Angeles he jumped ship, and through friends of friends found a small apartment on El Cerrito Place, in Hollywood. He stayed a few months and put his many skills to work, from painting backgrounds for movie sets, to ditchdigging, washing dishes in a restaurant, and displaying folding beds in a store window. Charlie joined Paul in Los Angeles, and they had a rollicking time as they hitchhiked back east together.

In 1925, when he was twenty-three, Paul found work at Little Tree Farm in Framingham, Massachusetts, not far from Boston, but he was at loose ends. Following his instinct and a chance opportunity, he embarked on his first career.

Though he never graduated from college, Paul was a natural student and teacher. He knew a good deal about drawing and painting, American literature, French language, fencing, and judo. In April he was offered an unusual job: to become a private tutor to the children of a wealthy American family living in Asolo, in the Veneto, north of Venice, Italy. He jumped at the chance. And he loved Italy and living in Europe. In October of that year, he quit his job and moved to Paris, which quickly became his "favorite city on earth."

Living cheaply in Paris, Paul became fluent in French, discovered a passion for wine, and found the joys of affordable French cuisine. He worked odd jobs, such as making stained-glass windows for the American Church (where his nickname was "Tarzan of the Apse"), and visited museums and art shows, learned woodworking, made etchings, and painted canvasses of street scenes and landscapes. It was a romantic, if somewhat threadbare, artistic existence. In September 1926, Paul took a new teaching job, this time at a boarding school in Neuvic sur l'Isle, in the Dordogne, in southwestern France. He spent two happy years there, but in the meantime Charlie and his wife Fredericka (known as "Freddie"), Bertha, and Meeda Child had all moved to Paris. Paul found himself inexorably drawn back to the City of Light.

By the fall of 1928, the American expatriate scene was in full swing in Paris, and the Childs mingled with other artists, including Ernest Hemingway and Gertrude Stein. Paul was becoming cultured and worldly, and he had an active romantic life, dating several French and American women.

Tiring of life on the margins, and in search of gainful employment, Paul returned to the States. In 1930 he resumed teaching, at the Shady Hill School, a progressive institution in Cambridge. One of his students there was Robert Woods Kennedy who had a divorced mother, Edith Kennedy, with whom Paul soon became involved. Paul had known Edith vaguely in Boston and in Paris. She was twenty years older than he, with a charismatic personality and sophisticated taste. She was a writer and painter, and a legendary conversationalist. Devoted to Mozart, she also embraced the modern music of composer Elliott Carter. Edith lived in Cambridge, and convened heady literary salons featuring some of Harvard's best-known professors, including Perry Miller, an intellectual historian, F. O. Matthiessen, a well-regarded literary critic, and Harry Levin, a comparative-literature scholar at Harvard. These were just the kinds of people Paul dreamed of rubbing shoulders with.

Paul fell deeply in love with Edith, who was known as "Slingsby." Her world seemed to represent a kind of intellectual utopia on a hill: a moneyed, worldly set

who valued knowledge and the arts; they lived the life he craved but had never been able to fully participate in. But it wasn't simply Edith's milieu. He loved the person, and found her a "flirtatious, witty, naughty, dynamic and intelligent woman," he wrote Charlie. She returned the favor and encouraged Paul's interest in food, wine, and art. They spent summer months in New Boston, an artistic community in New Hampshire, where his skill in painting and writing steadily improved.

Charlie in Asolo, 1925

Paul considered his relationship to Edith Kennedy "life affirming." Yet, having been burned once, she adamantly refused to remarry. This didn't bother Paul too much, and they lived together for a decade, which was considered socially unacceptable at the time.

They rented a house in Cambridge. The following year, in 1931, Paul accepted a new teaching job at Avon Old Farms, the prep school near Hartford, Connecticut. He spent a decade at Avon, teaching French, art, and judo, before he was swept off to a new life.

In the meantime, his mother, Bertha, contracted meningitis and died in Paris in 1933, at age sixty-one. According to family lore, Charlie had Bertha cremated and illicitly sprinkled her ashes in Pére Lachaise, Paris's famous cemetery, though that story may have been wishful thinking.

Paul and Charlie had fallen out of touch with Meeda. She was an attractive and fiercely intelligent, if capricious, woman. A talented writer, she contributed articles from Europe to *Vanity Fair* and *Town & Country*. But by the late 1930s, when she returned to Boston from Paris, she had been married three times, was drinking heavily, and was in poor health. One day, a friend invited Paul to dinner in Boston's Back Bay and "he noticed a rather frumpy, beat-up bleached-blond drinking a martini at the bar," Julia recalled. "She called out to him 'Hi, Paulie.'" With a shock, Paul recognized the woman as his sister. "He was fittingly horrified, and never saw her again," Julia said. At the outbreak of World War II Meeda returned to Europe, perhaps in search of journalistic work. She died in 1940, though the circumstances

are mysterious: one version holds that she disappeared in Nazi-held territory while on assignment for *Town & Country*; another, more likely scenario is that she died of tuberculosis in Paris.

By necessity, Paul and Charlie had become self-sufficient at an early age, and rarely spoke about their sister or their parents. Yet Bertha and Charles Child continued to exert their influence on the twins even after death. Both were imbued with their father's scientific curiosity and rationalism, and their mother's vivid imagination and need for artistic expression.

Charlie was a confident extrovert who slept little, read voraciously, rarely got sick, and became a painter. He and Freddie raised three children—Erica, Rachel, and Jon—in a large stone house in Bucks County, Pennsylvania. Paul was a sensitive worrier who suffered health problems throughout his life—from insomnia and jangly nerves to amoebic dysentery during the Second World War, and later to bouts of heart trouble, prostate cancer, broken ribs, and other serious aches and pains. Though often self-doubting, he had a sense of humor about it, as when he wrote, in 1950: "Basically my whole life up to this point has been an effort to master the cosmo-conception of staying alive long enough to find out how not to die before finding out how to live like one not half dead, though I now realize this is harder than I thought when I first thought of it."

But Paul was also a physical man who pushed himself hard. Suffering from vertigo, he grew sweaty-palmed at the top of the Eiffel Tower in Paris, and wobbly-kneed when driving windy country roads up to the mountainous *villages perchés* (perched villages) in Provence. He forced himself to go to these places, just to prove that he could.

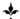

At Avon Old Farms Paul's interests came together in the school laboratory, where he first discovered photography. As was his wont, Paul studied the medium intensively, and soon began to teach it to his students.

Though a patient and sympathetic teacher, Paul believed there was no shortcut or easy way around learning technique. When the son of a friend grew tired of "academic" drawing taught by a bullying art teacher, Paul wrote Charlie: "I believe his only 'freedom' would lie in going through the forest of technical mastery, dark though it be, and emerging on the other side. Suppose someday he wants to paint a portrait and finds he can't draw a likeness because he's never hammered himself into shape on that anvil? I don't see any way of being a good artist, nor a good

pianist, potter, rug-weaver, composer, or ping-pong player, except by mastering the accumulated technical knowledge about the thing in question."

Paul was a popular teacher at Avon, and in 1941 he composed the school song, "Men of Avon." One of his students there was the future folk singer Pete Seeger. Another was Ben Thompson, whom Paul taught French, art, and judo. One day, Paul took Thompson aside and, in a friendly gruff way, said: "You are no good at any of these subjects. You should probably find another direction." Thompson went on to chair the Harvard architecture department and founded Design Research, a design store specializing in kitchenware, furniture, and tools for "contemporary living." He imported Marimekko fabrics from Finland, and decorated the set for *The French Chef*. Later Thompson and his wife Jane, with the Childs' vocal support, led the rehabilitation of Boston's Faneuil Hall into a modern version of Paris's Les Halles marketplace.

Another of Paul's students at Avon was Davis Pratt, a photographer who worked for Steichen at the Museum of Modern Art in New York and became associate curator of photographs at Harvard's Fogg Art Museum. (He was also the uncle of Katie Pratt, the photo editor of this book.) Paul mentored these young men, and in the case of Pratt, helped to shape his career.

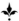

Paul was thriving professionally, but all was not well in his private life. By 1942, Edith Kennedy was suffering from a weak heart and edema, the swelling of tissues with fluid, which made her breathing slow and heavy: "a horrid fish-out-of-water gasping," as Paul described it. The once vivacious Slingsby grew pale and listless. She lost the ability to read, write, or listen to music, and began to hallucinate. Paul did what he could, but he was helpless. At the end of the summer, Edith Kennedy died.

Paul was lonely and bereft, and convinced "I shall never again have the kind of companion who . . . knew and appreciated both the latest jazz and the opus numbers of Beethoven quartets, who could talk lovingly about the art of writing, who was a master cook and gourmet, who could manage a household of complicated people with a sincere artistry, who enjoyed a wrestling match or the shape of a flower, who knew the vagaries and depths of the human heart, who could be completely objective . . . an Ali Baba's cave of the best human qualities."

In subsequent years Paul would date other women, but they never ranked close to Edith, his "touchstone," the one "against which I try the others. Nobody

begins to measure up to that standard." Reeling from his loss, Paul wrote his happily married twin, "You will never know what it is to feel profoundly lonely, to have your vitals twisted by the need for companionship . . . but when you have sown the seed of love, weeded and watered its field, reaped its harvest and stored the golden grains, and: Then! The barn burns down, and the fields are flooded— well you become empty, unbased, and bereft . . . since Edith's death I am rootless, or soil-less."

It is possible, even likely, that Paul would have remained a schoolteacher the rest of his career had World War II not erupted. When it did, Paul was flung to a far corner of the globe, where he had experiences and met people that radically altered his life's trajectory.

WAR AND LOVE

The United States entered the Second World War on December 7, 1941, and within a few months Paul had been recruited to join the OSS, the precursor to the CIA, in Washington, DC. They liked that he had a facility for art, languages, and judo, was self-motivated, had an appetite for adventure, and had lived abroad.

Paul was assigned to the Visual Presentation Division, a creative group that included filmmakers like John Ford, writers like Budd Schulberg, architects like

Paul while serving in the OSS, Ceylon, 1944

Eero Saarinen, and journalists like Theodore (Ted) White. Paul illustrated diagrams and manuals, animated films, and designed posters for the war effort. Charlie worked nearby, as a Cultural Affairs Officer at the State Department, where he arranged for the exchange of artists and their work between the US and its allies.

In 1944, the OSS sent Paul to Ceylon (now Sri Lanka). Posted to a leafy tea plantation near the city of Kandy, he was put in charge of the Presentation Division. He made diagrams of troop movements, posters of poisonous tropical plants and animals, charts of Japanese camouflage patterns, renderings of Japanese warplanes and battleships, and built a top-secret War Room for Admiral Lord Louis Mountbatten. It was exciting and demanding work, and he was

surrounded by professional soldiers, spooks and strategists, academics, safecrackers, and code breakers.

Paul was intellectually engaged by the war effort, but in private he was lonely, sexually frustrated, and worried that without Edith Kennedy he would spend the rest of his life alone. Writing to his twin nearly every day, he produced gloomy poetry, such as:

> These pipes, pulsing in my flesh,
> Water no garden, fertilize no flower.
> Bitter, bitter on the sand is love.
> Love lost, love never gained, love unfulfilled.
> The teeming world is lonely as a moorland,
> As a bird in the middle of the sea.

"When am I going to meet a grown-up dame with beauty, brains, character, sophistication, and sensibility?" Paul despaired.

In 1943, a noted astrologer in Washington named Jane Bartelman had made a series of predictions about Paul's future: he would experience "something . . . terrific, that would involve a secret mission . . . require[ing] a lengthy journey to the Far East," she said. Bartelman also predicted that "sometime after April 1945" he would fall in love with an "intelligent, dramatic, beautiful" person, "a modern woman." It would prove a remarkably accurate prediction, Paul later marveled.

In Kandy, he was looking for romance, and there were plenty of candidates. The lovely Nancy, whom he code-named Zorina. Janie, who spoke French and Malay. And Marjorie, who had a "first class brain." None of these infatuations resulted in a lasting partnership.

But sitting in an adjacent office was a willowy, six-foot-two-inch-tall Californian with an open face and a ready laugh, Julia McWilliams. She was not a spy, as she would later winkingly insinuate; she worked in the Registry as a clerk typist, and spent a lot of her time filing reports; she handled secret information and learned to be vigilant and organized. Occasionally, she worked on special projects, such as developing a shark-repellent or a signal-mirror to aid downed airmen.

Paul Child and Julia McWilliams struck up a friendship.

He was ten years older than she was, and considered Julia's "sloppy thinking" unsophisticated and occasionally "hysterical," though he admired her "long gams" and her "somewhat ragged, but pleasantly crazy sense of humor." She considered his prominent nose and moustache "unsightly." He had a precise, decisive,

skeptical intellect. Compared to many of his colleagues, Paul was a sophisticated aesthete, and confided to his twin that he believed himself to be "one of the few really mature people around here." But beneath his apparent hauteur, Paul Child was a charming and gentle man, an artist who loved good food, a wonderful raconteur who kept up with the news and liked to discuss history and politics.

Paul and Julia slowly warmed up to one another. She was impressed by his facility with language, his willingness to try exotic foods, and his stories about life in Paris, where she had never been. He enjoyed her intelligence and personability, her ability to get things done, and her healthy appetite. To release the pressure of their nearly nonstop wartime work, they would watch movies, borrow a jeep and poke around local food stalls, or go for an elephant ride at the Temple of the Tooth. And as they talked and talked, Paul and Julia became close friends.

Paul at Kapurthala House, OSS, New Delhi, 1943

In January 1945, Paul was suddenly rushed off to Chongqing, China, to build a war room for General Albert C. Wedemeyer. In the spring of that year, both Paul and Julia were transferred to Kunming, where he built another war room and she established another registry. Kunming was the capital of Yunnan province, where the food is strongly flavored, and they continued to explore restaurants and court obliquely over food. (The Childs later maintained that Chinese cooking was their second-favorite cuisine, after French.)

In August 1945, the United States dropped two atomic bombs on Japan, and the war ended shortly thereafter. Paul was now forty-two, Julia thirty-two. Their experience in Asia had profoundly changed them, "for the better," she'd say. But the future was a blank page. Paul admitted to Charlie that he had become "extremely fond" of Julia, but they were no more than "passionate friends," he said. "We liked each other a lot," he would reminisce to *TV Guide* in 1970. "It wasn't like lightning striking the barn on fire. I just began to think, my God, this is a hell of a nice woman, sturdy and funny withal. And responsible! I was filled with admiration for this classy dame. At some point, we

Julia McWilliams at OSS headquarters in Kandy, Ceylon, 1943

Julia McWilliams, 1940s

took a jeep and went out on the Burma Road. And it was there that we said 'let's consider marriage.' Well, it worked out. She's my favorite friend, and we love working together."

On August 15, 1945, Julia's thirty-third birthday, Paul wrote her a sonnet filled with romantic, lusty imagery:

> How like the Autumn's warmth is Julia's face
> So filled with Nature's bounty, Nature's worth.
> And how like Summer's heat is her embrace
> Wherein at last she melts my frozen earth.
> Endowed, the awakened fields abound
> With newly green effulgence, smiling flowers.
> Then all the lovely riches of the ground
> Spring up responsive to her magic powers.
> Sweet friendship, like the harvest-cycle, moves
> From scattered seed to final ripened grain,
> Which, glowing in the warmth of Autumn, proves
> The richness of the soil, and mankind's gain.
> I cast this heaped abundance at your feet
> An offering to Summer and her heat.

After the war, Paul and Julia "took a few months to get know each other in civilian clothes," she would say. They visited her father, "Big John" McWilliams, in Pasadena, then drove cross-country to Maine, where they stayed with Charlie and Freddie and their kids. It was there that they took a deep breath, and gravely announced: "We have decided to get married."

"It's about time!" the family cheered.

On September 1, 1946, Paul Child and Julia McWilliams married. Julia's forehead was decorated with a large bandage, the result of a car crash the day before, which had sent her flying through the windshield.

In those hectic, postwar days, Paul and Julia didn't have the time or where-withal for a proper honeymoon. Instead, they moved to Washington, DC, where Paul worked for the USIS on exhibits. Julia set up house in a small yellow cottage which they bought on Olive Avenue, in Georgetown. She could barely cook at the time, and recalled attempting a wildly ambitious, thoroughly inedible dish of calves' brains simmered in red wine. But Paul was infinitely patient, and in love with her, and he bore up. "Her first attempts were not altogether successful," he

Julia and Paul on their wedding day, at Charles and Fredericka Child's house, Lumberville, Pennsylvania, September 1, 1946. Julia's forehead is bandaged after a car accident the day before

admitted to an interviewer. "I was brave because I wanted to marry Julia. I trust I did not betray my point of view."

The Childs were ardent Democrats, and Julia's family, the McWilliamses, were conservative Republicans from Pasadena. (Her brother John was a mild conservative, and her sister Dorothy stood to Julia's left.) Julia's mother, Carol "Caro" McWilliams, was a warm spirit who had died at age sixty of high blood pressure. "Big John," remarried and ran the family real-estate business. He hoped Julia would marry a banker or lawyer, join his country club, and produce children. He was deeply disappointed by her marriage to Paul—an East Coast intellectual, an artist, a midlevel diplomat without grand financial prospects, a son-in-law who produced no grandchildren. (John McWilliams senior also disapproved of Dort's husband, Ivan Cousins.) But Julia was thrilled with her marriage. "If I'd done what my father wanted, I'd have probably become an alcoholic, like friends of mine," she quipped.

After graduating from Smith College in 1934, and earning twenty-five dollars a week while living in New York, Julia said, "that's when I became a Democrat." Besides, she added, "I like eggheads!" like Paul Child. This made occasional family gatherings awkward for both sides. Paul tried his best to bite his lip when his father-in-law railed against African-Americans, Jews, Liberals, and Europeans—especially the French—but sometimes he had to walk away, muttering. In fact, Paul and Julia itched to go abroad, especially to France. But it took time. After two years in Washington, DC, they were finally posted to the US Embassy in Paris in 1948. When Paul was hired to run the USIS Visual Presentation Department, Julia "tagged along" and tried to decide what to do with her life. "He took me to live in dirty, dreaded France," Julia reminisced. "I couldn't have been happier!"

The narrative of Paul and Julia's marriage is reminiscent of *My Fair Lady* (or its inspiration, George Bernard Shaw's *Pygmalion*). At first, Paul was akin to

Professor Henry Higgins—a sophisticated older man who tutored the ingénue Julia in French and about wine, developed her palate in marketplaces and restaurants, pushed her to express herself clearly and write without cliché, and took her to new places where he goaded her to try new things. Julia, à la Eliza Doolittle, was an avid student; she lapped up the experience of living abroad, especially in Paris. "I loved France so much that I secretly thought I *was* French, only no one had told me," she recalled.

Over the next decade, the Childs moved from posting to posting: after France the State Department sent them to Plittersdorf, Germany, near Bonn. It was a prestigious job, and Paul relished his work there, even as Julia struggled to learn the language and local foods. When, in 1955, Paul was recalled from Germany to Washington, DC, expecting a long-overdue promotion and raise, he was stunned by Senator Eugene McCarthy's sinister acolytes, Roy Cohn and David Schine, who asked if he was a Communist and a homosexual. Uneasily, Paul laughed off the accusations. But they left "the taste of ash" in his mouth, and contributed to his later decision to take an early retirement from the Foreign Service.

In the event, however, the Childs were posted to Washington, DC, in 1956, where Paul was temporarily named the USIS's chief of exhibits. They fixed up their little house on Olive Avenue, and Julia bought a Garland professional range for her kitchen, and continued to work—via a flood of transatlantic letters—with Simca and Louisette on their cookbook.

In May 1959, Paul and Julia arrived in Oslo, Norway, for what would be his final diplomatic posting. Paul brought his paints and cameras, and in his spare time made pictures of the fjords, evergreens, and cod fishermen. Julia brought her book notes and *batterie de cuisine*, tried cross-country skiing, and learned to make gravlax.

The Childs thoroughly enjoyed their two years in Norway. The rocks-and-sea landscape reminded them of Maine, where they had helped Charlie's family build a log cabin. But after eighteen years in the diplomatic service, Paul decided that "there must be more to life" than nomadic wandering around the world, at the beck and call of unsympathetic bureaucrats, with nary a "thank you." In all that time, Julia wrote, he had been rewarded "with exactly one measly promotion and one disgraceful investigation." Paul could have stayed on to reach twenty years of government service, whereupon he would be guaranteed a stipend of $3,000 a month. It was tempting. But he was desperate to return to native soil, settle down, and devote himself to photography and painting. On May 19, 1961, Paul Child retired from the diplomatic service. He was fifty-nine years old, and Julia was forty-nine. "Hooray!" they crowed. "Now what?"

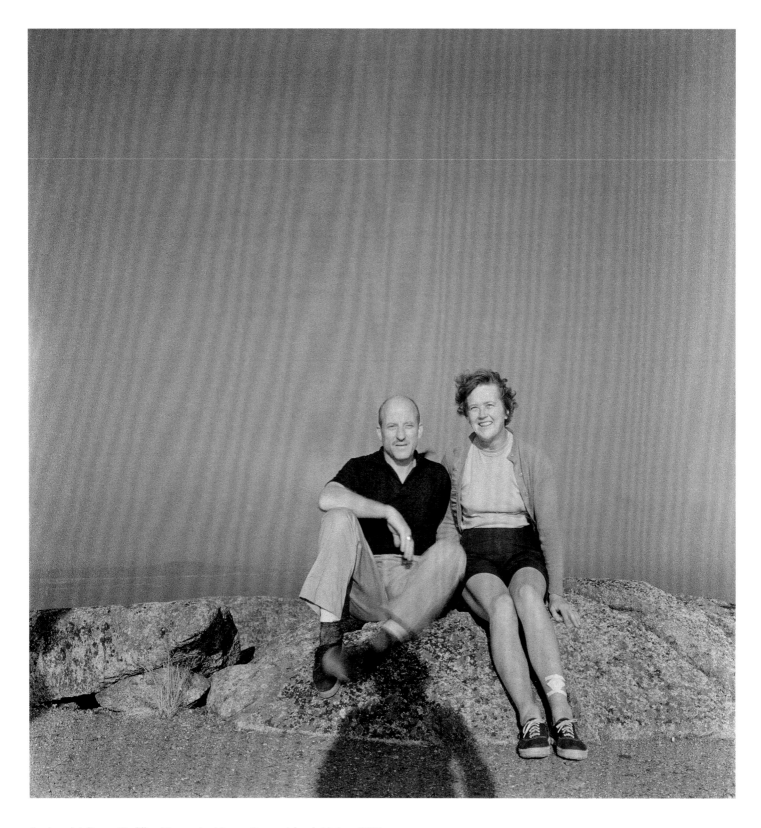

Paul and Julia on Cadillac Mountain, Mount Desert Island, Maine, 1951

CAMBRIDGE

As the Childs prepared to depart the States for Oslo in 1959, Avis de Voto urged Paul and Julia to buy a "special" house in Cambridge, Massachusetts. It was a large gray clapboard Victorian at 103 Irving Street, built in 1889 by the philosopher Josiah Royce. It had a short driveway, a small garden, a large kitchen, three floors, and a full basement. "103 Irving," as they called it, was on a quiet, leafy block behind the Harvard campus and not far from MIT. The Childs' neighbors included the John Kenneth Galbraiths, the Arthur Schlesingers, a smattering of artists and architects, academics of all stripes, Yankees and European refugees who had fled the Nazis, and other "eggheads," as Julia affectionately called them.

The Childs rented out 103 Irving while they finished their stint in Norway. When Paul retired in May 1961, they renovated the house to create a wine *cave* in the basement, a user-friendly kitchen with high countertops on the first floor for Julia, and a photo/painting studio for Paul on the second floor. It was their first permanent home together. After eighteen years of living abroad, he declared: "Ah, freedom at last—no more of this hurly-burly, thank you very much!" Paul and Julia planned a quiet life together: he would take photographs, paint, write, and garden; she would teach cooking classes and work on cookbooks. They would attend concerts and sample restaurants in Boston, just across the Charles River. And they would socialize with their eclectic neighbors. But life, and Julia, had other plans for them.

When Knopf published *Mastering the Art of French Cooking* in October 1961, the book was launched to a rave review by Craig Claiborne in *The New York Times*, and celebrated at a New York book party hosted by James Beard. In February 1962, while John Glenn orbited earth aboard Friendship 7, Julia appeared on a television show in Boston called *I've Been Reading*, which aired on the local public television station, WGBH. She brought a hot plate and supplies and was so intent on demonstrating an omelet that she forgot to mention the title of her book. It didn't matter. Twenty-seven viewers wrote the station, demanding more of that "tall, loud woman cooking on television." This led to Julia taping three pilot programs about cooking in 1962; each went slightly better than the one before. And in February 1963, Julia Child began a weekly cooking show on WGBH called *The French Chef*. From then on, her career quickly blossomed.

Waving fish in the air, dropping a potato pancake on the stove ("when you're alone in the kitchen, who's to know?" she warbled), brandishing an enormous "fright knife," and blasting desserts with a blowtorch, Julia became a cultural

phenomenon. She was a deeply knowledgeable, hilarious, and encouraging culinary guide who was celebrated and spoofed across the country.

In the 1960s, she became a best-selling author and TV star, and in 1966 she won an Emmy and appeared on the cover of *Time*. By 1970, she had won a Peabody Award and the French *Ordre du Mérite agricole* (Order of agricultural merit); shot documentary films about a state dinner at the Johnson White House (1967) and artisanal food in France (1970); coauthored three cookbooks—*Mastering the Art of French Cooking* (1961), *The French Chef Cookbook* (1968), and *Mastering the Art of French Cooking*, Volume II (1970)—and helped launch the American food revolution.

At 103 Irving Street, Julia's Pygmalion-like transformation was complete: now *she* was the star and "senior" member of the marriage. Paul stepped back from the limelight, allowed Julia to flourish, and supported her career from behind the scenes. It was a remarkable, and almost intentional, role reversal—one that Paul was happy about: "I feel Nature is restoring an upset balance," he wrote Charlie.

"We are a team," he and Julia would always say. She made sure to note that Paul had been her original inspiration and was essential to her success. In *The French Chef Cookbook*, Julia described him as "the man who is always there: porter, dishwasher, official photographer, mushroom dicer and onion chopper, editor, fish illustrator, manager, taster, idea man, resident poet, and husband."

As noted earlier, Paul frequently quoted Alfred Korzybski's "the word is not the thing" to Julia, spurring her skepticism of conventional wisdom, and encouraging her to try recipes for herself and make up her own mind about them. Perhaps this focus on logic was a way for Paul to control his occasionally chaotic life. "If variety is the spice of life, then mine must be one of the spiciest you ever heard of," he wrote in 1953.

The Childs kept their connection to France by visiting for several weeks or months every year. With Julia's success, they began to dream of buying a house or an apartment there. Paris remained their favorite city, and was their first choice for a second home. But they often spent a part of their vacation in the company of Julia's *Mastering* coauthor, Simca Beck. (Louisette Bertholle dropped out of the collaboration.) In 1964, Simca and her husband, Jean Fischbacher, suggested Paul and Julia build a small house on the edge of their property in Plascassier, a little

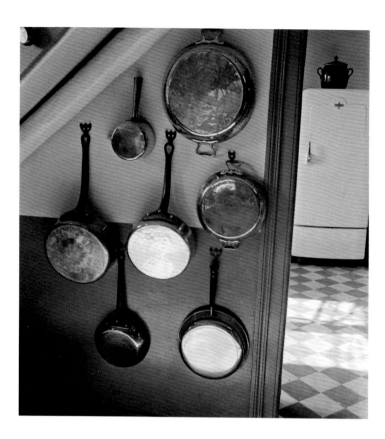

town outside of Cannes, in the south of France. The Childs were thrilled and agreed to lease the property and pay for the construction of a simple stucco house; once they were no longer using the house, they agreed, ownership of the property would revert to the Fischbacher family. The deal was sealed with a handshake. It was a very un-American and un-French arrangement, but it suited the four friends perfectly.

By the summer of 1965, construction on the house was complete. Paul and Julia named it La Pitchoune ("the little thing" in Provençal dialect), which they quickly nicknamed "La Peetch." Julia dubbed it "the house the book built," or "the house built on friendship," because it was largely paid for with earnings from *Mastering* and was made possible by the Childs' friendship with Jean and Simca. La Peetch was the Childs' "lovely hideaway," a touchstone, the place Paul and Julia would retreat to every year in order to rest from the spotlight of Julia's career, recharge, and enjoy what Paul called "the reverse-hornet sting" of France and its food. Their French neighbors had no idea who "The French Chef" was, and didn't care. For Paul and Julia, their house, friends, and the food of Provence proved hugely restorative and inspirational.

In 1971, Julia and Simca split professionally and went their own ways: Simca continued to teach cooking classes in France and wrote several memoir/recipe books. Julia stopped performing as "The French Chef," and eschewed her strict adherence to *la cuisine bourgeoise*. Reinventing herself as "Julia Child," she cooked recipes from around the world, began to write in the first person, and embarked on a second, American phase of her cooking career. Yet the Childs returned to France every year, and remained close friends with Simca and Jean for the rest of their lives.

In August 1974, as they were celebrating Julia's sixty-second birthday at La Pitchoune with the American chefs James Beard and Richard Olney, Paul suffered

a gushing nosebleed. He was seventy-two, and in excellent physical shape. "You have the heart of a racehorse," his doctor had said, so he didn't think much of it. But during a checkup at New England Sinai Hospital, near Boston, Paul recalled that he'd felt a slight pinching feeling in his chest for several years. This, plus the unusual nosebleeds, led the doctor to send him directly to intensive care. A series of tests revealed that two of Paul's major arteries were blocked. The doctors ordered a heart-bypass operation. It was a success, surgically speaking, but it forever altered Paul's carefully controlled and curated life.

While the details are sketchy, it appears that the oxygen flow to his brain was interrupted during the operation, leaving Paul with a case of what Julia called "the mental scrambles." He spent weeks in the hospital recovering. He stopped taking photographs and making paintings, confused names, lost his fluent French, and saw his artful handwriting reduced to shaky scribbles. For a man who had devoted his life to "the clarity of perception and expression," it was torment.

Julia visited him daily, sometimes twice a day. And while she remained upbeat and stoic in public, she was heartbroken in private. "My poor husband, he who took such pride in lifting heavy suitcases and felling massive trees, hated to be so weak and confused," she wrote. "So do I."

Paul's convalescence was slow, "but if he had not had this operation he would probably be dead," Julia wrote to Simca. "It will take 6 months at least to get him back on his feet, but when that occurs, he should be just fine. Thus we are making no plans at all." When he did finally return to 103 Irving Street, Paul had to learn how to walk and speak clearly again. It was a struggle, and even the optimistic Julia was forced to admit that his recuperation was "slow as a snail," and that he might not return to his former self. Paul's health eventually improved to the point that he was able to shoot photographs, travel to France, and accompany Julia to television studios and book-signings. But he never fully recovered. I recall moments when Paul was acute and wholly present in the 1970s, but as time wore on he suffered a series of small strokes, eye and prostate issues, cracked ribs from a fall, and other ailments that left him worn out, befuddled, and ill-tempered. "We must be thankful for each day," Julia confided to Simca, whose husband Jean was also beginning to decline. "*L'âge, ma Chérie*. Suddenly it is there, staring at you."

Indeed, Paul's sister-in-law Freddie died in 1977, and Charlie in 1983, age eighty-one. Jean Fischbacher died in 1986. Simca died in 1991. One afternoon in 1989, Paul wandered out of 103 Irving Street and got lost in the streets of Cambridge. He was found and returned, but Julia was afraid to leave him alone.

That September, she moved Paul into an assisted-living facility outside of Boston. She paid daily visits, or, when she was traveling, would call him at the same time every day.

In 1992, her husband and friends no longer with her, Julia decided to turn the beloved "house built on friendship" over to its legal owners. Toasting La Pitchoune and its memories with Champagne and a final *bœuf en daube à la provençal*, Julia handed the keys to France Thibault, Simca's sister-in-law, and drove away for the very last time, "with no regrets whatsoever."

Though his body remained strong, Paul's once formidable brain faded away. It was sad to watch. But he seemed content in his little room at the nursing home, surrounded by a few of his paintings and favorite photographs. On January 15, 1994, Paul turned ninety-two years old. On May 12, he died quietly in his sleep. When I helped Julia write her memoir, *My Life in France* (2006), she dedicated the book to Paul, and said: "Without Paul Child I would never have had my career."

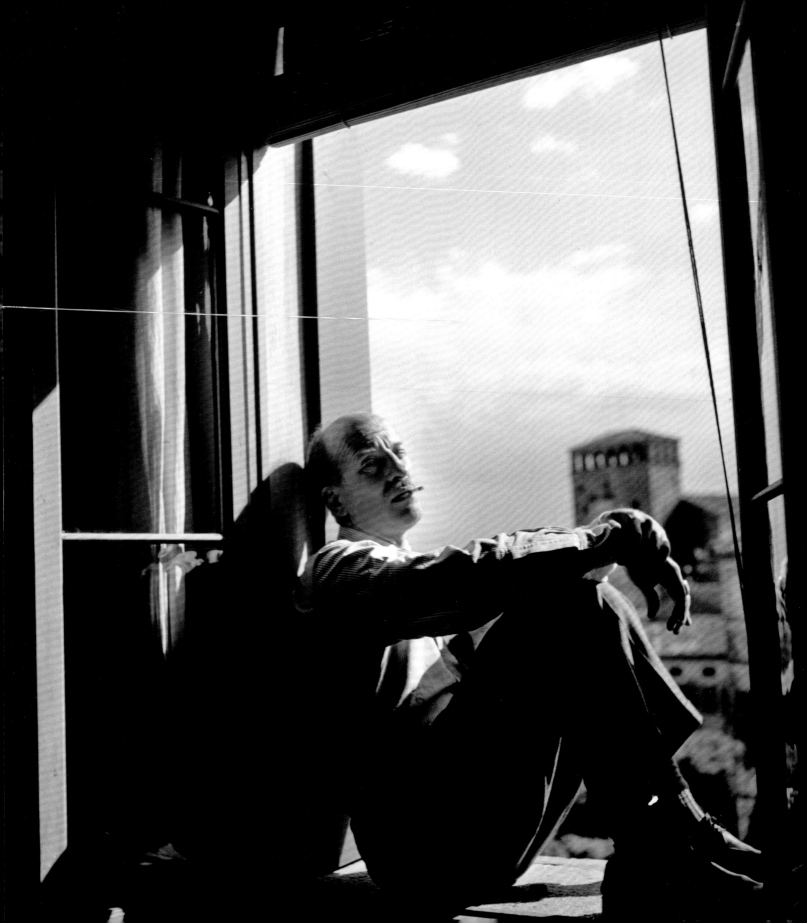

Everything is Go

In 1964, when he was sixty-two, Paul wrote a poem, "Everything Is Go," and scrawled across the top of the page: "To myself, after I have died: In remembrance!"

Everything Is Go

Life's rocket streaks toward nothing,
Burning what once were months and days –
Now minutes, seconds.
Looking back, down, down to childhood, slow-paced and painful,
I did not foresee this roaring toward oblivion.
But here I am
Rushing –
Yet standing still when I think back—
Filled with triumphs and anguishes
Summoned up like jinns.
Now every look, sound, taste and touch, every sunset,
Brings a hundred others into mind,
And every soaring bird a thousand birds.
Aeolian harmonics,
Overtones and octaves of experience,
Dance in the wind of memory.
I place myself in the impact position,
Facing backward,
Hoping my gaze
May still attach me to the dwindling Earth,
But there are no mooring hawsers in the sea of time.

Paul in the window, Asolo, 1952

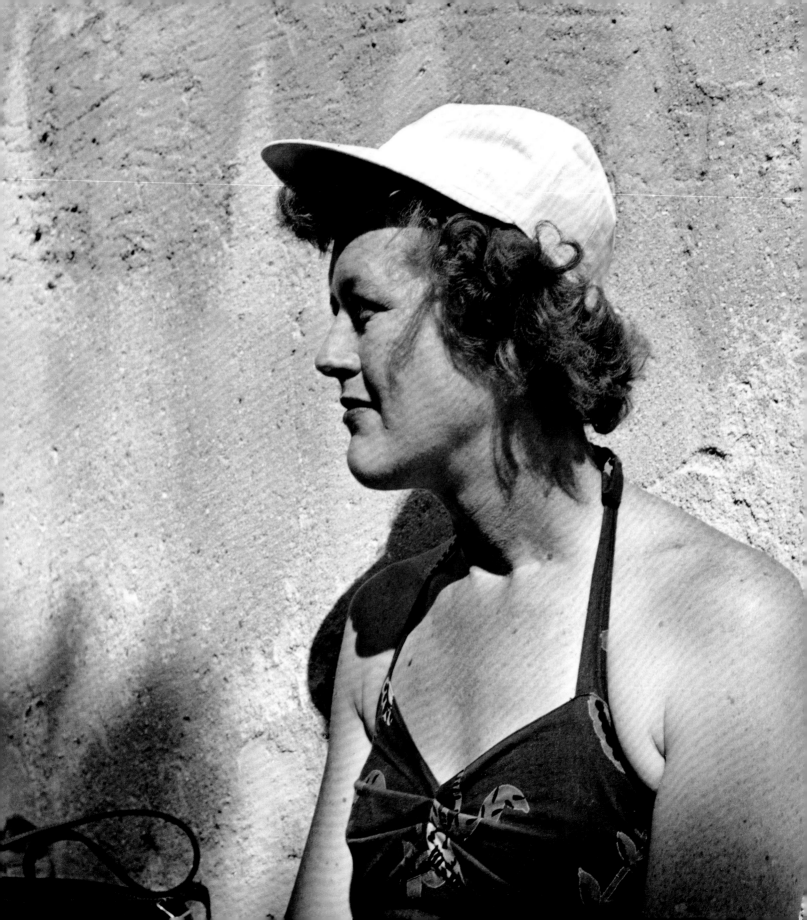

Acknowledgments

With much gratitude to all those who inspired me and believed in my doing this book project, especially: my parents Pat and Herb Pratt, Julia and Paul Child, Davis Pratt, Richard Lorenz, Joshua Partridge, Elizabeth Wolpert Partridge and Rondal Partridge, and Lynda McDaniel, as well as William A. Truslow, Philadelphia Cousins, Dorothy and Ivan Cousins, Rosemary Manell, Jim Dodge, Eric W. Spivey, and Richard and Thekla Sanford. Also, to the Schlesinger Library, the Julia Child Foundation, Alex Prud'homme, and Thames & Hudson.

—Katie Pratt

As with any book, *France is a Feast* was a collective effort, and we are indebted to those who helped us.

First and foremost, we thank Paul and Julia Child, who led such exemplary and inspiring lives, and to whom this book is dedicated. As mentioned in the Prologue, *France is a Feast* evolved from Julia's memoir, *My Life in France*, which the public embraced as much for Paul's photographs as for Julia's "toothsome" stories about their years in Paris and Marseille. After Paul's death in 1994, Julia often mentioned that she would like to create a book of Paul's images—both to serve as a tribute to her husband, and to introduce him to the public as a gifted artist. I think Julia would be thrilled to see this beautiful book in print at last.

It is safe to say that without my collaborator, Katie Pratt, this volume would not exist. *Merci, mon amie*, for your years of dedication to the project, your keen eye, and your boundless enthusiasm about the life and work of Paul Child.

We are also grateful for the support of the Julia Child Foundation for Gastronomy and the Culinary Arts, which Julia created to support non-profit efforts to educate and encourage people to cook, eat, and drink well. With grants and the annual Julia Child Award, the Foundation has enhanced and extended Julia's legacy in many ways. We hope this volume will help further that goal, while shining a light on Paul's side of the story.

We could not have found a better home for our work than Thames & Hudson. With patience, care, and a sense of humor, our publisher, Will Balliett, our editor, Christopher Sweet, and their colleagues helped us shape and refine our story.

Indispensable assistance came from Katie's parents, Pat and Herbert Pratt, who were among the Childs' best friends in Cambridge, Massachusetts. Not only did they provide moral support for our project, they housed many of Paul's photos, negatives, and notebooks in their living room for a time.

Paul and Julia's papers are now housed at the Arthur and Elizabeth Schlesinger Library on the History of Women in America at the Radcliffe Institute, Harvard University. The Schlesinger Library is an unparalleled resource for scholars and members of the public interested in the Childs' lives. Katie and I spent countless hours poring over Paul's images, and their collected papers. We are deeply grateful for the support of Lizabeth Cohen, Marilyn Dunn, Diana Carey, and their colleagues at the Radcliffe Institute. When it came time to select and print the photos for this book, Harvard Imaging Services was a stalwart ally.

Julia's Cambridge kitchen and some of Paul's photographs are on display at the National Museum of American History, at the Smithsonian Institution, in Washington. We salute the wonderful team there who have shared the Childs' stories and artifacts with the public for years. "Julia's Kitchen" is a terrific display, and well worth a visit.

And last but not least, *bises* to my family—Sarah, Hector, and Sophia—for your unwavering support.

Toujours bon appetit!

—Alex Prud'homme

Julia, Cassis, 1950
OVERLEAF: Julia with grain stacks, 1951

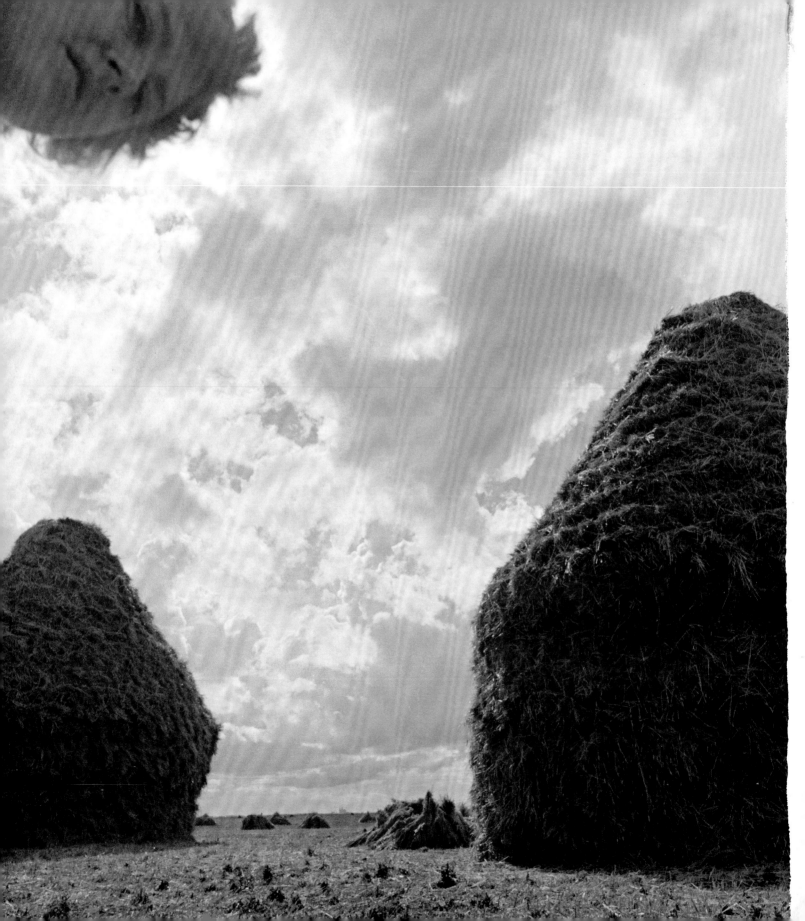

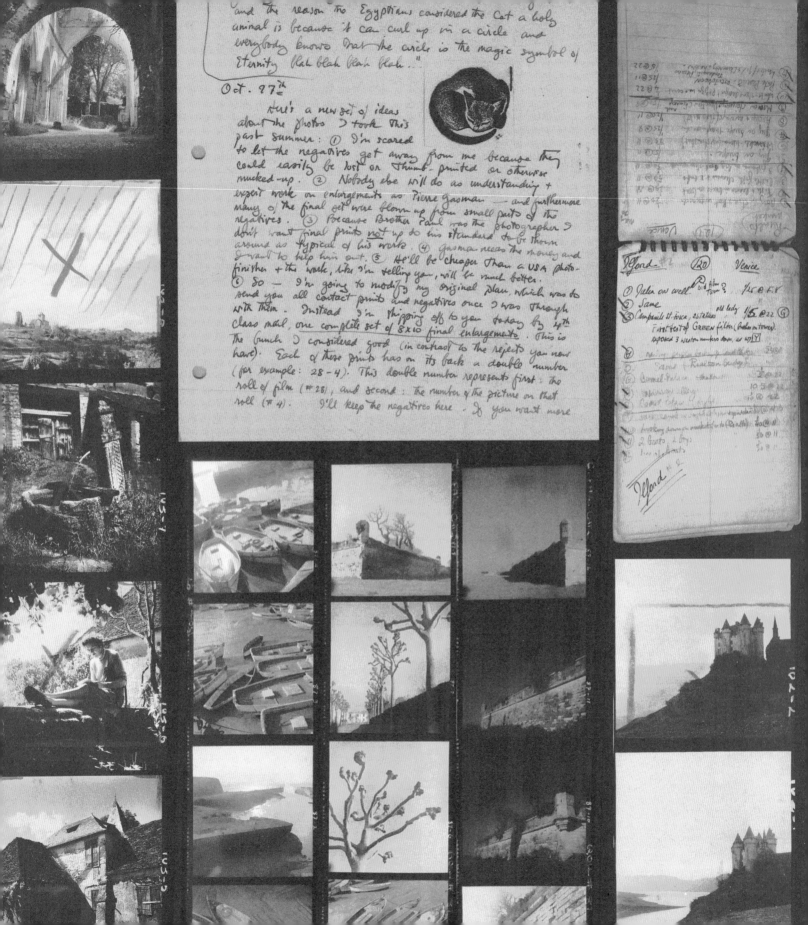

"...and the reason the Egyptians considered the Cat a holy animal is because it can curl up in a circle and everybody knows that the circle is the magic symbol of Eternity blah blah blah blah..."

Oct. 27th

Here's a new set of ideas about the photos I took this past Summer: ① I'm scared to let the negatives get away from me because they could easily be lost or Thumb-printed or otherwise mucked-up. ② Nobody else will do as understanding + expert work on enlargements as Pierre Gasman — and furthermore many of the final set were blown up from small parts of the negatives. ③ Because Brother Paul was the photographer I don't want final prints not up to his standard to be thrown around as typical of his work. ④ Gasman needs the money and I want to help him out. ⑤ He'll be cheaper than a USA photo-finisher + the work, like I'm telling you, will be much better. ⑥ So — I'm going to modify my original plan, which was to send you all contact prints and negatives once I was through with them. Instead I'm shipping off to you today by 4th Class mail, one complete set of 8x10 final enlargements. This is the bunch I considered good (in contrast to the rejects you now have). Each of these prints has on its back a double number (for example: 28-4). This double number represents first: the roll of film (#28), and second: the number of the picture on that roll (#4). I'll keep the negatives here - If you want more